The Landscape Photography
WORKSHOP

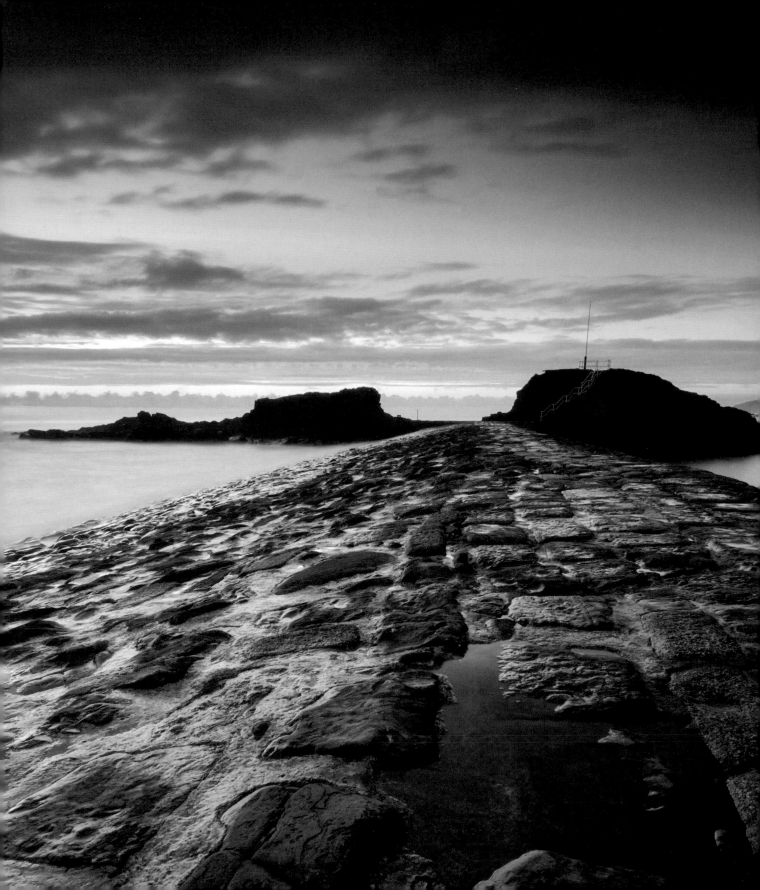

The Landscape Photography
WORKSHOP

**ROSS HODDINOTT
& MARK BAUER**

AMMONITE
PRESS

First published 2013 by
Ammonite Press
An imprint of AE Publications Ltd
166 High Street, Lewes,
East Sussex, BN7 1XU,
United Kingdom

This title has been created with materials first published in
The Landscape Photography Workshop (2011)

Reprinted 2014

Text and photographs © Ross Hoddinott and Mark Bauer, 2011
Copyright in the Work © AE Publications Ltd, 2013

ISBN 978-1-90770-897-8

Publisher: **Jonathan Bailey**
Production Manager: **Jim Bulley**
Managing Editor: **Gerrie Purcell**
Editor: **Tom Mugridge**
Managing Art Editor: **Gilda Pacitti**
Designer: **Simon Goggin**

SET IN FRUTIGER

Color origination by GMC Reprographics
Printed and bound in China

Picture credits:
p71 (left) © iStockphoto.com
p87 © www.2020v.org/Ross Hoddinott
p97 © AA Photo Library/Mark Bauer
p100 © www.2020v.org/Ross Hoddinott
p140 (left) © Canon (UK) Ltd

CONTENTS

INTRODUCTION

WORKSHOP *(Noun)*

A meeting of people to discuss and/or perform practical work. Training in a subject, skill or activity.

We have been hosting landscape photography workshops in the south-west of England for several years. We thoroughly enjoy sharing our skills and experience as professional, award-winning landscape photographers, and we cram lots of practical help and information into our workshops. Participants often comment on how they wish they could remember everything they learned during the course – but the human brain being what it is, this just isn't possible. That's why we decided to create a workshop in book form – to provide a useful, practical resource, covering all the essentials photographers need to improve their landscape images. We also appreciate that not everyone can afford to attend a workshop, or justify the time away from work or domestic duties. Therefore, we hope this book will – to some extent, at least – provide a cost-effective alternative to attending a workshop in person.

Landscape photography has a broad appeal. It is accessible to everyone, and photographers will often find themselves amid extraordinary scenery, witnessing the wonder of nature and the effect of light as it sculpts the landscape. The word 'photography' literally means 'painting with light', and light is the key ingredient in all photographs. However, beautiful scenery and magnificent light won't guarantee a great shot. Your equipment and choice of lens will greatly influence the final result, and the focal length you use can dramatically alter the way a scene is recorded. Exposure settings are crucial to achieving great photographs: aperture and shutter speed have a reciprocal relationship, and dictate the depth of field (back-to-front sharpness) and the way motion is recorded. Composition is also key: to create strong images, you must develop the ability to arrange the key elements within the landscape in interesting ways. In-camera filtration remains an essential part of digital landscape photography, for both corrective and creative purposes.

All of these topics are covered in *The Landscape Photography Workshop*, but the book, like our workshops, goes much further – beginning with a chapter on Advanced Technique (Chapter 7), in which we share professional methods for exposure, focusing and maximizing sharpness. Most landscape photographers now shoot digitally (and this is the system we recommend), so Chapter 8 is dedicated to Post-processing. This chapter will introduce you to Raw processing, exposure blending and stitched panoramics. Digital printing is an art in itself, and Chapter 9, Printing, will help you achieve the best possible results from your favourite images.

We also set you a range of Creative Assignments (Chapter 10), which simulate some of the challenges we set for our workshop participants, including working in overcast conditions and low light, breaking the accepted rules of composition, and using very long exposures – after all, the best way to learn photography is to go out and do it. Finally, there is a section devoted to the questions we are asked most frequently by workshop participants, which we answer in a jargon-free, easy-to-understand style.

We run our workshops in a friendly, relaxed and personal manner. We aim to ensure that beginners don't feel intimidated, or more experienced photographers patronized. We have tried to replicate that approach in *The Landscape Photography Workshop*, explaining the subject in straightforward language but with enough additional detail and expertise to satisy those familiar with the basics. The book is illustrated with our own images, taken using the skills we share with you here. Quite simply, this is a landscape photography workshop in book form. We hope you enjoy it.

Mark Bauer and Ross Hoddinott
Dawn 2 Dusk Photography

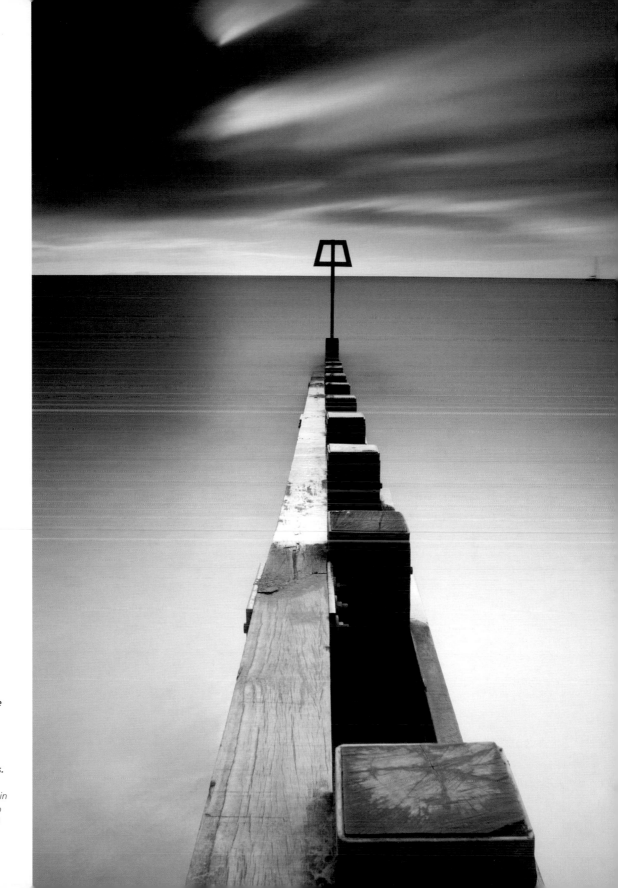

GROYNE

By sharing our skills and experience as professional landscape photographers and workshop leaders, we hope to help you broaden your own photographic horizons.
Nikon D300, 10–24mm (at 20mm), ISO 100, 3 min at f/22, polarizer, 10-stop ND filter, 3-stop ND grad

▶ CHAPTER ONE > **EQUIPMENT**

Before attending a workshop or embarking on any photographic project, you must carefully consider the equipment you require. To help you make those vital decisions, this chapter is dedicated to cameras, lenses and the accessories that we consider either essential or at least desirable. Part of the appeal of landscape photography is that it is accessible to everyone, and it is possible to take great images even with the most basic set-up – a creative eye is more important than buying the latest, most expensive equipment. Ideally, however, you need a camera that will give you total creative control. A digital SLR (DSLR) system is affordable, expandable and versatile, and is the choice we recommend.

BRUSHSTROKES
Simplicity is the key to this image.
A long exposure rendered the moving
cloud as brushstrokes of colour.
Nikon D300, 24–85mm (at 85mm), ISO 200,
2 min at f/11, 10-stop ND filter

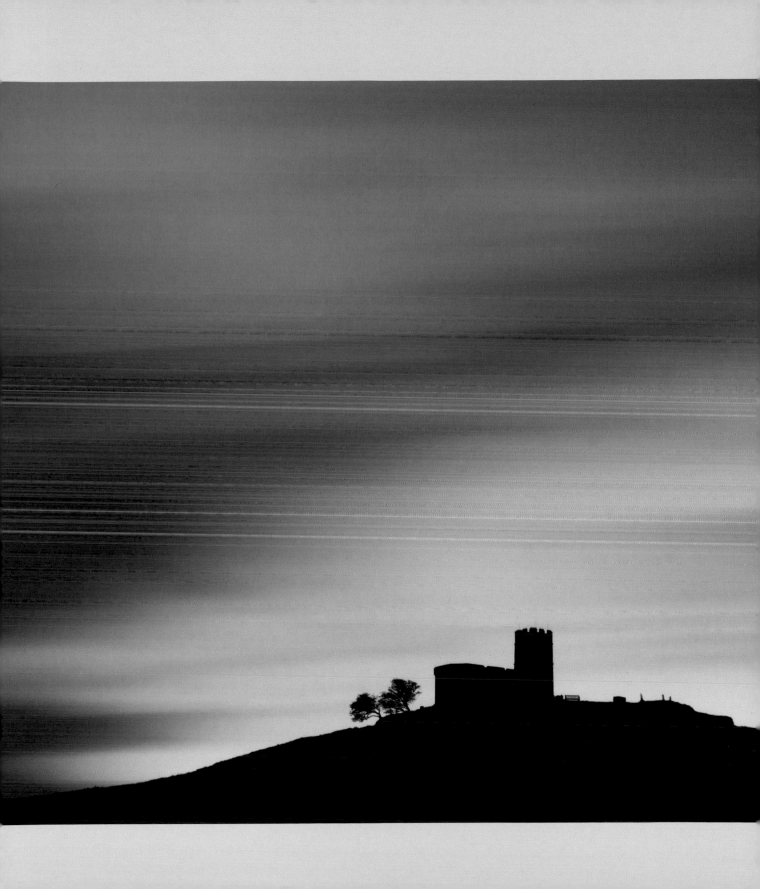

THE DIGITAL SLR

You don't need the latest, most expensive camera to capture great photographs. Good landscape images are within everyone's grasp, regardless of whether you use a digital compact, a bridge camera or even a camera phone. However, the versatility, quality and affordability of the digital SLR mean that it is the system we recommend for serious landscape enthusiasts.

WHAT IS A DIGITAL SLR?

The digital Single Lens Reflex camera – digital SLR or DSLR for short – resembles the traditional film SLR in that the photographer is looking through the actual taking lens when he or she peers through the viewfinder. The DSLR camera employs a mechanical mirror system and pentaprism to direct light from the lens to an optical viewfinder at the rear of the camera. When a photograph is taken, the mirror assembly swings upward, narrows to the specified setting, and the camera's shutter opens to allow the lens to project light onto the digital sensor positioned behind it. The whole process can occur in just a fraction of a second – some digital SLRs are capable of capturing images at staggeringly fast speeds of up to 10 frames per second.

Digital SLRs are popular among photographers in all genres and at every level of experience and ability. They remain relatively compact and lightweight and offer exceptional image quality, with a resolution capable of exceeding that of older 35mm and medium-format film cameras. They typically offer photographers greater creative control, lower levels of noise (see page 80), superior build quality, superb ergonomics and a large, bright viewfinder, which aids focusing and precise composition. While high-specification models can be costly, entry-level and consumer models are increasingly affordable.

One of the biggest assets of the DSLR system is its great versatility. DSLR cameras are compatible with a vast range of accessories, including lenses, filters and flashguns. As a result, the capabilities and potential of the DSLR are, quite simply, endless.

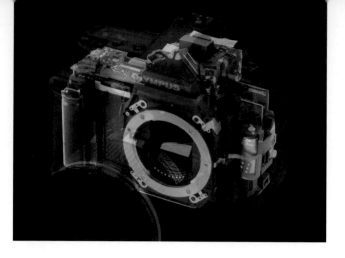

DIGITAL SLR
Light entering the lens of a digital SLR strikes a mirror installed in the camera body at a 45° angle, directing it into the viewfinder pentaprism. When the picture is taken, the mirror flips up out of the way, the shutter opens and the sensor is exposed to the light.

THE DIGITAL SENSOR

Every time a digital image is captured, your camera makes millions of calculations in order to capture, filter, interpolate, compress, store, transfer and display the photograph. At the heart of every digital camera is its sensor, which determines the camera's resolution and image quality. The majority of modern digital SLRs have very high resolution, exceeding 12 million pixels (1 million pixels equals 1 megapixel). Generally speaking, a larger sensor produces higher image quality. Compacts and camera phones often boast a high pixel count, but they employ smaller chips – therefore, with millions of pixels (or 'photosites') crammed onto a small sensor, they are more prone to image-degrading noise (see page 80) and don't perform well in low light. The highest-quality sensors are found in larger format digital cameras, but they are costly. There are three different sensor types commonly found in digital SLRs: full-frame, APS-C or 'cropped', and Four Thirds.

FULL-FRAME SENSORS

The 35mm format has remained popular and relatively unchanged since its inception in the late 19th century, and it remains the standard we refer to even in the digital age. The sensor in a full-frame digital SLR is equivalent in size to a traditional 35mm negative – 36 × 24mm. Being larger, full-frame chips are more

expensive to manufacture, so are typically only found in high-specification models such as Nikon's range of FX-format cameras. Unlike consumer models, full-frame DSLRs have no multiplication (or 'crop') factor. This means that the attached lens will create the same field of view as it would on a 35mm film camera, retaining the characteristics of that particular focal length. Full-frame sensors also possess larger photosites. Therefore, they are able to capture more light with less noise, so images are smoother, sharper and more detailed. Their superior quality makes full-frame models an excellent choice for landscape photography.

APS-C OR CROPPED SENSORS

The majority of entry-level and consumer digital SLRs have APS-C sensors, equivalent in size to Advanced Photo System (APS) film images (25.1 × 16.7mm). However, sensor size can vary from 20.7 × 13.8mm to 28.7 × 19.1mm, depending on the manufacturer. Because it is smaller than the traditional 35mm standard, this format is often described as 'cropped'. Due to the smaller sensor, APS-C cameras appear to multiply the focal length of the lens attached. This is known as the crop factor, multiplication factor, or focal length multiplier. This factor has to be applied to calculate the camera's 35mm-equivalent focal length. The degree of multiplication depends on the exact size of the sensor, but it is typically 1.5×. Therefore, a 28mm wide-angle lens will effectively be 42mm (28mm × 1.5) when attached to camera with a factor of 1.5×. Depending on the scene you are photographing, this can be an advantage or a drawback. For example, traditional wide angle lenses will lose their characteristic effect, meaning that you require an even shorter focal length to retain a similar angle of view. However, when photographing distant subjects, such as a lone tree or faraway building, the effect can prove quite useful.

FOUR THIRDS SENSORS

The size of the imaging sensor found in digital SLRs that employ the Four Thirds system is 18 × 13.5mm (22.5mm diagonal). It is 30–40% smaller than an APS-C sensor, with an aspect ratio of 4:3 (hence the name). This is squarer than a conventional frame,

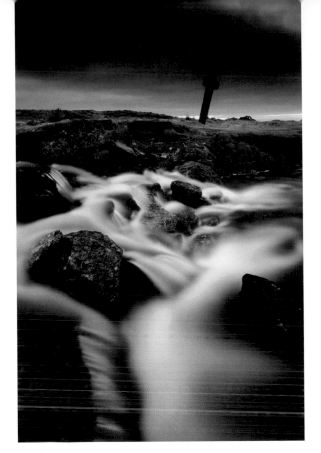

THE WINDY POST
It may be a cliché, but a great image is created by the photographer, not the camera. You can capture striking landscapes regardless of the camera you own. However, the versatility, quality and expandability of digital SLRs make them an ideal choice for scenic photography.
Nikon D300, 10–24mm (at 10mm), ISO 100, 30 sec at f/20, 3-stop ND grad

which is typically 3:2. The Four Thirds system was conceived by Olympus and Kodak with the intention of freeing manufacturers from the need to provide compatibility with traditional camera and lens formats. Subsequently, the system has been endorsed by both Panasonic and Sigma. The diameter of its lens mount is approximately twice the size of the image circle, allowing more light to strike the sensor from directly in front, which helps to ensure sharp detail and accurate colour even at the periphery of the frame. The small sensor effectively multiplies the focal length by a factor of 2×, enabling manufacturers to produce smaller, lighter lenses. The Four Thirds system is providing a growing challenge to the conventional systems.

LENSES

One of the greatest benefits of using a DSLR camera is that it is compatible with a wide range of lenses, from both the camera manufacturer and third-party lens brands. Different focal lengths suit different scenes, and your choice of lens will have a huge impact on the look and feel of your landscape images.

FOCAL LENGTH

The focal length of a lens determines its angle of view and the extent to which the subject will be magnified. It also helps to determine perspective (see page 50). The power of a lens is represented in millimetres – a low number indicates a short focal length (or large angle of view) and a high number represents a long focal length (small angle of view). Optics range widely in design and strength – from circular fisheyes, which give an ultra-wide, distorted perspective, to powerful telephotos exceeding 1000mm. Human eyesight is roughly equivalent to 50mm on a full-frame DSLR, so focal lengths in this range are considered 'standard'. Anything smaller than 50mm is typically referred to as 'wide-angle', while anything longer is considered 'telephoto'.

A longer focal length makes the subject appear larger in the frame than a shorter lens from the same distance. The relationship is geometric. For example, assuming the same subject-to-camera distance, doubling or halving the focal length will also double or halve the size of the subject in the frame. Many digital SLR cameras have a sensor smaller than the 35mm standard (see pages 10–11) and this effectively increases the focal length of the lens. As a result, a shorter lens is required to achieve an equivalent angle of view. It is for this reason that digital SLR/lens combinations are often stated in terms of their 35mm-equivalent focal length.

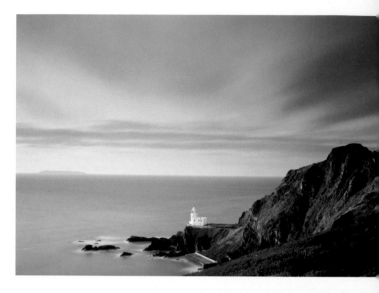

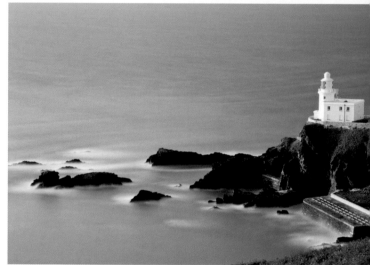

FOCAL LENGTH
Altering the focal length of the lens can radically alter the look, feel and emphasis of the photograph. In the first image (top) shown above, I photographed the lighthouse using a 21mm lens. This gave a wide-angle result, placing the building in context with its surroundings. For the second image, I switched to a 70mm focal length, isolating the lighthouse.
Nikon D300, ISO 200, 2 min at f/11, 10-stop ND

PRIME VERSUS ZOOM LENSES

There are two types of lens: prime and zoom. A prime – or 'fixed' – lens has a specific focal length that cannot be altered. The focal length of a zoom lens is adjustable, allowing you to choose from a range of focal lengths without having to change the lens. Both types have advantages and drawbacks.

Generally speaking, prime lenses have the edge optically. Typically, they are also faster – for example, many prime wide-angles have a maximum fixed aperture in the region of f/2.8. This is beneficial in low light, as it provides a brighter viewfinder image. The construction of a prime lens is less complex than that of a zoom, so prime lenses also tend to be lighter and more compact. However, they lack the versatility of their zoom counterparts.

Zoom lenses cover a range of focal lengths, so you only need to carry one lens, rather than two or three – potentially saving money and conserving space in your camera bag. You can remain in the same position yet create radically different compositions and results by simply zooming in and out. If your budget allows, avoid cheaply constructed zooms – they are more prone to aberrations, flare and diffraction (see pages 110–1). Better quality zooms can rival the image quality of primes. However, zooms tend to have a slower maximum aperture, and this may not be fixed – some zooms become progressively slower as the focal range is increased. Another drawback is that zooms do not have detailed depth-of-field scales marked on the lens barrel, making it more difficult to set the hyperfocal distance (see pages 108–9) with any accuracy.

It's a difficult choice, and your decision will be dictated by your own personal requirements and budget. However, for most landscape photographers, the convenience and flexibility of zoom lenses make them the preferred choice.

Tip: If you are using a lens with optical image stabilization (OIS), ensure the OIS function is switched off when your camera is mounted on a tripod. Some forms of OIS can actually generate blur if camera movement is not detected.

IMAGE STABILIZATION

Many modern lenses benefit from optical image stabilization (OIS) technology. This is designed to compensate for the photographer's natural movement, minimizing or eliminating the degrading effect of camera shake. 'Shake' shifts the angle of incoming light relative to the optical axis during exposure, resulting in image blur. OIS can allow photographers to shoot up to three or four stops slower than would otherwise be possible. Using internal motion sensors, or gyroscopes, it works in inverse relation to the movement of the lens, maintaining the position of the light rays on the sensor.

Lens brands have different names for this function – Image Stabilization (Canon), Vibration Reduction (Nikon), Optical Stabilization (Sigma) and Vibration Compensation (Tamron) – but the principle remains the same. Some manufacturers, including Pentax, Olympus, Samsung and Sony, employ shake-reduction systems in the camera itself, rather than the lens – the advantage being that all attached lenses benefit from the technology.

While OIS is very effective, scenic photographers tend to benefit from it least. This is because, when shooting views, you are advised to use a tripod for stability whenever possible (see Tip). As a result, the extra cost, size and weight of a lens with image stabilizing technology may be unnecessary.

NIKON VR LENS
Image-stabilization systems such as Nikon's VR (Vibration Reduction) are beneficial when shooting handheld.

LENSES FOR LANDSCAPE PHOTOGRAPHY

One of the questions most often asked by workshop participants prior to a course is, 'Which lenses should I bring?' Wide-angles are the most useful and commonly used type of lens for landscape photography. However, depending on the scene, the location and the result you wish to achieve, almost any focal length can be used to shoot stunning landscape images.

WIDE-ANGLE LENSES

Any focal length shorter than 50mm is generally considered wide-angle. Wide-angle lenses are an essential tool for landscape photographers and a must-have for workshop participants. They enable you to capture expansive, distant views, and one of their key characteristics is the way in which they stretch the relationship between near and far, exaggerating the scale of foreground subjects. Landscape photographers can manipulate this effect to produce images with enormous depth, dimension and impact.

A focal length of, or equivalent to, 28–35mm is generally considered to be the standard, traditional wide-angle. This is wide enough to capture large vistas, but not so wide that it distorts perspective, and is well suited to capturing faithful-looking landscapes. For more dynamic results, opt for a super- or ultra-wide-angle lens, equivalent to 15–21mm. This may not seem a significant shift in focal length, but at this end of the spectrum, just a few millimetres' difference can radically alter coverage and the way in which you are able to capture a scene. Although lens distortion is more difficult to control using such wide focal lengths, they enable you to capture more dramatic results and stretch perspective to the limit. They are most effective when there is interesting subject matter in the foreground. If you fail to include strong foreground interest when using short focal lengths, you risk producing dull compositions full of large, empty spaces. Therefore, they have to be used with care and consideration.

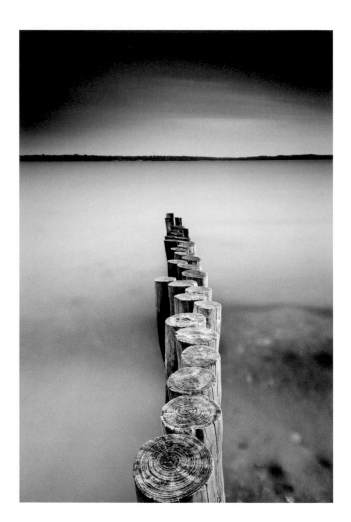

WEATHERED GROYNE
Wide-angle lenses stretch the relationship between near and far. Foreground objects seem larger and more dominant, while those in the distance look even further away. This effect can be utilized to create depth and impact in landscapes.
Nikon D300, 12–24mm (at 17mm), ISO 200, 8 min at f/11, 3-stop ND grad, 10-stop ND filter

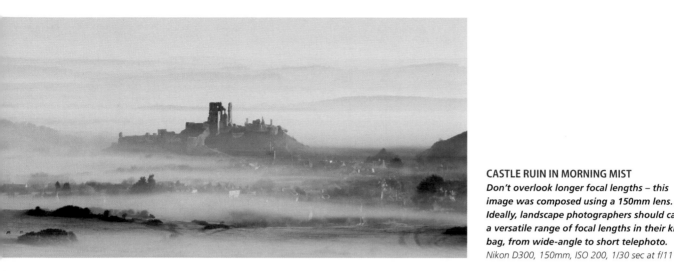

CASTLE RUIN IN MORNING MIST
Don't overlook longer focal lengths – this image was composed using a 150mm lens. Ideally, landscape photographers should carry a versatile range of focal lengths in their kit bag, from wide-angle to short telephoto.
Nikon D300, 150mm, ISO 200, 1/30 sec at f/11

When photographing scenery, a large depth of field (see page 30) is often a priority, to ensure that everything from the nearest object to the far distance is acceptably sharp. Wide-angles have a more extensive depth of field than any other type of lens, which is another benefit of using a wide-angle for shooting scenery. No other lens type is better suited to landscape photography.

STANDARD LENSES

A focal length in the region of 50mm – roughly equivalent to human vision – is considered a 'standard' lens. Standard lenses display minimal distortion and provide a natural-looking perspective, making them well suited to landscape photography. However, standard lenses are often overlooked in favour of a wider, more dynamic perspective. This is a mistake, as standard lenses are wide enough to capture expansive views with depth, yet possess an angle of view narrow enough to allow photographers to capture simple and precise compositions. A standard lens is a good choice if you want to place more emphasis on background subjects, or when you simply wish to guard against the risk of foreground objects dominating your composition. Prime standard lenses are typically fast, compact and optically superb, making them a good addition to a landscape photographer's kit bag.

TELEPHOTO LENSES

A lens exceeding 50mm in length is regarded as a telephoto. Telephoto lenses have a narrower angle of view than the human eye, so a scene or subject appears magnified in the frame.

Telephotos are available in a wide range of focal lengths, up to and exceeding 1000mm. They can be broadly divided into three categories – short, medium and long. Medium and long telephotos are generally best suited to distant subjects, like wildlife, sport and action photography. Generally speaking, their angle of view is too narrow to capture scenery. However, short telephotos – which fall within a focal range of 50–135mm – can prove very useful for isolating detail and interest within the landscape – for example, a lone tree, church steeple or building. Longer focal lengths foreshorten perspective, and landscape photographers can utilize this to emphasize a subject or main focal point. Short telephotos tend to be fast, relatively compact and lightweight.

Tip: Aim to buy two or three different zoom lenses that cover shorter ranges, rather than one all-purpose 'super-zoom'. Lenses with smaller ranges often offer superior image quality.

CAMERA SUPPORTS

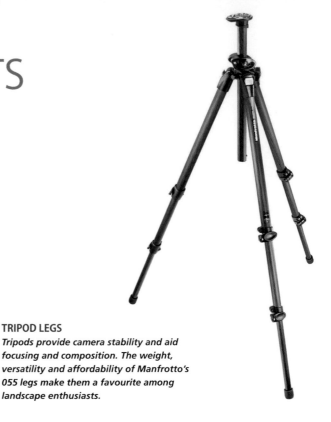

Investing in a good quality, sturdy camera support will dramatically improve your landscape photography. It is false economy to buy a top of the range camera if you then shoot handheld or buy a lightweight, flimsy support. When photographing scenery, shutter speeds (see pages 28–9) will often be slow, as you will select a small aperture (see pages 26–7) to maximize depth of field. Therefore, the risk of camera shake is greatly increased. But, as we shall see, stability isn't the only reason why a tripod is an essential piece of equipment for landscape photographers.

TRIPODS

While other types of camera support are available, nothing can rival the stability of a good tripod. While it can be heavy and inconvenient to carry, it is a must-have for landscape enthusiasts. A good tripod will practically eliminate the risk of camera shake and guarantee consistently sharp results. Many of the most creative landscape images are captured in low light using lengthy exposures – results made possible only by the use of a tripod.

Although primarily designed for stability, tripods will also assist your photography in other ways. Using one slows down the picture-taking process, giving you more time to let your eye wander around the frame and consider your composition. Also, without a tripod, it is more difficult to use the hyperfocal distance technique (see pages 108–9) and align graduated filters (see pages 81–2) accurately. Quite simply, to get the most from this book – and to complete the assignments in Chapter 10 – you need a tripod.

If you don't currently own a tripod, or you wish to upgrade, deciding which model to buy will depend on your budget, the weight you can comfortably carry, and your height. There is a wide range of models and designs on the market, from leading brands like Benbo, Giottos, Gitzo, Manfrotto, Slik and Velbon. It is best to opt for a tripod that doesn't come as a single unit, as you can then combine the legs and tripod head of your choice. Tripod legs can vary widely in price, but you don't have to spend a fortune.

TRIPOD LEGS
Tripods provide camera stability and aid focusing and composition. The weight, versatility and affordability of Manfrotto's 055 legs make them a favourite among landscape enthusiasts.

For example, the Manfrotto 190 and 055 legs represent excellent value for money. Choose a design that allows you to select a low shooting angle – this is ideal in situations where you want to get down low and close to foreground subjects. Next, consider the weight. A lightweight support may be easier to carry, but, if it is too light, its efficacy will be limited as it will be unable to support a heavy set-up and will be prone to movement in windy conditions.

A sturdier tripod is preferable, and essential if you are using a weighty high-end digital SLR. Unfortunately, sturdy often means heavy, which can be a problem if you intend to walk long distances to a location. If your budget allows, carbon-fibre legs are lighter but still offer excellent stability. Also consider height. Tripods are usually designed with either three or four adjustable leg sections, so buy a support that will extend to a height you are comfortable with – you don't want to be constantly bending over to peer through the viewfinder. It's worth remembering that extending a tripod's centre column can begin to compromise its stability, particularly in windy conditions. Always fully extend the legs first and only raise the centre column if necessary.

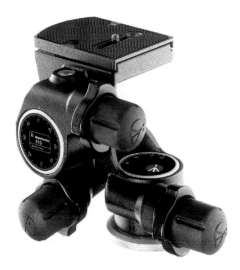

GEARED HEAD
*Geared tripod heads such as the Manfrotto
410 Junior, though more expensive, give you
very precise control.*

MONOPODS

A monopod is a simple camera support with a single leg. You attach the camera either via a head or directly to a screw thread. A monopod normally has two or three sections and, once it is adjusted to the height you require, you are ready to begin shooting. Although using one is preferable to taking pictures handheld, monopods are unable to offer the level of stability that landscape photographers require, particularly with longer exposures. Their design and manoeuvrability make them more suitable for sports and nature photographers using long telephotos.

TRIPOD HEADS

Although budget tripods are often 'all in one' designs, with head and legs fixed together, it is better to buy them separately. This enables you to select the type of head that you find easiest to work with. The range of designs may seem daunting, but most are simply a variation on either a traditional pan-and-tilt head or a ball-and-socket design. Ball-and-socket heads allow you to smoothly rotate the camera around a sphere, and then lock it into position. They are quick and easy to use. Some photographers find them very precise, while others find them fiddly and frustrating to use – it is a matter of taste. A pan-and-tilt design offers three separate axes of movement – left-right tilt, forward-back tilt and horizontal panning. Geared models are also available, which – although more costly – allow you to make very fine, accurate adjustments to composition.

Most tripod heads are designed with a quick-release plate. This secures directly to the camera via its screw thread/tripod bush and snaps on and off to allow you to quickly attach and detach your camera. The size and design of the plate varies from head to head, so test a variety of designs in the shop before making your decision. It is important to buy a head that you find comfortable to use.

GORILLAPOD

Gorillapods have short, flexible, gripping legs that can either be stood up or, for elevation, be wrapped around a post or fence. They are available in a range of sizes, but the Focus is the strongest member of the family and the one best suited to supporting a digital SLR. A Gorillapod isn't a replacement for a tripod, but it is a good compromise in situations where a tripod isn't practical or convenient. Due to its small size, the viewpoints from which you can take photographs using a Gorillapod are limited. However, the compact Gorillapod can be slipped into a camera bag or rucksack and carried around without adding too much extra weight to your load.

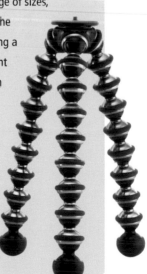

ACCESSORIES

You don't need to spend a fortune on accessories and attachments. Filters (see Chapter 5) are usually the biggest investment you will need to make. However, there are a handful of other accessories that are also very useful when photographing scenery.

REMOTE RELEASE CORD

Even when your camera is mounted on a tripod, pressing the shutter-release button can create a small amount of movement or vibration. Although this may be very slight, it can soften the resulting image enough to be noticeable when the photograph is enlarged or printed. To avoid the problem, you can release the shutter remotely using either a remote cord or a wireless device. Remote cords attach to digital SLRs via the remote terminal on the camera body, and consist of a cable with a trigger button at the end. They vary widely in size and design, but landscape photographers will usually only require a unit with a short cord. Basic models are designed with just a simple trigger to release the shutter, while more sophisticated models may be equipped with

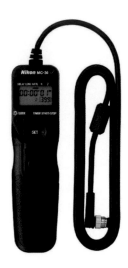

REMOTE RELEASE
To maximize image sharpness and eliminate any risk of camera movement, release the shutter remotely using a device such as the Nikon MC-36.

a speaker, interval timer, backlit control panel and timer. Infra-red remote controls are also available, but generally they don't offer the same level of control. Using a remote release of some kind is highly recommended, although the camera's self-timer facility can be used as an alternative.

Not only do remote cords allow photographers to release the shutter without handling the camera, they are also an essential attachment when you wish to employ lengthy, timed exposures using the camera's Bulb mode (see page 119).

HOTSHOE SPIRIT LEVELS

A small, inexpensive, but very useful camera accessory is a double-axis spirit level. This is simple to install, attaching directly to the camera's flash hotshoe, and allows you to check that the camera is aligned accurately and is level. This is particularly useful for photographers who struggle to keep horizons straight and level in their landscape images. A camera-mounted spirit level is also helpful when shooting multiple frames to create a stitched panoramic (see pages 136–7). Some tripods are equipped with a built-in spirit level.

Some digital SLR cameras are now designed with built-in technology to help you level the camera. A virtual horizon can be displayed on the camera's LCD monitor showing its position relative to the horizontal. Used in combination with a tripod, this makes it possible to align the camera precisely.

CAMERA BAGS

Outdoor photographers regularly walk long distances, trekking up steep hills or along rough paths to find beautiful, remote scenery. Therefore, it is important to buy a good camera bag that allows you to carry your equipment comfortably.

Backpacks distribute the weight of your kit over your shoulders and back. While shoulder bags make it easier to access your camera quickly, they are less practical for the outdoor photographer. Crumpler, Kata, Lowepro, Tamrac and ThinkTank are among the leading manufacturers of camera backpacks.

There are a number of key features to consider when selecting a new bag. Before buying, think about comfort, capacity, features, build quality and price. Comfort is very important. If you are carrying a lot of weight, look for a model with wide, well-padded shoulder straps. Waist straps are also important, relieving tension from the lumbar region and helping keep your back straight and your posture good. Capacity is a crucial consideration. How much equipment do you plan to carry? Most bags have adjustable internal compartments, allowing you to tailor the bag to your equipment. Has the bag got a sufficient number of pockets and compartments for your accessories? Look at the layout and try to envisage how exactly you would arrange your kit. Opt for a bag that is slightly bigger than you presently require, so there is room to spare if you upgrade or buy more equipment in the future. Weatherproofing is important for outdoor photographers, so invest in a bag that is weather-resistant or has an internal all-weather covering. Also, consider accessory clips, which allow you to attach a tripod directly to the bag, rather than having to carry it by hand. If you want to carry a laptop, buy a bag with a dedicated compartment. Build quality is also an essential consideration. Good padding is important, giving your kit plenty of protection from knocks and bumps. The material, zips and stitching need to withstand regular use in the outdoors. Finally, consider price. A backpack is an important investment, so don't simply opt for the cheapest model. Identify the bag that satisfies your own personal demands before committing to buy.

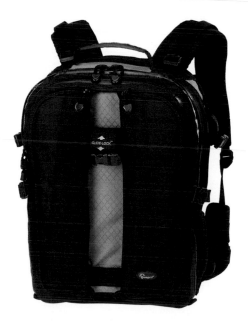

BACKPACK
A backpack like this Vertex model is well suited to outdoor photography. It will evenly distribute the weight of your equipment, making long walks more comfortable.

Tip: Always carry spare memory cards on a shoot. Large-capacity cards are now very affordable. However, opt for several lower-capacity cards instead – perhaps 4GB or 8GB. By doing so, you won't lose all your valuable images if your card develops a fault, becomes corrupted, or is lost.

CAMERA CARE

Cameras, lenses and filters represent a significant investment. Keeping your equipment clean and well-maintained will help to ensure optimum performance and long life.

CAMERA CARE

Most digital SLRs are well constructed, well sealed and relatively robust. However, it is still wise to keep them protected from dirt and moisture whenever possible. You shouldn't need to clean your camera too often if you keep it in a camera bag (see page 19) when it is not in use. Simply give it a wipe over from time to time using a soft cloth and use a blower to remove dust from the eyepiece. If your camera has been exposed to salt water and spray, wipe the body over with a well-wrung damp cloth to protect against corrosion. It is worthwhile keeping a small sachet of silica gel in your camera bag to absorb any moisture and prevent condensation. However, while it is relatively easy to keep a camera's exterior clean, keeping its sensor free of dust can prove more difficult.

SENSOR CLEANING

The electromagnetic properties of imaging sensors mean they attract dust and dirt. Dirt settling on the sensor – or its protective low-pass filter – is an unavoidable headache. You can minimize the problem by keeping the body cap on when the camera is not in use, and changing lenses quickly and efficiently. Many digital SLRs are now designed with sensor-cleaning systems, which greatly reduce the amount of dust settling on the sensor. However, with regular use, you will inevitably notice black specks and marks appearing on your images. These can be removed in post-processing with the Clone Tool or Healing Brush, but this soon becomes a chore. The only real solution is to clean the sensor itself.

You can have your camera's sensor cleaned by an approved technician, but this can be inconvenient and costly, and many photographers prefer to do it themselves. The sensor and low-pass filter are delicate components and should be treated with great care. Before beginning, consult your camera's manual. Most digital SLRs have a sensor-cleaning mode. This varies from model to model, but the basic principle is the same – turn the camera on, lock up the mirror and open the shutter curtain to reveal the sensor. The camera must remain switched on during cleaning, so always use a freshly charged battery. If the power switches off, the shutter curtain will drop – which can result in damage if it shuts on your cleaning tool.

Begin by using a rocket blower to remove any particles of grit, which could scratch the sensor's surface during cleaning. Always use a mechanical blower; do not use compressed air on the sensor. When this is done, you can start cleaning. There are various different sensor-cleaning solutions on the market. The Arctic Butterfly is one of the best dry-cleaning methods. Its micro-fibres are negatively charged, so, as the brush passes, they collect particles from the sensor. For more stubborn marks, a wet clean will be required. Typically, paddle-shaped micro-fibre swabs are used, together with a dedicated, non-alcoholic, non-toxic, non-corrosive cleaning fluid. Swabs are available in different sizes, depending on sensor size (see pages 10–11). Always follow the supplied instructions carefully.

DRY CLEANING
One of the best dry-cleaning solutions on the market is the Arctic Butterfly, made by Visible Dust. Its micro-fibres are negatively charged, and when the brush passes, they collect any small particles from the sensor.

Place the swab at one side of the sensor and gently wipe across in one smooth motion. Try to get into the corners and cover the full surface of the sensor. Use a fresh, clean side of the swab for each stroke across the surface of the sensor, and throw it away after use.

LENS CARE

Dirty, marked or scratched lenses will adversely affect image quality. You can't prevent dust and dirt settling on the front element of the lens. While it is best not to clean optics more than is required, it is important to keep them clean to maximize image quality and lower the risk of lens flare. When you clean a lens, first use an air blower or dedicated soft brush to remove loose particles of dust and dirt. If you fail to do so, you may inadvertently rub tiny, hard particles across the lens, which can result in fine scratches. To remove smears, dirt, fingerprints or spray, use a dedicated micro-fibre lens cloth, using a gentle, circular motion to clean the lens. Photographic wipes and lint-free tissues are also available. For stubborn marks, you may require a cleaning fluid. Only buy solutions intended for photographic lenses and – unless the instructions state otherwise

– apply it to the cleaning cloth, not the lens itself. Never attempt to clean using ammonia or other household cleaning solutions. Don't overlook the rear of the lens – dust on the rear element can fall into the camera body and settle on the sensor. Finally, remember to keep the rear and front caps in place whenever the lens is not in use, as they protect against dust, dirt and damage.

Tip: Some tripods are susceptible to corrosion, particularly if they are exposed to salt water. Bathe the legs in warm water to loosen any sea salt, then brush. Rinse, and apply a small amount of oil to nuts and bolts.

INSURANCE

Make sure your equipment is properly insured. Never assume your kit is covered on your household policy, unless you have it in writing that your insurers are fully aware of the equipment you own and its value. Some insurers will consider a photographer 'professional' if they have sold just one or two images, or if they actively market their images on a website. This can invalidate some household policies. List all items of value and supply your insurers with serial numbers, make, model and replacement cost. Don't under-insure – it is always best to err on the side of overvaluation. Keep a list of all the equipment you own and update it regularly. This will help if you need to make a claim. For enthusiasts, we recommend using an insurance company that specializes in camera equipment. It may prove to be money very well spent.

BLOWER
A blower such as the Giottos Rocket Air is useful for maintaining your equipment. It gives a strong blast of air, perfect for removing dust from cameras and optics.

► CHAPTER TWO > **EXPOSURE**

Before you venture out on location, it is time for the
workshop briefing – a discussion of the fundamentals
and mechanics of photography. Exposure is at the heart
of all photography, and a good working knowledge of
the subject is essential. At our workshops, participants
range widely in terms of their knowledge and experience.
Therefore, this chapter explains exposure in a language
that is easy for beginners to understand, but without
being patronizing to more experienced photographers.
For newcomers, this chapter is arguably more important
than any other. Even if you are an accomplished enthusiast,
it is always useful to refresh your knowledge, and you
may even learn something new.

BEACH HUTS
*This image contains very bright highlights,
so careful exposure was required. A digital
SLR's histogram screen (see pages 34–5) is
a valuable tool for assessing exposure.*
*Pentax K10D, 18–55mm (at 18mm), ISO 100,
1/80 sec at f/11, handheld*

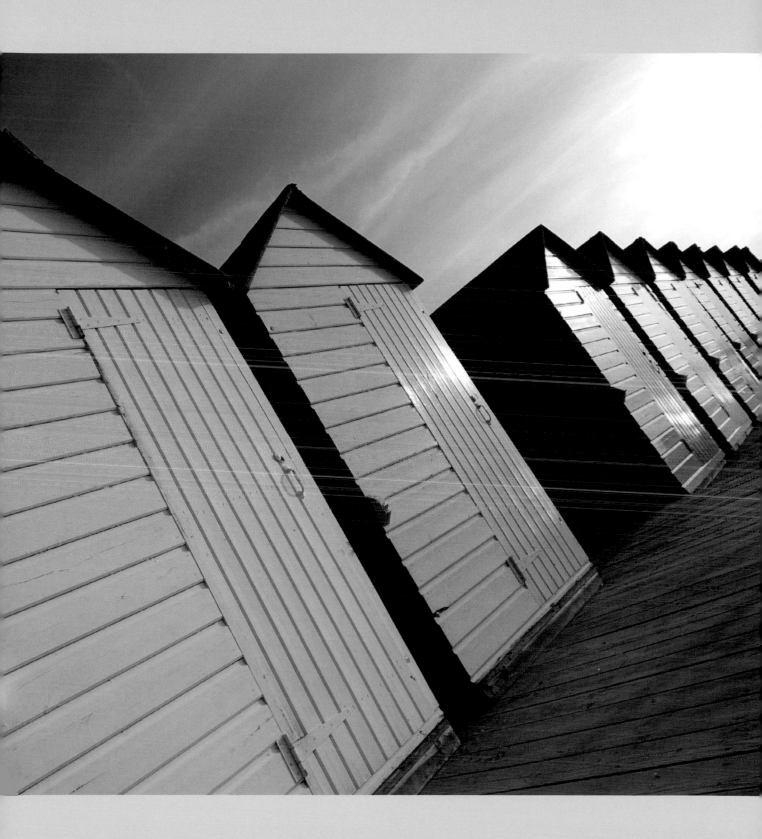

EXPOSURE

Exposure is the process of light striking a photosensitive material, such as a digital camera's image sensor. Photography has changed dramatically since the very first permanent photograph was captured nearly 200 years ago by French lithographer, Nicéphore Niépce. However, the three principal mechanisms employed to control exposure remain the same – shutter speed, lens aperture and the photographic material's level of sensitivity to light (ISO sensitivity). Understanding and accurately controlling exposure is essential if you wish to capture consistently good landscape images.

UNDERSTANDING EXPOSURE

A 'correct' exposure is easy to define – it is an exposure that achieves the effect the photographer intended. If the picture is too light, it is overexposed; if it is too dark, it is underexposed. Modern cameras are designed with sophisticated through-the-lens (TTL) metering systems. Although these are reliable under most lighting conditions, you shouldn't always rely on your camera to set the correct exposure. Metering systems are not infallible and the camera is unable to predict the effect you are trying to achieve.

For creative photography, a good understanding of the three exposure variables – and their relationship to each other – is vital. Underexposure can be remedied by increasing the aperture (smaller f/number), selecting a slower shutter speed, or increasing ISO sensitivity. Overexposure can be corrected by making the lens aperture smaller (bigger f/number), increasing the shutter speed, or reducing the ISO sensitivity. When you have selected an appropriate combination of lens aperture and shutter speed – for a given ISO sensitivity – a change in one will require an equal and opposite change in the other. It is these three factors that control exposure.

Many newcomers to photography believe that achieving the desired exposure in-camera is less important in the digital age, as it can be corrected during post-processing using tools like Levels (see page 125) and Curves (see page 126). While it is true that digital images – particularly Raw images (see page 122) – have a greater tolerance to error, image quality is still degraded if the original is poorly exposed. For example, if a photograph is overexposed, detail may be lost in the highlights, and this data is normally unrecoverable. If you have to lighten an underexposed image, you will introduce more noise (see page 80) to the photograph, which will obscure detail and sharpness. Achieving the correct exposure in-camera is as important today as it has always been.

EXPOSURE COMPENSATION

Metering systems are not infallible. Light meters work on the assumption that the subject being photographed is a mid-tone. While this will produce correctly exposed results in the majority of situations, high-contrast scenes, backlighting and predominantly dark or light subjects can deceive your camera. As a result, it sets a faster exposure than is needed, resulting in underexposure. Equally, very dark subjects may fool the camera into setting an exposure that is too long. With experience, the errors your metering system is likely to make become predictable. To correct exposure error, apply exposure compensation. If a scene is rendered too light, shorten the exposure by applying negative (-) compensation. If it is too dark, positive (+) compensation is required to lighten the image. The precise amount of positive or negative compensation needed will depend on the subject and lighting conditions. When applying compensation, use the image's histogram (see pages 34–5) to guide you. Most cameras have a dedicated exposure compensation button – dial in the level of compensation you require by pressing the button while rotating the Command dial. Most digital SLRs enable you to apply exposure compensation in 1/3-stop increments.

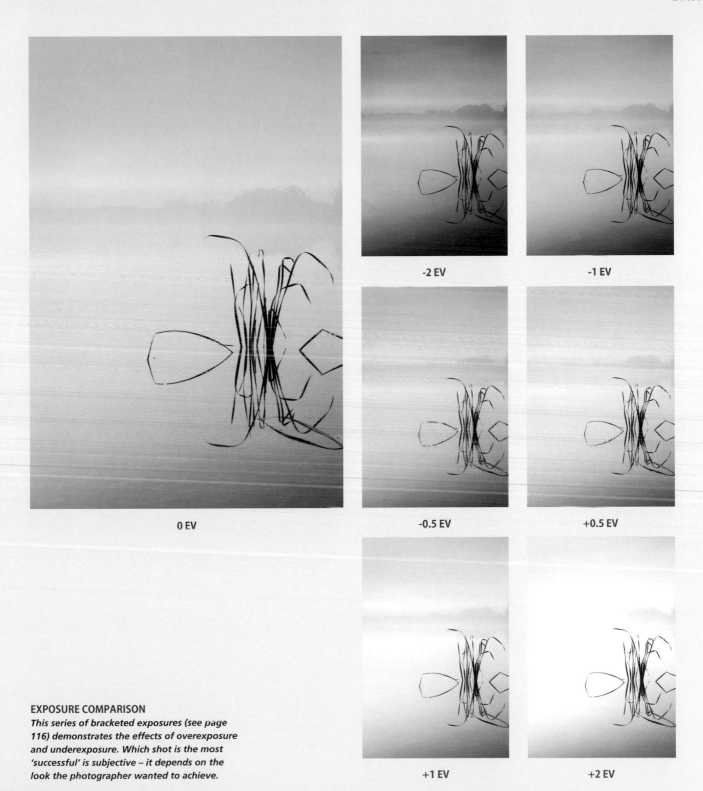

0 EV

-2 EV

-1 EV

-0.5 EV

+0.5 EV

+1 EV

+2 EV

EXPOSURE COMPARISON
This series of bracketed exposures (see page 116) demonstrates the effects of overexposure and underexposure. Which shot is the most 'successful' is subjective – it depends on the look the photographer wanted to achieve.

APERTURE

At first, aperture and the way it works can seem confusing. With practice, however, it becomes quite easy to understand, and, for scenic photographers in particular, it is vital to have a thorough grasp of its role. Basically, aperture is the common term for the iris diaphragm of a lens. This consists of a number of thin blades that adjust inwards or outwards to alter the size of the near-circular hole they form (the aperture) through which light passes. Altering the size of the iris determines the amount of light that is allowed to enter the lens and hit the sensor (the exposure).

Aperture is one of the key variables in controlling exposure. Crucially, however, it also dictates the depth of field that will be recorded in the final image. A small aperture (large f/number) will create a larger depth of field, while a large aperture (small f/number) will produce a shallower depth of field.

UNDERSTANDING F/STOPS

The lens aperture is similar in principle to the pupil of an eye. Put simply, the pupil widens or contracts to control the amount of light that hits the retina. The camera's aperture works in a similar way. Adjusting the size of the aperture alters the amount of light that can pass through the lens: if you select a large aperture, more light can pass though; if you choose a small aperture, less light reaches the camera's sensor. Aperture works in conjunction with shutter speed (see pages 28–9) to determine the overall exposure.

Apertures are stated in numbers, or f/stops. Typically, this scale ranges from f/2.8 to f/22, though some lenses have more or fewer settings. The standards for aperture are as follows: f/2.8, f/4, f/5.6, f/8, f/11, f/16, f/22. These relate to whole-stop adjustments in aperture. It is also possible to alter aperture size in 1/2-stop and 1/3-stop increments for even greater exposure control. The f/number corresponds to a fraction of the focal length. For example, f/2 indicates that the diameter of the aperture is half the focal length; f/4 is a quarter; f/8 is an eighth, and so on. With a 50mm lens, the diameter at f/2 would be 25mm; at f/4 it is 12.5mm, and so on.

EXTENDED DEPTH OF FIELD
Selecting a small aperture (large f/number) extends the depth of field – ideal for landscape photography. In this instance, I prioritized a small f/stop of f/16 to ensure that the heather in the foreground, the old engine house and the distant horizon all remained acceptably sharp.
Nikon D700, 17–35mm (at 22mm), ISO 100, 30 sec at f/16, 2-stop ND grad, polarizer

Tip: Landscape photographers often require back-to-front image sharpness and will instinctively select the minimum aperture to maximize depth of field. However, lenses don't give optimal performance at their smallest aperture. A slightly larger aperture helps to maximize sharpness (see pages 110–1).

A lens is often referred to by its maximum and minimum aperture settings. Its maximum – or fastest – aperture relates to the widest setting, while closing it down to its smallest setting – which allows the least amount of light through – is said to be the minimum aperture of the lens. The factor that often causes the most confusion among beginners to photography is the way in which large apertures are represented by low numbers – for example, f/2.8 or f/4 – while small f/stops are indicated by large figures, such as f/22 or f/32. To help you remember which value is bigger or smaller, it is helpful to think of f/numbers in terms of fractions – for example, 1/8 (f/8) is smaller than 1/4 (f/4).

In the past, lenses were constructed with an aperture ring, which was adjusted manually by the photographer to select the desired f/stop. Today, few lenses are designed with a manually adjustable ring – instead, the aperture is selected via the camera itself, often using a Command dial or wheel.

SHALLOW DEPTH OF FIELD
To create a shallow depth of field, choose a large aperture – f/2.8, for example. This will keep the main subject sharp while throwing foreground and background detail into soft focus. This directs the viewer's eye to your intended focal point.
Nikon D700, 70–200mm (at 155mm), ISO 200, 1/40 sec at f/2.8, polarizer

Tip: It is important to remember that lens aperture has a reciprocal relationship with shutter speed (see pages 28–9). A change in either the aperture or shutter speed setting requires an equal and opposite adjustment in the other in order to achieve the same exposure.

SHUTTER SPEED

Shutter speed is the second factor that determines exposure; it has a reciprocal relationship with lens aperture (see pages 26–7). If the shutter speed is too short, insufficient light will reach the sensor and the image will be too dark (underexposed). If the shutter is open too long, too much light will strike the sensor and the image will be too light (overexposed).

UNDERSTANDING SHUTTER SPEED

The shutter speed is the length of time the camera's mechanical shutter remains open during exposure. The shutter speed can be as brief as 1/8000 sec or more than 30 sec – the precise length you need depends on the light available, the corresponding aperture and ISO sensitivity selected, and the effect desired.

Although its primary function is to ensure that precisely the right amount of light is allowed to reach the camera's sensor, shutter speed is also an important creative tool for landscape photographers. By adjusting the shutter speed you can control the way that subject movement is recorded in your images. A fast shutter will freeze the subject, while a slow speed will blur subject movement – this creates the impression of motion.

While many people consider the landscape a static subject, in reality it is full of movement – for example, clouds, water and foliage are constantly in motion. If you want to suspend – or 'freeze' this movement, prioritize a faster shutter speed. However, if you prefer to blur motion for creative effect, opt for a slow shutter speed. The shutter speed you select will greatly affect the look and feel of the final image.

Changes in shutter speed – and aperture – values are referred to in 'stops'. A stop is a halving or doubling of the amount of light that reaches the sensor. For example, altering shutter time from 1/60 sec to 1/30 sec will double the length of time the shutter is open, while adjusting it to 1/125 sec will halve exposure time. The majority of DSLRs allow exposure time to be adjusted in 1-stop, 1/2-stop and 1/3-stop increments.

CAPTURING MOTION

Subject motion is recorded differently at different shutter speeds, and adjusting the shutter speed can change the look, feel and mood of a scene. You can create the impression of motion by selecting a slow exposure and intentionally blurring the movement of cloud, water, foliage, flowers, crops and even people. These two images of the same scene were taken at different shutter speeds. The difference between the two shots is significant.
Above: Nikon D300, 12–24mm (at 15mm), ISO 200, f/11 at 1/4 sec
Right: Nikon D300, 12–24mm (at 15mm), ISO 200, 25 sec at f/22, 3-stop solid ND filter

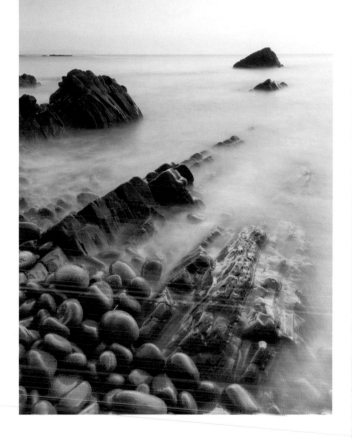

ISO SENSITIVITY

The ISO (International Standards Organization) setting (or ISO equivalency) refers to a sensor's sensitivity to light. It is a term adopted from film photography, when film was rated depending on the way it reacted to light. A low ISO rating – or number – is less sensitive to light, so it requires a longer exposure. A high ISO rating is more sensitive to light, so it requires less exposure. Every doubling of the ISO speed halves the brightness of light – or the length of time required – to produce the correct exposure, or vice versa.

The sensitivity of an image sensor is measured in much the same way as film. For example, setting your camera's ISO equivalency to 200 means that the sensor will have the same sensitivity to light as a roll of film with the same rating. Digital cameras give you the luxury of altering the ISO sensitivity quickly and easily between one frame and the next. However, at higher ISO ratings, the amount of signal 'noise' (see page 80) increases. Noise degrades image quality, so it is always best to select the lowest practical ISO rating. For landscape photography, you will rarely need to select anything but your camera's highest-quality base rating – typically ISO 100. If your camera has an Auto ISO feature, ensure it is disabled and then manually select its lowest ISO sensitivity.

BULB SETTING

A digital SLR normally boasts a maximum automatic exposure of 30 seconds – although it is a minute on some models. For exposures longer than this, the camera needs to be set to 'Bulb' or 'B'. Using this setting, the shutter will remain open for as long as the shutter-release button is depressed – either via a wireless device or remote cord. When using the bulb setting, exposure has to be timed manually. Some cameras have an automatic counter on their LCD to aid precise timing – otherwise, you will need to time exposures. When using shutter speeds of this length, a sturdy tripod is essential to ensure sharp results.

Tip: If you are not using a tripod or other camera support, it is important to select a shutter speed that is fast enough to eliminate camera shake. When using short focal lengths in the region of 18–50mm, a speed of 1/125 sec or faster will normally be sufficient.

DEPTH OF FIELD

Adjusting the size of the aperture doesn't just alter the amount of light that passes through the lens. It is also the key factor in determining the area of your photograph that is recorded in sharp focus – otherwise known as depth of field. While focal length and camera-to-subject distance also affect back-to-front sharpness, lens aperture is the primary means of controlling it. Therefore, aperture selection is one of the most important considerations when setting up your landscape images.

UNDERSTANDING DEPTH OF FIELD

Depth of field is an important creative tool. It refers to the zone – in front of and behind the actual point of focus – that is recorded in sharp focus. Understanding and controlling depth of field will enable you to capture the landscape exactly as you visualized it.

By varying the size of the aperture, you will generate either more or less front-to-back sharpness. At large apertures – f/2.8 or f/4, for example – depth of field is shallow, helping to throw background or foreground detail out of focus. While large apertures are generally less widely used for landscape photography, they can be useful for emphasizing your main subject or point of focus (see page 27), or for creative effect. However, smaller apertures, in the region of f/16, are the most common choice for scenic photography. They generate extensive depth of field, particularly in combination with short focal lengths. When shooting large, sweeping vistas, a small aperture enables you to capture everything from foreground interest to infinity in acceptably sharp focus.

Depth of field is also affected by the focal length of the lens, the subject-to-camera distance and the point of focus. It is useful to know this when you wish to maximize the zone of sharpness without altering the f/number. For example, longer lenses create a shallower zone of sharpness than shorter focal lengths. The distance between the camera and the object being photographed also has a bearing on depth of field – the closer you are to the subject, the less depth of field you will obtain in the final image.

DEPTH OF FIELD PREVIEW

Many – but not all – digital SLRs have a very useful depth-of-field preview button. DSLRs are designed to automatically set the lens's fastest (maximum) aperture to ensure the brightest possible viewfinder image – this aids viewing and focusing. Therefore, what you see through the viewfinder when composing your images rarely represents the depth of field that will be captured in the image. The preview button works by stopping the lens down to the chosen f/stop, allowing you to assess whether or not the selected aperture will provide sufficient depth of field. When you press the button (which is normally located near the lens mount), the viewfinder image darkens: the smaller the aperture, the darker the preview. If the depth of field is insufficient, adjust the aperture accordingly. The function can take a while to get used to, but it is helpful. If you are struggling to get to grips with it, try adjusting the aperture gradually, stop by stop, so that the shift in depth of field becomes more obvious. It may be easier to use your preview button in conjunction with Live View mode (see page 109), if your camera has it.

Tip: Don't leave your aperture setting to the discretion of your camera's automatic exposure modes. To retain control of aperture, switch your DSLR to either Aperture Priority or Manual exposure mode (see page 33).

The final factor that affects depth of field in an image is the precise point of focus that you have chosen. Depth of field extends from approximately one-third in front of this point of focus, to around two-thirds behind it. If you focus on the wrong point, you risk 'wasting' some of the depth of field available to you. A technique known as hyperfocal focusing (see pages 108–9), will help to ensure you always maximize depth of field.

By understanding depth of field, you can control the zone of sharpness and apply it to suit the scene you are photographing, helping you achieve exactly the result you want.

FRONT-TO-BACK SHARPNESS
To achieve front-to-back sharpness in your images, prioritize a small aperture, such as f/16. This will generate a large depth of field. In conjunction with the hyperfocal distance technique (see pages 108–9), this will give you the depth of focus you need to keep everything within the frame, from nearby objects to the distant horizon, acceptably sharp. This technique will not work with larger apertures such as f/2.8 or f/4.

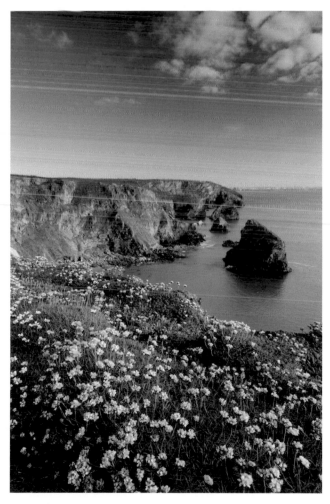

Nikon D300, 12–24mm (at 12mm) ISO 200, 1/500 sec at f/4, polarizer

Nikon D300, 12–24mm (at 12mm) ISO 200, 1/30 sec at f/16, polarizer

EXPOSURE MODES

Digital SLRs give you a choice of several exposure modes, offering varying degrees of control. Entry-level cameras will normally have a number of pre-programmed Picture, Scene or Subject modes, which are tailored to optimize camera settings for that particular scene or subject. There is often a Landscape mode, which will prioritize a large depth of field while selecting a shutter speed fast enough to prevent camera shake. However, such modes are generally best avoided – they don't provide photographers with sufficient creative control. Instead, rely on the 'core four' modes – Programmed Auto, Aperture Priority, Shutter Priority and Manual. They are found on almost all digital SLRs and give you a far greater level of control over exposure – a crucial factor in successful landscape photography.

THE CORE FOUR
PROGRAMMED AUTO MODE

Programmed Auto (**P** on the camera dial) is a fully automatic mode, in which the camera selects what it calculates to be the most suitable combination of aperture and shutter speed. Sophisticated TTL metering means that this mode can be relied upon to achieve correctly exposed results in most situations. However, the camera is in complete control of the exposure equation. A camera cannot predict the type of effect you wish to achieve, so this mode can stifle creativity. While it is fine for quick snaps and test shots, we recommend that you opt for either Aperture Priority or Manual exposure mode as the default setting for scenic photography.

SHUTTER PRIORITY MODE

Shutter Priority (**S** or **Tv**) is a semi-automatic mode. You set the shutter speed, and the camera selects the corresponding f/stop. Typically, shutter speeds can be set to values ranging from 30 sec to 1/4000 sec – or, on high-spec digital SLRs, even faster. This mode is useful for determining the appearance of motion – for example, if you wish to blur subject movement, you should prioritize a slow shutter speed. If you wish to freeze motion, opt for a fast shutter speed. This mode is particularly suited to action, sport and wildlife photography, when photographers need to quickly select the fastest shutter speed available. Scenic photographers will often prioritize aperture selection over shutter speed, which is why this mode is less popular among landscape enthusiasts.

SEAWEED
Depth of field is usually the top priority when shooting landscapes, so Aperture Priority is the preferred exposure mode. In this instance, I manually selected an aperture of f/16 to keep everything from the seaweed in the foreground to the horizon acceptably sharp. The camera did the rest.
Nikon D700, 17–35mm (at 20mm), ISO 100, 2 sec at f/16, 3-stop ND grad, polarizer

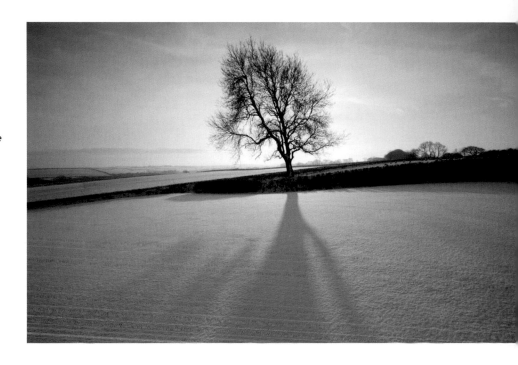

WINTER TREE
When photographing snow, metering systems are commonly fooled into thinking the scene is brighter than it is, and therefore select a faster exposure than is required. To avoid underexposure, I applied positive (+) compensation using Manual mode.
Nikon D700, 17–35mm (at 17mm), ISO 100, 15 sec at f/16

APERTURE PRIORITY MODE

Aperture Priority (**A** or **Av**) is the mode most suited to landscape photography and the one we recommend to our workshop participants. Aperture Priority works in the opposite way to Shutter Priority – you select the f/number you require, and the camera sets a corresponding shutter speed to achieve the correct exposure. This mode is designed to give photographers control over depth of field (see pages 30–1), making it ideal for shooting landscapes. Using this mode, you can quickly and precisely select the aperture you require to generate sufficient depth of field for the subject. Assuming you are using a tripod, the length of the resulting shutter speed is often immaterial; front-to-back sharpness is the first priority. The majority of professional landscape photographers work using this mode.

MANUAL MODE

Manual mode (**M**) is the most flexible exposure mode, but also the one that relies most on the photographer's input. In Manual mode, the camera's automatic settings are overridden, and the photographer sets the value for both aperture and shutter speed.

Working in Manual may sound daunting at first, but it is surprisingly simple and the camera still does the majority of the hard work. First, select the aperture you require. Semi-depress the shutter-release button, and the camera will take a meter reading for the scene. The resulting metering information is displayed in the viewfinder and/or LCD control panel via the exposure display. This simple display comprises a row of tiny bars or segments, with a **-** (minus) sign at one end, a **+** (plus) sign at the other, and a **0** (zero) above the centre of the display. Below this is an adjustable indicator. To select the exposure value recommended by the camera, rotate the Command dial until the indicator is aligned directly below the **0** setting. Essentially, the camera is still calculating the exposure, but it is at your discretion whether or not to apply the suggested settings. You may want to ignore the camera's recommended settings in order to expose creatively, or select a degree of negative compensation to protect the highlights, and you can do so by rotating the Command dial to one of the positive or negative settings. Shooting in Manual allows you to quickly fine-tune exposure and apply exposure compensation (see page 24), with the minimum of fuss.

HISTOGRAMS

The basic principles of exposure have remained unchanged since the days of Fox Talbot. However, digital technology has revolutionized the photographic process, and photographers today have far more creative control. Of the new tools available, histograms are, arguably, the most useful. A histogram is essentially a graph that represents the tonal range of an image. Interpreted correctly, it can help to ensure you always achieve the correct exposure.

USING THE HISTOGRAM

When you play back an image on your camera's LCD monitor, you can scroll through several pages of picture information. Of these, the most useful is the histogram screen, as it gives a graphic illustration of how the tones are distributed in that image. Histograms are two-dimensional graphs, which often resemble a range of mountain peaks. The horizontal axis represents the picture's tonal range from pure black (0, far left) to pure white (255, far right), while the vertical axis shows how many pixels have that particular value.

When a histogram displays large numbers of pixels grouped at either edge, it is often an indication of poor exposure. For example, a large peak on the left of the graph can indicate underexposure, while a sharp peak on the right side of the graph is usually an indication of overexposure, with detail lost or 'blown out' in the highlights – this is also referred to as 'clipping'. A graph with a narrow peak in the middle – with no black or white pixels – illustrates a photograph that is lacking in contrast. With practice, interpreting a histogram becomes almost second nature.

THE 'PERFECT' HISTOGRAM

Photographers often strive to achieve the 'perfect' histogram – one that shows a good range of tones across the horizontal axis, with the majority of pixels positioned around the middle (100, mid-point). However, in reality, this is not always possible, or even desirable. When assessing exposure via the histogram, it is important to consider the brightness of the subject itself. For example, a scene containing a high percentage of light or dark tones, such as a snowy landscape or a silhouette, will naturally affect the appearance of its corresponding graph. Therefore, it is impossible to generalize about what is and isn't a 'good' histogram. While an even spread of pixels across the graph is often considered desirable, you will also need to use your own discretion.

Many photographers play back images on the LCD screen after taking a picture, but this is not a very reliable way of reviewing exposure – particularly in bright conditions, when light reflecting from the monitor makes it difficult to assess brightness. Viewing the image's histogram is a far better method of assessing exposure. Getting into the habit of reviewing histograms after image capture will help you identify exposure errors, so that you can adjust your camera settings and re-shoot if necessary.

Tips: Most digital SLRs include a Highlights screen among their playback functions. This acts as an exposure warning: if the highlights in the image exceed the sensor's dynamic range (its ability to capture a full range of tones, from shadows to highlights), the affected areas of the image will flash or blink. You can then adjust your exposure settings and re-shoot.

A working knowledge of histograms is essential if you wish to use the advanced technique of exposing to the right (see pages 112–3). This technique helps to maximize image quality and relies on reference to the image's histogram.

INTERPRETING HISTOGRAMS

Some subjects will naturally produce a histogram with peaks weighted to one side of the graph. The two images shown here are both correctly exposed, but, due to the contrasting lighting conditions, their histograms look very different.

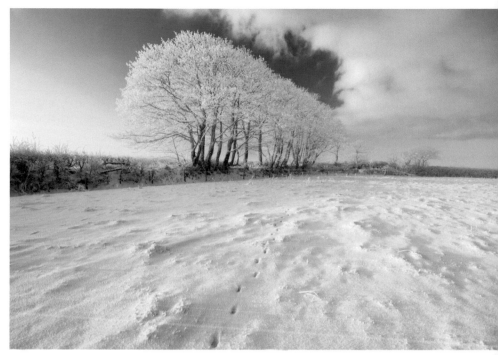

Nikon D700, 17–35mm (at 28mm), ISO 200, 4 sec at f/18, polarizer

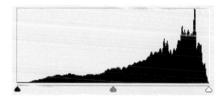

Nikon D300, 24–85mm (at 70mm), 4 sec at f/11

WHITE BALANCE

White balance (WB) is an important camera function that is designed to neutralize colour casts produced by the varying temperatures of light. The human eye is so sophisticated that it naturally adjusts for the temperature of the light – natural or artificial – enabling us to always perceive it as white or neutral. A camera's sensor isn't as discerning, which is why it needs help in the form of the white-balance control. However, while it is intended for correction, this function can also be used creatively.

UNDERSTANDING COLOUR TEMPERATURE

Every light source contains a varying proportion of the three primary colours: red, green and blue (RGB). Lower temperatures have a greater precentage of red wavelengths, so they appear warmer; higher temperatures have a greater proportion of blue wavelengths, and appear cooler. The temperature of light is measured in degrees Kelvin (°K). For example, the concentrated warm light of a candle flame has a low value of around 1,800°K, while shade under a cool blue sky is equivalent to around 7,500°K. Light is considered neutral at around 5,500°K – this is roughly equivalent to equal amounts of the RGB wavelengths of white light. To capture colour faithfully, photographers need to match the colour temperature of the light falling on the subject with the appropriate white-balance value.

To help photographers, digital SLRs have an Auto white balance function, in which the camera examines the overall colour of the scene and sets the white balance using a 'best guess' algorithm. This can be relied upon to produce natural-looking results in most situations. Cameras are also programmed with a range of white-balance presets, designed to mimic common lighting conditions – for example, Incandescent, Fluorescent, Daylight, Cloudy and Shade. Although these do not guarantee perfect colour reproduction, they certainly help you get acceptably close to it.

You can also customize the white balance by selecting a specific colour-temperature value; this is best done in combination with a colour-temperature aid such as a grey card or ExpoDisc.

Most scenic photographers simply select their camera's Daylight preset, and rarely alter it, as they do not want to neutralize the warmth of early morning or late evening light – it's this quality and colour that helps 'make' the image. However, we also like to use white balance creatively. The most aesthetically pleasing result is not always the one that is technically correct. Deliberately mismatching the white balance will create a colour cast that can produce a far more striking, pleasing result. Consider white balance as form of in-camera filtration – cooling down or warming up an image at the turn of a dial. For example, selecting the Incandescent or Fluorescent preset will add a blue hue to an image – useful for lending a cool feeling to your shots. The Cloudy or Shade settings can add a warm cast to your images – perfect for adding impact to sunsets or boosting the warmth of evening light.

If you shoot in Raw format (see page 122), you can adjust the white balance during processing, making it less important to select the correct white-balance setting at the time of capture.

COLOUR TEMPERATURE

This chart shows the approximate colour temperatures for different types of light source.

	
1,800–2,000°K	Candle flame
2,500°K	Torch bulb
2,800°K	Domestic tungsten bulb
3,000°K	Sunrise/sunset
3,400°K	Tungsten light
3,500°K	Early morning/late afternoon
5,200–5,500°K	Midday/direct sunlight
5,500°K	Electronic flash
6,000–6,500°K	Cloudy sky
7,000–8,000°K	Shade

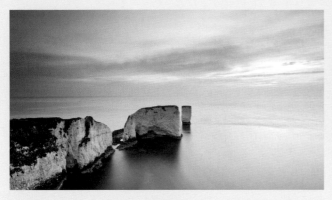

AUTO

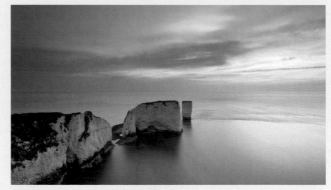

TUNGSTEN

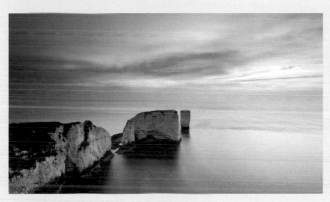

FLUORESCENT

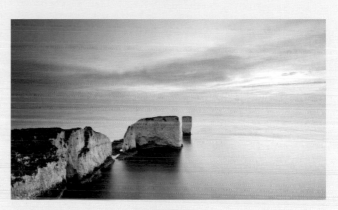

DAYLIGHT

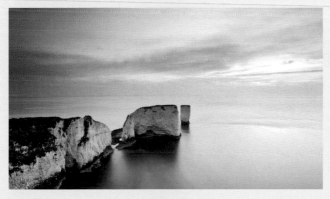

CLOUDY

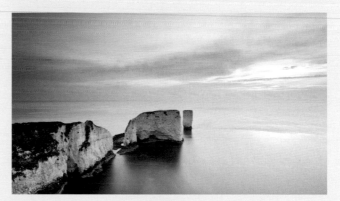

SHADE

WHITE BALANCE COMPARISON

This sequence illustrates the dramatic effect that different white-balance settings can have on a scene. Presets designed to correct a low colour temperature – such as Incandescent and Fluorescent – will cool down an image, while settings designed to balance a high colour temperature – such as Cloudy and Shade – will produce a warm cast. The white-balance setting can have a dramatic impact on the image's look, feel and mood.

► CHAPTER THREE > **COMPOSITION**

When you are shooting on location, the most important, and often the most difficult, decisions that you have to take are those regarding the composition of your image – what to include and exclude, and how to arrange the elements within the frame. The two biggest compositional challenges are how to balance the elements of the picture, and how to represent a three-dimensional scene in a two-dimensional medium. Luckily, there are a few key compositional 'rules' to help you, along with other techniques and tips which, if applied appropriately, will enable you to take striking, well-balanced photographs every time.

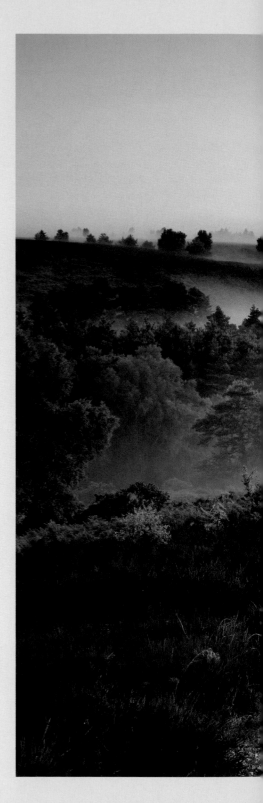

PRINCIPLES OF COMPOSITION
Three basic principles of composition are combined in this image: it is divided roughly into thirds, there is a strong leading line pulling the viewer's eye into the picture, and the layering in the background helps to increase the sense of depth.
Canon EOS 1Ds Mk II, 24–105mm f/4L (at 45mm), ISO 100, 1/4 sec at f/11, 2-stop ND grad

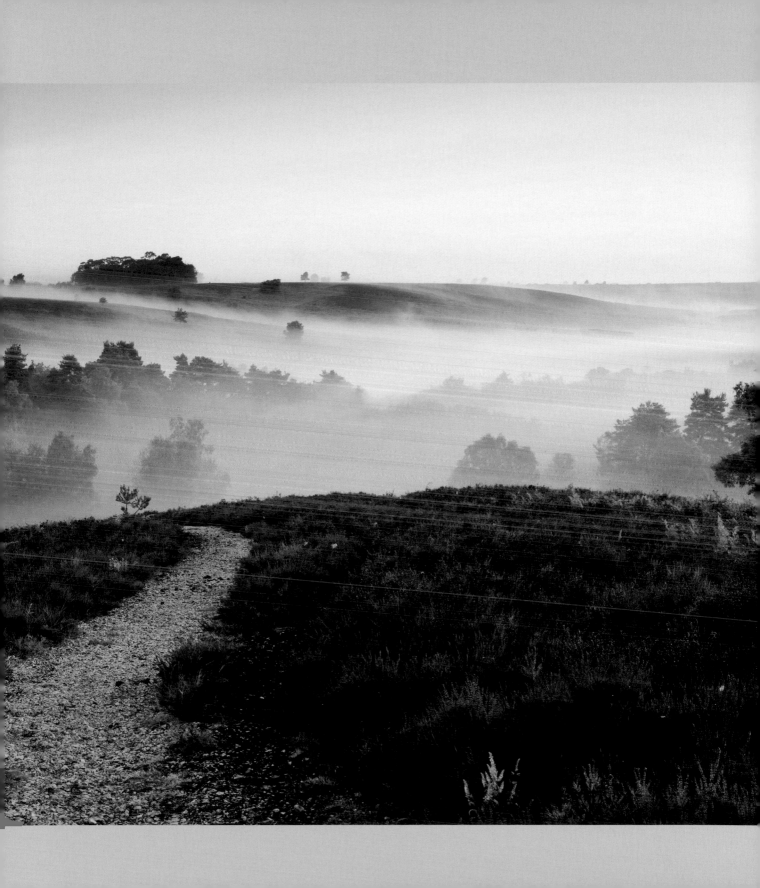

RULES OF COMPOSITION

A few lucky people may have a 'natural eye' for a picture, but for the rest of us, composition is a skill that has to be learned. The good news is that your compositional ability will improve quickly as you gain experience, and the process will soon become instinctive. In the meantime, however, there are a number of 'rules' we can follow to help us get to grips with effective composition. Of course, as with all rules, they are best applied judiciously.

RULE OF THIRDS
In this image, most of the elements are arranged according to the rule of thirds. The horizon is placed roughly on a third, and the bottom two-thirds of the picture are divided into approximately two-thirds sea and one-third land. The lighthouse, as the main focal point, is placed on an intersection of thirds.
Canon EOS 5D Mk II, 24–105mm f/4 L (at 24mm), ISO 100, 25 sec at f/11, 4-stop solid ND, 2-stop ND grad

THE RULE OF THIRDS

The basic goal of a composition is to achieve a balance between the elements in the frame. One tried and tested method of doing this is to arrange those elements according to the rule of thirds. To apply the rule of thirds, imagine a grid overlaying your viewfinder, dividing it into thirds horizontally and vertically. Organize the elements in the scene according to the lines on the grid. The obvious starting point is to place the horizon on one of the dividing lines. In many photographs, the frame will be divided into two-thirds land and one-third sky, though if the sky is dramatic, reversing these proportions gives a good result. Having decided where to place the horizon, you then need to organize the other points of interest. A composition will often benefit from having a strong focal point, and the points where horizontal and vertical lines intersect in the rule of thirds grid are particularly powerful places to put such a point of interest.

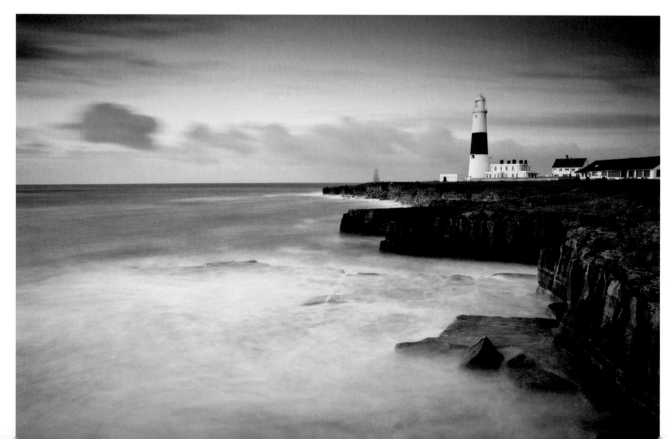

THE GOLDEN SECTION

The rule of thirds works well, but is in fact a simplified version of a proportion known as the Golden Ratio – or, when it applies to a rectangle, the Golden Section. In theory, the Golden Section should provide an even more harmonious division of the frame. Used in art and architecture for centuries – da Vinci's works are full of examples – the Golden Section also occurs frequently in nature, and there is research to suggest that our brains are 'hard-wired' to respond positively to images and objects that demonstrate this proportion.

To understand the Golden Ratio, imagine three lines: *A*, *B* and *C*. The Golden Ratio states that line *C* is proportional to line *B* as line *B* is proportional to line *A*. Expressed mathematically, the proportion is approximately 1:1.618; lines *C* and *B* differ in length by a ratio of 1:1.618, and lines *B* and *A* differ by the same ratio.

In terms of composition within a 35mm frame, the basic principle is this: if you divide the frame into two rectangles, the ratio of the small rectangle to the large one is the same as that of the large one to the whole frame. The sections can then be subdivided according to the same ratio, and you end up with a grid that is just slightly different from the rule of thirds grid. Once again, the intersections of horizontal and vertical lines are ideal places to position focal points in the image. For painters, applying the Golden Section is easy – they can sketch the grid onto their canvas – but it was more difficult for photographers in the early days, and the theory was simplified to become the rule of thirds.

To begin with, the Golden Section is best used as an analytical tool. Look at a selection of images – yours and other people's (and not just photographs, but any images) – and examine the extent to which they conform to the Golden Section. This will help you to familiarize yourself with the ratio, so that you can start applying it intuitively in your own compositions.

USING THE GOLDEN SECTION
The elements in this image are arranged around a Golden Section grid. In particular, the folly on the cliff edge sits precisely on one of the vertical lines.
Canon EOS 5D, 17–40mm f/4L (at 28mm), ISO 100, 15 sec at f/16, 2-stop ND grad

THE GOLDEN RATIO
*The proportional relationship between **B** and **C** is the same as the proportional relationship between **A** and **B** – a ratio of 1:1.618.*

A

B

C (A + B)

THE GOLDEN SECTION
A frame divided according to the Golden Section can be used in a similar way to the rule of thirds grid.

FOCAL POINT

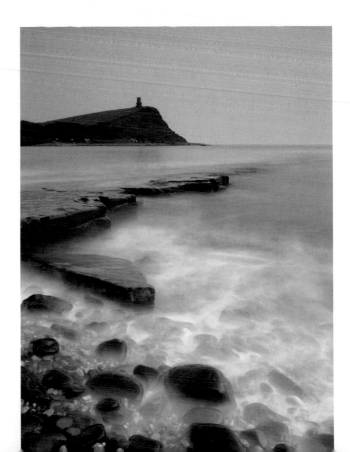

THE RULE OF ODDS

The rule of odds is mentioned far less often than the rule of thirds, but it is remarkably straightforward: it simply states that odd numbers in a composition tend to be more pleasing than even numbers.

Imagine a tree-topped hill as the focal point of a photograph. Imagine a single tree on the hill, then two trees and three trees. Somehow, the single tree and the three trees just 'work', while the hill with two trees doesn't. Related to this is the observation that triangles are an aesthetically pleasing implied shape within an image. Portrait and wedding photographers, when photographing groups of people, often organize them so that they form a triangle, and if you can find this shape in the natural world, it can often form the basis for a powerful composition.

STANDING STONES
This composition is based very clearly around the rule of odds, and the three stones also form an implied triangle in the composition. If you cover up the background stone, the composition falls apart.
Canon EOS 1Ds Mk II, 24–105mm f/4L (at 24mm), ISO 100, 6 sec at f/16, 2-stop ND grad

Tip: Some DSLRs have a custom function that superimposes a rule of thirds grid in the viewfinder, or on the review screen in Live View mode (see page 109). This grid can be a valuable compositional aid for beginners.

BALANCE AND HARMONY

Photographers often talk about trying to achieve a 'balanced' composition. However, the word 'balance' can be misleading in this context, as it may suggest symmetry, and visual balance is not necessarily the same thing (see pages 46–7 for more on symmetry in photographic composition). In general, it is better to think in terms of achieving 'harmony' in your photographs.

PLACING THE SUBJECT

Although a landscape photograph may not have a single, obvious subject in the same way as, say, a portrait – the view itself may be the subject – most successful landscapes contain a strong point of interest, or focal point. This could be a tree, a dominant hill or a building – a church, for example.

Placing the subject centrally in the picture frame usually results in a static rather than a dynamic composition, as the eye tends to shoot straight to the subject; the viewer's gaze is not encouraged to travel around the frame. Simply by placing the main subject off-centre, the picture becomes more dynamic, as the eye is encouraged to move around the frame, seeking out the subject. There are, of course, exceptions to this – for example, when there are powerful converging lines in the scene (see page 45).

To increase the sense of harmony in a composition, you can use lines, either real or implied, arranged according to the rule of thirds (see page 40) or the Golden Section (see page 41) with the focal point on a horizontal/vertical intersection.

Tip: Many DSLRs have a Live View function on the rear LCD screen (see page 109). This can give you a better idea of how balanced the composition will look in the final photograph.

HARMONY
Placing the focal point in the centre of the frame can result in a rather dull, static image (top). Placing the main subject off-centre encourages the eye to move around the frame, producing a more dynamic image.
Canon EOS 5D Mk II, 70–200 f/4L (at 70mm), ISO 100, 30 sec at f/11, 4-stop solid ND, 2-stop ND grad

LEAD-IN LINES

Another way to emphasize the main subject of your photographs is by using lines to lead the viewer's eye through the frame. This can also help to highlight the relationship between the subject and the foreground and enhance the feeling of depth in a photograph.

Lines are everywhere in the landscape and can be man-made, such as roads, paths and hedgerows, or natural features such as rivers or coastline. Lines don't have to be 'real'; they can also be implied – examples include the patterns created by waves photographed with a long exposure, or a row of objects.

Using implied lines is a subtle, but very effective way of highlighting the focal point in a landscape. It's not always easy to do, but if you can find a composition in which other objects are pointing towards the main subject, the results can be powerful.

Wide-angle lenses can help you achieve this, as distortion at the edges of the frame can stretch and enhance lines and angles. Having 'pointers' in the corners of the frame also helps to direct attention inward and stop the eye wandering out of the frame.

HIGHLIGHTING THE MAIN SUBJECT
Use lines to lead the viewer into the frame, emphasizing the main subject. This often creates a powerful composition.
Pentax 67II, 45mm f/4, f/16m Fuji Velvia, 2-stop ND grad

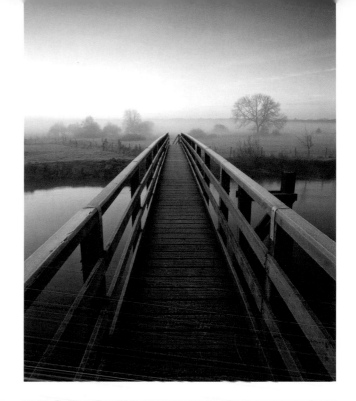

CONVERGING LINES

Converging lines are hughly dynamic, but take care when constructing a composition around them, as it is very easy to lead the viewer's eye straight out of the picture. In this example, there is sufficient interest in the middle distance, with the trees and mist, to prevent this from happening.

Pentax 67II, 45mm f/4, f/22, Fuji Velvia, 3-stop ND grad

CURVES

Gently curving lines lead the eye through a picture slowly, encouraging the viewer to examine the details of the composition. Rivers, streams and paths all make excellent photographic subjects.

Pentax 67II, 45mm f/4, f/22, 2-stop ND grad

DIAGONALS AND HORIZONTALS

Diagonal lines in an image suggest action and depth. They work particularly well if they come from the left of the frame, travelling towards the right, following the natural scanning pattern of the human eye. Bottom left to top right suggests more depth. The feeling of dynamism is increased if you shoot in portrait format, as this allows a more acute angle.

As with converging lines (see above), there is a risk that strong diagonals will lead the eye out of the photograph – using them to highlight a point of interest in the frame will help to prevent this. In general, diagonal lines should enter the frame from just above or below the corner, so that the frame is not split in two.

Horizontal lines are more relaxing than diagonals, suggesting peace, calm and a sense of restfulness. Related to horizontal lines is the use of layers in a composition. Layers have the same tranquil properties, but can also help to enhance depth in a photograph (see page 50).

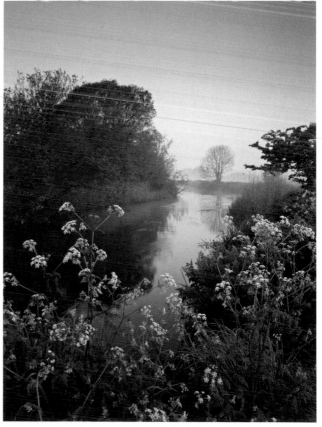

SYMMETRY

The rule of thirds (see page 40) is one of the fundamental principles of composition, and one of the first that photographers try to get to grips with. However, if you follow it too slavishly, your pictures can become a little boring and predictable, and it is important to be aware of other possibilities in a scene. For example, in direct contradiction to the rule of thirds, you will sometimes find that centring your subject has the greatest impact.

BALANCE

Symmetry is one way to create balance in an image, but remember that symmetry doesn't automatically produce harmony (see page 43). Symmetry occurs when objects on one side of an imaginary line that bisects the frame are mirrored on the other side of the line. The line is often referred to as the plane of symmetry.

A vertical plane of symmetry tends to provide the best feeling of balance in symmetrical images. Part of the reason for this is that our own plane of symmetry is vertical, so images organized in the same way are naturally pleasing. Of course, this is not to say that you should never have a horizontal plane of symmetry; many subjects, such as reflections in lakes, suit this approach.

In addition to the balance on either side of the plane of symmetry, consider the balance in the rest of the image. With a vertical axis, top-to-bottom balance is important. Most images look more stable if the bottom is slightly heavier. If the top seems too heavy, the composition can look unbalanced.

For a symmetrical composition to work, the plane of symmetry must be properly centred – any slight deviation will be instantly noticeable and jarring, and will look like a mistake.

Symmetry is found everywhere, both in nature and in man-made objects. As a result, many subjects naturally suit a symmetrical composition: reflections in water, architecture, bridges, rivers, paths and roads. Scenes with strong converging lines (see page 45) are particularly suitable for symmetrical compositions, especially if the lines lead to a strong focal point.

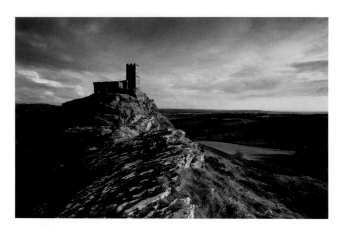

CENTRED HORIZON
Sometimes, placing the horizon in the centre of the image is the only option. In this image, it was important for the church to be placed according to the proportions of the Golden Section (see page 41) and for the clouds to fan out to the corners of the frame. For this to happen, the horizon had to be centred.
Canon EOS 5D Mk II, 17–40 f/4L (at 20mm), ISO 100, 2/3 sec at f/16, 2-stop ND grad

CENTRING THE HORIZON

Placing the horizon in the centre of the frame directly contradicts the rule of thirds, but there are times when it is appropriate to do so. Apart from obvious situations – for example, reflections in water, where symmetry is suggested along a horizontal axis – it's always worth looking around the frame before automatically placing the horizon on a third, and making sure that all the other elements are balanced; sometimes, these other elements will only be balanced when the horizon is centred, and you will have to decide which is more important – adhering strictly to the rules and placing the horizon off-centre, or achieving balance with the other elements within the scene.

Although a centred horizon can result in a dull, static composition, it can also emphasize a feeling of stillness and tranquility, so it works well for images in which other elements, such as the weather, also convey this atmosphere.

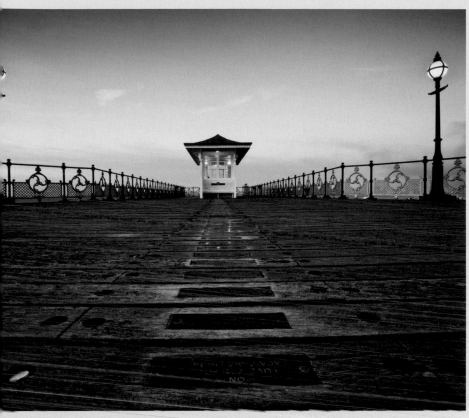

PIER

There were other compositional possibilities for this image, but the strong converging lines and powerful focal point, in the form of the shelter, made symmetry an obvious choice. Although the street lamps provide interest in the top part of the image, most of the information and interest is in the lower half, making the image look more stable.

Canon EOS 5D Mk II, 17–40 f/4L (at 17mm), ISO 100, 5 sec at f/22, polarizer, 2-stop ND grad

TRANQUILITY

Centring the horizon in this shot not only makes the most of the reflection, but also adds to the feeling of stillness and tranquility in the scene.

Canon EOS 5D Mk II, 17–40mm f/4L (at 23mm), ISO 100, 8 sec at f/16, polarizer, 2-stop ND grad

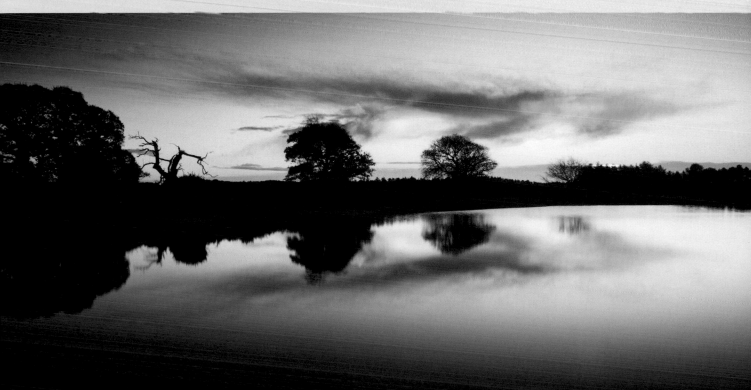

CREATING DEPTH

One of the biggest problems facing landscape photographers can be summed up quite simply: the world is three-dimensional, but the medium in which we are trying to represent it has only two dimensions. One of the main reasons why landscape photographs fail is that they don't convey the sense of depth that we perceive when we view the scene in reality. Often, when we see a photograph that doesn't quite work, and we say it looks a little flat, we mean it quite literally.

Fortunately, there are a few compositional and technical tricks we can employ to circumvent this problem and create the illusion of depth in a two-dimensional medium.

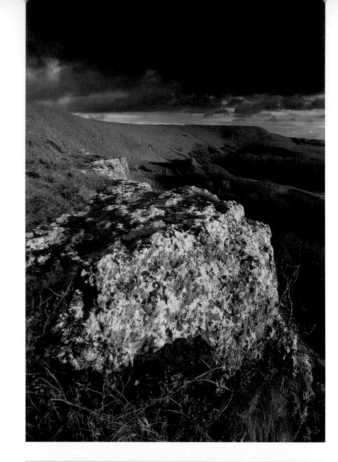

Tip: Using a wide-angle lens exaggerates perspective, enhancing the feeling of depth in a photo. It has the additional benefit of increasing depth of field, helping to create front-to-back sharpness, which can also add to a feeling of depth.

CHOOSING THE RIGHT FOREGROUND
It's easy to allow a foreground element to become too dominant, and small changes of position can have a big impact. In the first picture (top), although the light is dramatic and reveals the texture of the foreground rock, the rock itself is badly placed in the frame, blocking the view of the middle distance. The second picture demonstrates a much more considered use of the same foreground rock – it frames the picture at the bottom, lines up with the peak of the hill in the background, and the lines pointing inward at the bottom of the frame help to draw the eye into the picture.
Top: Canon EOS 1Ds Mk II, 17–40 f/4L (at 20mm), ISO 100, 1/5 sec at f/16, polarizer, 2-stop ND grad
Bottom: Canon EOS 1Ds Mk II, 17–40 f/4L at 20mm, ISO 100, 1/2 sec at f/16, polarizer, 2-stop ND grad

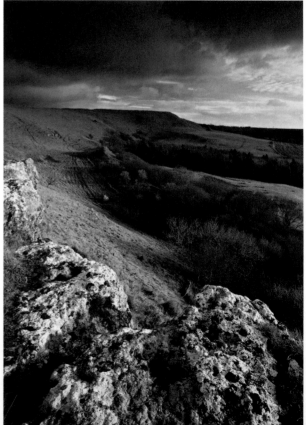

FOREGROUND INTEREST

One very effective way to create depth in a photograph is to include a strong foreground element, often in conjunction with the use of a wide-angle lens. Emphasizing the foreground in this way adds depth to a picture by creating an entry point for the eye, pulling the viewer into the scene and providing a sense of distance and scale. This technique works particularly well with wide-angle lenses because of the way they stretch perspective, exaggerating the size of elements close to the lens and opening up the view beyond.

When using this technique, you will need to pay attention to what's going on in the middle distance, and also to the height of the camera. Because of the way in which a wide-angle lens can open up the planes in the middle distance, if you shoot from too great a height, there can be too much empty space in this area. The solution is to shoot from a lower viewpoint, which compresses the middle distance. Get too low, however, and you may find that there's not enough separation between objects in the middle distance, or between the middle distance and the background

It may sound like a straightforward technique, but to apply it well takes skill and attention to detail. Too often, photographers seem to fall into the trap of sticking anything and everything in the foreground, regardless of whether it suits the picture or not, and ignoring the rest of the scene. It's worth spending time finding foreground elements that complement the background, and finding ways of relating foreground, middle distance and background to make a cohesive whole.

AERIAL PERSPECTIVE
Hazy or misty conditions are excellent for exploiting aerial perspective (see overleaf) and creating a feeling of depth, especially if there is a degree of backlighting.
Canon EOS 5D, 70–200 f/4L (at 90mm), ISO 100, 1/60 sec at f/11, 2-stop ND grad

LAYERING LIGHT
For this shot of the white horse at Cherhill in Wiltshire, UK, I set up as a shower began to clear. As the clouds receded, the white horse was spot-lit and the light caught the tops of the folds of the hills, highlighting their form and creating a layered light effect.
Canon EOS 5D Mk II, 24–105 f/4L (at 35mm), ISO 100, 1/50 sec at f/11, polarizer, 2-stop ND grad

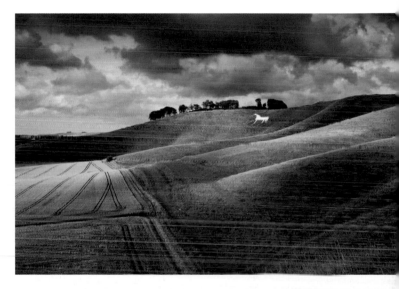

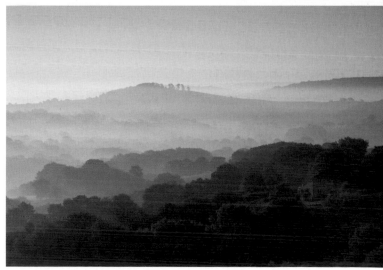

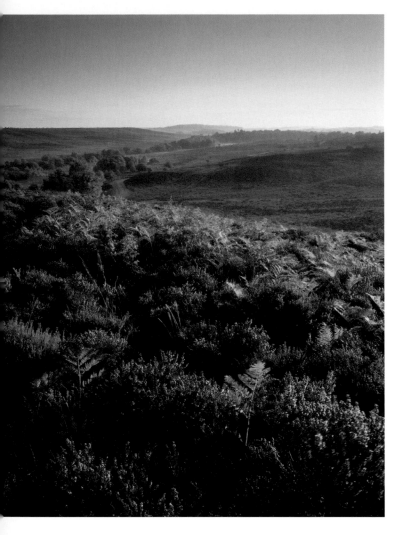

COLOUR AND DEPTH
*The warm oranges and purples of the bracken
and heather in the foreground, and the cool
blues and cyans in the background, help to
enhance the feeling of depth in this shot.*
Pentax 67II, 45mm f/4, Fuji Velvia, 2-stop ND grad

USING COLOUR TO ENHANCE DEPTH

In visual terms, warm colours advance and blue colours recede. We can use this to enhance the feeling of depth in a composition, by placing warm colours, such as reds and oranges, in the foreground, and cool colours, such as blues and greens, in the background.

LAYERS AND PLANES

Another useful technique for adding depth is to create layers in an image. Layers can be formed by a series of overlapping shapes, or by strong side-lighting, creating alternate bands of light and shade, giving a layered light effect. A layered look can also be enhanced by aerial perspective, in which receding shapes, such as a range of hills, appear lighter the further away they are. This effect is especially noticeable in hazy, misty or foggy conditions. This type of image works particularly well with longer lenses, which have the effect of compressing perspective (see page 15) and stacking overlapping forms to exaggerate the layered effect. If you are using longer lenses, remember that they have less depth of field than wide angles, so you may need to use smaller apertures, such as f/16.

BIG FOREGROUNDS

The 'big' foreground has been a popular look in landscape photography in recent years, partly due to the popularity of the excellent work of photographers such as Joe Cornish. It is, however, in danger of becoming a visual cliché and it's worth remembering that foreground interest doesn't have to be big to be effective. More subtle elements can often work just as well – for example, reflections in wet sand, the pattern of waves breaking on the shore or the shadows cast by trees.

FROSTY TEASELS
By taking a low viewpoint, I was able to use the frosty teasels on the edge of the river to make a natural frame for the view beyond – and for the focal point, the old mill on the far bank.
Canon EOS 1Ds Mk II, 17–40 f/4L (at 20mm), ISO 100, 1 sec at f/22, 2-stop ND grad

OTHER COMPOSITIONAL TRICKS

In addition to the rules of composition (perhaps they are better thought of as general guidelines) – the rule of thirds, the Golden Section, the rule of odds and so on – there are a number of other compositional tricks you can use to organize the frame and draw attention to the main subject. These are the use of frames within frames; movement and texture; and shapes and patterns.

FRAMES WITHIN FRAMES

One way to keep a composition tight and focus attention on the main subject is to use a natural frame, such as an overhanging branch, archway or other object, to frame the principal subject. This technique is very popular with landscape and architectural photographers and has become something of a cliché, but in the right circumstances it is still very effective.

By framing the scene, attention is focused inward to the main part of the picture. Rock formations, archways, branches and leaves make excellent natural frames. It's best to be bold when using such frames for your landscapes. It's also effective to partially frame a view, perhaps with an arrangement of rocks at the bottom of the frame (as in the image at the bottom of page 48). This works particularly well if there is a strong sky above the landscape, which frames the top of the picture.

MOVEMENT AND TEXTURE

Although it isn't always strictly necessary, landscape compositions often work best when they have a strong centre of interest. The other elements in the picture should direct or lead the eye to that centre of interest. This can be achieved by using lead-in lines (see pages 44–5) or by employing objects that point into the frame. One way to create lines and pointers is to use movement.

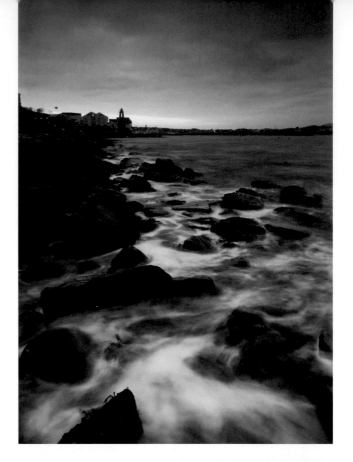

If you use solid neutral density (ND) filters to extend exposure times (see pages 79–80), you can create lines and pointers from the resulting patterns of movement – for example, the 'S' curve created by a wave breaking on the shore.

In macro (extreme close-up) shots, texture can be a subject in itself, but in a landscape, texture can make an effective foreground. Used well, it can make the viewer want to reach out and touch it, pulling them into the picture. Contrasting textures, such as hard and soft, can also be used to create tension within a composition.

SHAPES AND PATTERNS

We have a predisposition towards finding a natural order in scenes, even in chaotic environments. When we look at a scene, or a representation of that scene, we will try to impose order on it by picking out shapes and patterns. For example, if we see three trees in the landscape, we will tend to see them as a triangle, even if the spacing is uneven. Photographers can help the viewer in this search for order by picking out shapes and repeating shapes (i.e., patterns).

Different shapes have different aesthetic properties. Squares and rectangles are static, and tend to block a view. Circles are calming. Triangles are dynamic; they lead the eye into a picture and make good pointers for highlighting subjects. With its base at the bottom of the picture, a triangle suggests stability; with its apex at the bottom, it suggests imbalance and precariousness.

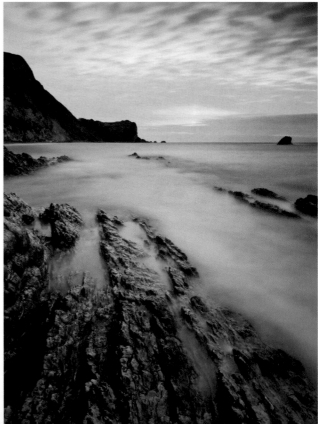

SUNSET SHORE
(Top) By shooting the waves breaking on the foreground rocks with a two-second exposure, I was able to use the movement patterns to create lines that curve into the frame.
Canon EOS 5D, 17–40 f/4L (at 22mm), ISO 100, 2.5 sec at f/16, 3-stop ND grad

ROCKY LEDGES
(Right) Shooting with a long exposure as the waves washed over the rocks added texture to the foreground. The rocks act as strong lead-in lines, carrying the eye through to the headland.
Canon 5D2, 21mm f/2.8, ISO 100, 46 sec at f/22, 4-stop solid ND filter, 3-stop soft ND grad

BREAKING THE RULES

If you slavishly follow the rules of composition, you will create work that is competent but unimaginative and predictable. However, it is not simply the case that 'rules are made to be broken'. The rules have their uses. They can be used as a starting point – a way of looking at a subject that will enable you to get the best out of it. If you understand the rules and explore them while constructing an image, your composition is likely to improve – even if you end up with a picture that breaks every rule in the book.

PLACING THE HORIZON

According to the rules, the horizon line should be placed in the bottom or top third of the picture, depending on how much interest is present in the sky. However, there are plenty of situations in which you can consider other approaches.

If you are confronted by a scene that has little interest in the foreground or middle distance, and a particularly dramatic sky, placing the horizon at the very bottom of the frame can work very effectively. This also has the effect of increasing a sense of emptiness and isolation, particularly in minimalist compositions (see page 164). On the other hand, if the sky is clear, and lacking in interest, placing the horizon right at the top of the frame – or excluding it altogether – is often the best option.

Placing the horizon in the centre of the frame is also a viable option in many situations, for example when shooting a scene in which the sky is reflected in water. Placing the horizon in the centre of the frame can also enhance an atmosphere of calm and tranquility (see page 46), and, in the right lighting conditions, can be an effective treatment of the subject.

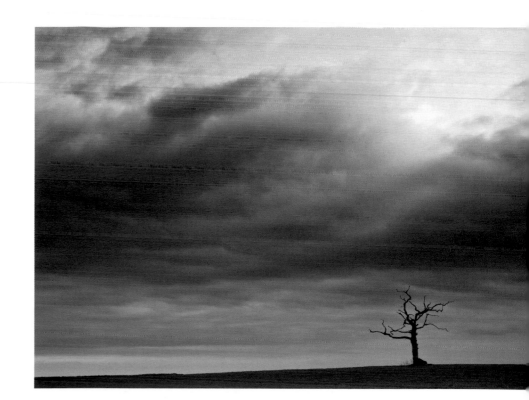

LOW HORIZON
Placing the horizon low in the frame can increase a sense of isolation, especially in conjunction with a dramatic sky. But the rules haven't been completely abandoned in this shot – the tree on the hill is still placed on a third.
Canon EOS 5D Mk II, 24–105 f/4L (at 55mm), ISO 100, 1/8 sec at f/11

BREAKING THE RULE OF THIRDS

The rule of thirds is a tried and tested way to create balance and harmony in a composition, but there are times when you want to explore other options. One situation in which a centrally placed subject works is when there's a strong sense of balance within the scene. This occurs when there are strong converging lines leading to the focal point, or when there is clear symmetry within a scene. Often, even when we think we are ignoring the rule of thirds, some elements in the picture will end up falling on thirds.

JETTY
This image was composed with the intention of cropping it to the square format, which often suits a symmetrical composition. At first glance it doesn't appear to conform to the rule of thirds – but look again at the position of the benches and the basket on top of the pole.
Canon EOS 5D Mk II, 17–40 f4L (at 19mm), ISO 100, 400 sec at f/8, 10-stop solid ND, 2-stop ND grad

BREAKING THE RULE OF ODDS

If there is a repeated element within a scene (trees, animals, rocks and so on), odd numbers are generally more pleasing. However, such elements are often out of the photographer's control – in contrast to, say, painters, who can put any number of elements they choose into a scene. Photoshop's Clone tool can be useful in this respect, but it's not always easy to clone parts of an image without making it obvious, and you may not wish to spend any more time in front of the computer than you have to.

Although the rule of odds is useful, don't let it become an obsession and if there are, say, four cows in a field, rather than the ideal three, then you should just get on and take the picture, concentrating on arranging the elements that are present in the scene in the most effective way possible.

Sometimes, where there are many elements present, they can also be viewed as a single group – a clump of trees, for example – or three, five or seven groups, and so on. Also, a number of repeated elements may work together to form a line – in which case, it doesn't really matter whether there is an odd or an even number.

FOCAL POINTS

It's usually desirable to have a strong focal point in an image, but in some situations, it's possible to create pictures without an obvious subject. One common example is when the light itself becomes the subject of the photograph – perhaps there is dappled light on a particular part of the landscape, or a strong layering of light that gives depth to a scene.

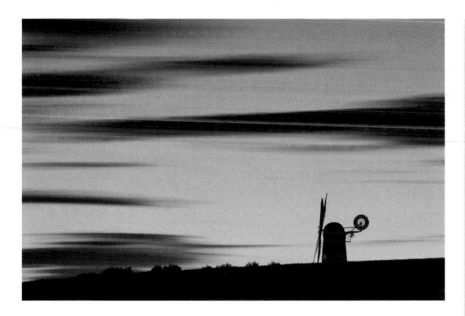

KEEP IT SIMPLE
Exclude any elements that don't enhance the composition, and keep your shot as simple as possible. This will often lead to the most satisfying image.
Canon EOS 1Ds Mk II, 70–200mm f/4L (at 200mm), ISO 100, 3 min at f/16

FINAL THOUGHTS

While the rules of composition are important, applying them indiscriminately can result in compositions that are no more considered than snapshots – always use your own judgement. As well as understanding the rules, there are other basic principles that can guide us. Perhaps the most important is to keep it simple: cluttered, fussy photographs rarely look good. Composition is as much about what you exclude from the frame as what you include. Identify a few key elements, arrange them effectively in the frame, and you'll be well on the way to making a successful picture.

▶ CHAPTER FOUR > **LIGHTING**

Light is the key ingredient in photography. It shapes the subject, adding texture and relief, and creates the mood of the image. Photography means 'painting with light' and, in many ways, it is the quality of the light that determines the success of an image. Closely related to light is colour, which also plays an important role in how we respond to an image, influencing our emotional response to it and even the way we perceive perspective within the photograph.

CORFE CASTLE, DORSET, UK
Strong backlighting creates an unusual view of this popular location, casting shadows in the mist, which race towards the camera. It has also reduced the colours to a warm monotone, giving the image a tranquil atmosphere.
Canon EOS 1Ds Mk II, 24–105 f/4L (at 67mm), ISO 100, 1/80 sec at f/16, 2-stop ND grad

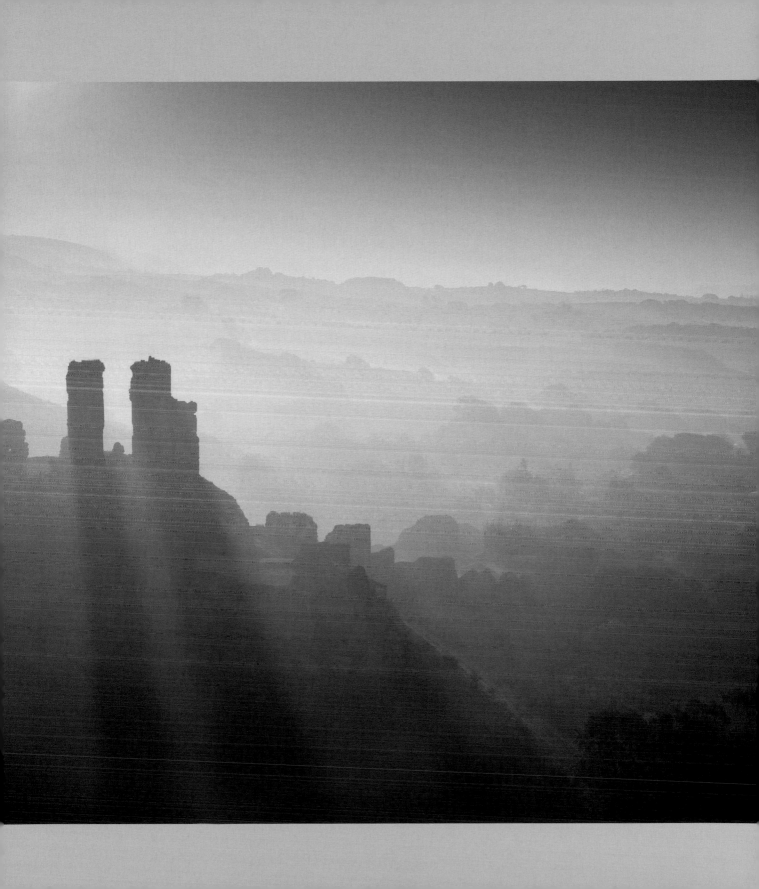

DIRECTION OF LIGHT

Lighting can influence a photograph in many different ways. One of the most important is its direction – whether the subject is lit from the front, side or back. Beginners in photography are often advised not to shoot directly towards the light source, but in fact there are no hard and fast rules regarding the direction of the light; it is simply a matter of being aware of the effects that are created by different types of lighting.

A scene can look very flat, with harsh shadows, when the sun is high in the sky and the subject is lit almost from above. However, with the right subject, even this can work well, especially if you shoot in black and white.

FRONT LIGHTING

Front lighting produces shadows that fall behind the subject, away from the camera. It doesn't pick out texture and form, and often makes a scene look flat and uninteresting, although if the sun is low over the horizon, it can provide good colour saturation. With low front lighting and wide-angle lenses, an additional problem is that you have to avoid your own shadow appearing in the picture.

SIDE-LIGHTING

Side-lighting is a favourite with many landscape photographers, as it reveals texture and shadows falling across the scene. This helps to highlight shape and form, adding more depth to a scene. Strong, low side-lighting has a modelling quality, creating relief in the landscape. In some scenes, if the direction of light is from the side and slightly behind, a layered light effect can result (see page 50), which can greatly enhance the feeling of depth in an image.

BACKLIGHTING

Backlighting can be very dramatic, with shadows racing towards the camera and the emphasis very much on shape and form. Trees, backlit by the rising or setting sun, can look very effective, with shadows spreading out in front of them and the sun's rays bursting through the branches. Do be careful, though, not to look directly at the sun, especially if viewing the scene through a telephoto lens, as this can cause permanent damage to your eyes. The technical danger here is that the camera will tend to underexpose backlit scenes, so you may need to add a little more exposure than suggested by your camera's meter. Remember to check the histogram and be prepared to reshoot if necessary.

ROCK ARCH
In this shot, the setting sun was almost directly behind the camera, and has given a golden glow to the rock arch. The lead-in lines created by the wave breaking in the foreground have helped to add depth to the scene, in lighting conditions that might otherwise look a little two-dimensional.
Pentax 67II, 45mm f/4, f/16, Fuji Velvia

DISTANT CHAPEL

(Above) Not only does the side-lighting in this shot help to reveal texture in the fields below the chapel, but also, with the side of the building lit and the front in shadow, it creates a three-dimensional look. The light has left the background in shadow, which highlights the building's dramatic position on top of a hill.
Canon EOS 1Ds Mk II, 70–200 f/4L (at 110mm), ISO 100, 1/5 sec at f/11

FOLLY IN SILHOUETTE

(Below) Choosing the right subject is crucial with silhouettes. Shooting this folly in silhouette reveals its dramatic shape.
Canon EOS 5D Mk II, 24–105 f/4L (at 65mm), ISO 100, 1/20 sec at f/11

SILHOUETTES

Strong backlighting is essential for creating silhouettes. Choose a single, isolated subject with an interesting shape – a gnarled tree, for example, or a folly (below left). It also helps if there is strong interest in the sky.

The technique is fairly simple. Firstly, it is best not to use graduated neutral density filters (see pages 81–2), as the idea is not to balance the exposure difference between the foreground and sky, but to allow the foreground to go dark.

Place the subject in a key area of the image and the horizon low in the frame – the foreground will be almost completely black, so you don't want to fill too much of the frame with it. Switch the camera's exposure mode to Manual, and take a reading from a bright part of the sky (but do not include the sun in the frame). Recompose and take the shot. The result will be an image in which the sky is well exposed, but the foreground and main subject are almost completely black. The image's histogram will be bunched up to the left, indicating a large percentage of shadow tones. With most images, this would indicate an exposure error, but silhouetting is deliberate underexposure of part of the image.

QUALITY OF LIGHT

Quality of light plays a huge part in determining the nature of an image. When we talk about the quality of light, we are really referring to its intensity and colour temperature – how warm or cool it is (see pages 36–7). The factors that affect the quality of light are the time of day, the season and the weather – the light is much less intense and more diffused on a cloudy day, for example.

There is no right or wrong light for shooting landscapes. Theoretically, it is possible to take good scenic photographs in any lighting conditions, given the right subject and composition, but there are certain conditions that are more flattering to the landscape, and it's important to understand the impact that the quality of light will have on the final image.

TIME OF DAY

The light at different times of day makes a huge contribution to the mood of a shot. Pre-dawn light is cool and blue, but as the sun gets close to the horizon, pink tones start to appear in the sky. This produces a calm, still and tranquil mood. If there are clouds, they will be lit from below, and can be colourful and dramatic. When the sun breaks over the horizon, the light is warm and the low sun highlights texture and form, bathing the land in a golden glow, though with cooler shadows. This is lighting for the big vista.

After the sun has risen, it's surprising how quickly the light can become harsh, especially if the sky is clear, and there's usually a window of about 30 minutes – or perhaps a little more, depending on the time of year – in which the lighting conditions are ideal for shooting landscapes. This half-hour on either side of sunrise is one of the 'golden hours' for landscape photography – the other being the half-hour on either side of sunset.

When the sun is high in the sky, creating a moody shot is more challenging. For a large part of the day, high contrast and harsh shadows provide little textural relief or modelling of objects. There is little warmth in this light and scenes can look flat. However, it is still possible to take good shots at this time of day. Strong colours can be intensified, especially if you are using a polarizing filter (see pages 76–8), and scenes with man-made structures in them can also work well, particularly in black and white.

The light towards the end of the day, and at sunset and just after, is similar to the light at the beginning of the day, but it tends to be warmer and more orange/yellow in colour. This is because the air is drier and filled with dust and other particles, including pollution, stirred up by activity during the day. The warm light of the sun therefore becomes diffused. These particles also block blue light to some extent, which makes sunsets redder than sunrises. The mood here is often one of high drama, rather than the more subtle, peaceful mood at the beginning of the day.

SEASONS

In winter, when the trees have dropped their leaves, the landscape is more exposed and the low sun casts long modelling shadows throughout the day. The air is more humid and contains less dust than at other times of year, giving the light a clarity not often found in the other seasons. Clear, cold nights often lead to a frost in the morning, complemented by pastel colours in the sky.

The light in summer is often less favourable for landscape photography, because the high sun creates harsh light for a large part of the day, while more dust and heat haze means that the light is generally less clear.

In early spring and late autumn, the light and clarity are better than in summer and it's possible to shoot for most of the day. The weather is also quite changeable at these times of the year, which can create plenty of dramatic photo opportunities. In late spring and early autumn, after a cool night, mist can often form at dawn as the land begins to warm up. This is the time to head for rivers, lakes or hills overlooking valleys. Certain locations will look more photogenic at different times of day and year than others. Carefully researching your locations and deciding which time of day or year will suit them best, is always time well spent.

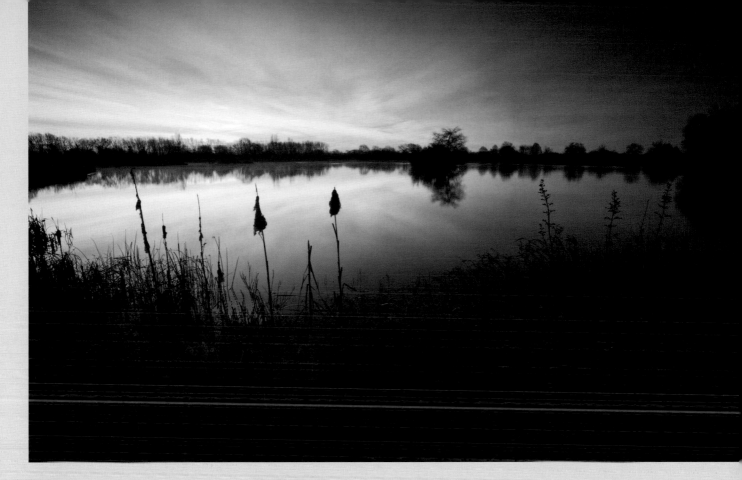

SUNRISE

It's difficult to resist sunrise and sunset, especially when there is the added drama of a strong sky.
Canon EOS 5D Mk II, 17–40 f/4L (at 17mm), ISO 100, 1.3 sec at f/22, 3-stop ND grad

AUTUMN MIST

Spring and autumn are the seasons for mist, which can add a romantic atmosphere to landscape photographs. Look out for a clear, still, cool night, especially if a gentle south-westerly wind is forecast for the morning, bringing some warmer air with it. Climb to the tops of hills overlooking valleys, especially if there is water nearby, or if the ground is wet after recent rainfall.
Canon EOS 1Ds Mk II, 24–105 f/4L (at 95mm), ISO 100, 1.6 sec at f/16, 2-stop ND grad

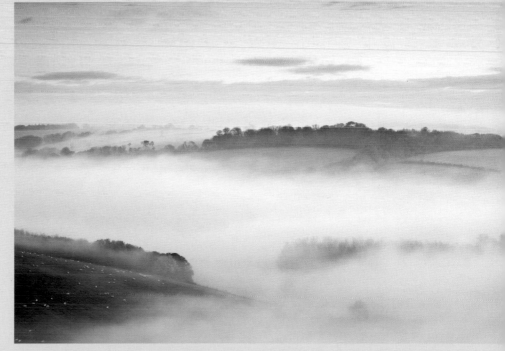

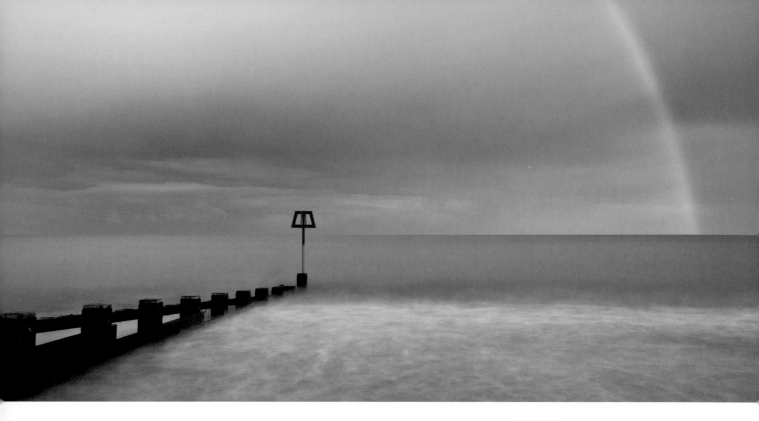

RAINBOW
If you're lucky enough to see a rainbow, use a polarizing filter (see pages 76–8) to enhance its colours.
Canon EOS 5D Mk II, 24–105mm f/4L (at 40mm), ISO 100, 20 sec at f/22, polarizer, 3-stop solid ND

WEATHER

People spend a lot of time talking about the weather, and landscape photographers are no exception. There's really no such thing as good or bad weather for landscape photography – each set of conditions brings its own challenges and opportunities. However, some weather conditions will enable you to produce more dramatic shots. The trick is learning to recognize and anticipate them.

Many landscape photographers get quite excited when the weather forecast predicts sunshine and showers, because this type of weather can provide some of the best opportunities. The clarity is often excellent on these days, and the light can be stunning during the moments when the rain stops and the sun breaks through, with foreground objects spot-lit against a dark, brooding sky. If you're lucky, you may even see a rainbow. These moments are fleeting, however, and you will probably find that you need to set up while it's still raining. On these occasions, take care to keep your equipment dry by placing it inside a rain cover. When the light breaks through, you will be ready to capture the dramatic lighting conditions, which may only last a few seconds.

Blustery days can also be interesting; the moments when the light breaks through the landscape can look very striking, but even when it doesn't, there are often dramatic clouds in the sky, and by using neutral density filters (see pages 79–80) to extend shutter speeds, you can capture the patterns of clouds streaking across the sky.

If the weather is grey, overcast and raining, there are still shots to be had. Head for woodland: the diffused, less contrasty lighting suits this type of location. Use a polarizer (see pages 76–80) to cut out the reflections and glare from wet foliage and saturate the colours. It's even possible to take good shots in the rain, as long as you can keep the lens or filters free from water droplets.

Ironically, probably the least inspiring weather for landscape photography is what most people would describe as a 'perfect' day – blazing sunshine and clear blue skies. The light is undiffused and harsh, and there is little interest in the sky above the landscape.

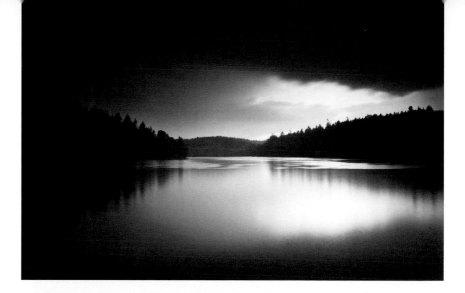

SETTING SUN
You can take dramatic shots even in poor weather – it was raining heavily when this shot was taken. The setting sun added some colour to the far end of the lake, and the rain has given a diffused quality to the light.
Canon 5D2, 24–105mm f/4L (at 24mm), ISO 100, 15 sec at f/16, 4-stop solid ND, 3-stop ND grad

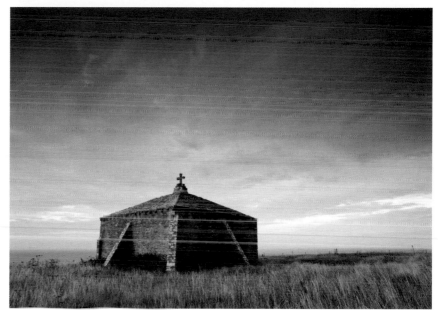

MATCHING THE LIGHT TO THE SUBJECT
Although there's no right or wrong light for landscape photography, it's important to choose subjects that suit the conditions. This Norman chapel at St Aldhelm's head in Dorset, UK, has a brooding presence that is best suited to low light and dramatic skies.
Canon EOS 5D Mk II, 21mm f/2.8, ISO 100, 0.6 sec at f/11, 2-stop ND grad

LIGHTING 'ON THE EDGE'

Much of the action in landscape photography happens 'on the edge' – the transition between one state and another. In terms of light, this means the transition from day to night, or vice versa; the change from one season to another; the transition from calm to stormy weather, and so on. Capturing these moments can result in very powerful pictures, especially when they are combined with other themes such as the transition between land and water or the edges of wilderness and civilization.

Tip: A rain cover is a useful accessory in wet weather. There are several commercially available rain covers, some more expensive than others, but the Optech Rainsleeve offers the best value for money. Alternatively, you can make your own by making a hole in a plastic bag and using an elastic band to seal it around the lens.

SHOOTING AT DAWN AND SUNRISE

The dawn shoot is one of the most popular events at our workshops, and with good reason. Although getting out of bed at what most people would regard as an unreasonable hour requires a certain amount of effort, it is an effort that is often well rewarded. Dawn is one of the golden hours for landscape photography (see page 60), when the light can be special and even mundane subjects are transformed when bathed in its warm hues.

PREPARATION

The light changes very quickly at dawn, so research and preparation are crucial. You need to arrive at a pre-selected spot a good half hour before sunrise, and have a clear idea of where the sun will be rising. The location you choose will also depend on the prevailing conditions – some look their best beneath a dramatic sky, while others are more suited to the softer, romantic mood that a mist brings to the scene. Checking the weather forecast the previous night is essential, although it's important to bear in mind that weather can be very localized – you should trust the evidence of your own eyes when setting off, and be prepared to adapt your plans. Sometimes the factors on which you base your decision will be based on your local knowledge, but there are also useful tools available to aid planning (see Useful websites, page 172).

TECHNICAL CHALLENGES

As well as the need to be prepared, and to work quickly due to the rapidly changing light, there are a number of other challenges arising from shooting at dawn. Firstly, the contrast range in a dawn scene can be surprisingly high. Pre-dawn, there is no direct light shining onto the land, but the sky is lit from below by the sun. As the sun nears the horizon, the sky becomes brighter and the contrast greater. This contrast will often be greater than the sensor can handle, so graduated filters (see pages 81–2) are a must. The degree of filtration necessary will vary, but be prepared to use heavier grads, or if the contrast is very high, shoot two exposures

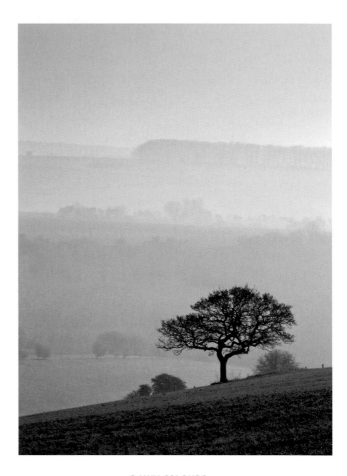

DAWN COLOURS
(Above) Dawn colours are often subtle, with a feeling of calm, stillness and tranquillity.
Canon EOS 5D Mk II, 70–200 f/4L (at 163mm), ISO 100, 1/8 sec at f/16, 2-stop ND grad

USING REFLECTIONS
The sky can be used to add colour and impact to the foreground. With a particularly striking reflection, don't be afraid to break the rules and not use foreground interest, which might reduce the impact of the reflection.
Pentax 67II, 55mm f/4 lens, f/16, Fuji Velvia

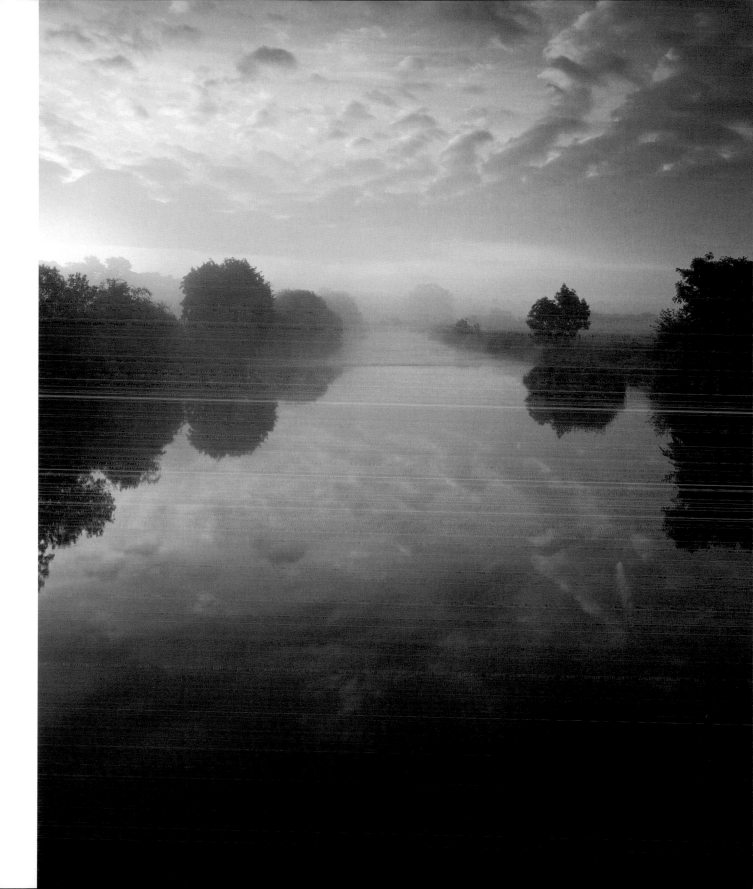

SHOOTING AWAY FROM THE SUN
I almost missed this dramatic scene because I was so intent on photographing the rising sun. I happened to glance behind me and noticed the dramatic cloud pattern, which had far more potential than the scene in front of me.
Pentax 67II, 45mm f/4 lens, f/22, Fuji Velvia

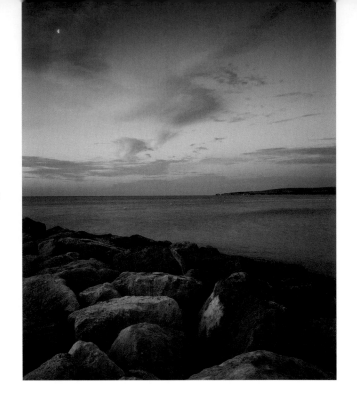

– one with the land/foreground correctly exposed, and another with the sky correctly exposed – and then blend them in post-processing (see pages 130–3).

If you have arrived and set up well before sunrise, the first shots you take will need fairly long exposures – perhaps one or two minutes, or more if you have stopped the lens down to increase depth of field. As most cameras only allow shutter speeds of up to 30 seconds, you'll need to switch to Bulb mode and lock the shutter open for the desired length of time. Remember that it will be getting lighter during the exposure, so you will need to take this into account when making your exposure calculations. If, for example, a meter reading suggests 60 seconds, shorten this by a half to one stop, and shoot for 45 or 30 seconds.

COMPOSITION

When shooting at dawn and sunrise, all the usual compositional guidelines apply, but there are one or two additional points to consider. When researching locations and planning shoots, look out for suitable foreground interest, and objects that would make good silhouettes. Placement of the horizon is key in a dawn shot – if the sky is dramatic, don't be afraid to choose a bold composition, with the horizon low in the frame; fill the rest of the frame with sunlit clouds. On the other hand, if the sky is clear, keep the horizon at the top of the frame or crop it out altogether – you could make the most of any reflections or texture in the foreground instead.

The temptation with dawn and sunrise shots is always to shoot towards the sun, but this will only be possible for a short time after the sun has broken the horizon, unless the sun is diffused by cloud or haze. But even before the sun breaks the horizon, keep looking around, as colour will often appear in other parts of the sky, depending on the cloud patterns. Some of the best dawn images can be taken by shooting in the opposite direction to the sunrise.

EQUIPMENT FOR DAWN SHOOTS

A sturdy tripod is essential for all landscape photography, but especially at dawn, when exposures can be very lengthy. You'll also need a cable release if you want to avoid camera shake. You'll be arriving and setting up while it's still dark, so a torch is useful, not only to help you see what you're doing when setting up, but also for safety.

Suitable clothing is a must. You'll be standing around waiting for the light, and it can get very cold at certain times of year. Several warm layers, including a hat, will help to keep you warm. Tripod legs can get particularly cold, and even if you're not carrying a tripod any great distance, warm gloves are a good idea. You might also want to keep some chemical hand warmers in your camera bag. The equipment list is the same if you are shooting at the other end of the day.

SHOOTING AT SUNSET AND DUSK

Few people can resist photographing a colourful sunset; it's the day's grand finale, and with the right sky, it can be a moment of high drama. However, despite the colour and natural beauty, capturing a sunset successfully is not always as straightforward as you might think, and results can be disappointing. By following the advice below, you should be able to improve your chances of coming away with great sunset and dusk images.

PREPARATION

In many ways, it is easier to predict how the light will change during a dusk shoot than it is during a dawn shoot, though much of the same advice applies. Research an area in advance and arrive well before sunset to set up and compose your shot. As with dawn shoots, knowing exactly where and when the sun will set is important – if you're rushing around at the last minute, trying to compose a shot because the sun isn't where you thought it would be, your results are unlikely to be very good.

Keeping a close eye on the weather forecast is another important part of your preparation. The ideal for photographing at sunset and dusk is a certain amount of cloud cover, to pick up the colours of the setting sun – around 50–70% is good. However, don't automatically cancel the shoot if the cloud cover is heavier than that. If there's a break on the horizon, there's a chance that the clouds will still be lit from below.

Many photographers pack up and go home when the sun has disappeared, but in fact, the best light often comes a few minutes after sunset – sometimes as much as 20 or 30 minutes afterwards, as a warm 'afterglow' spreads across the sky. And even after the strongest colour has gone, the light remains photogenic for a long time into dusk, especially on the coast – so be prepared to stay late.

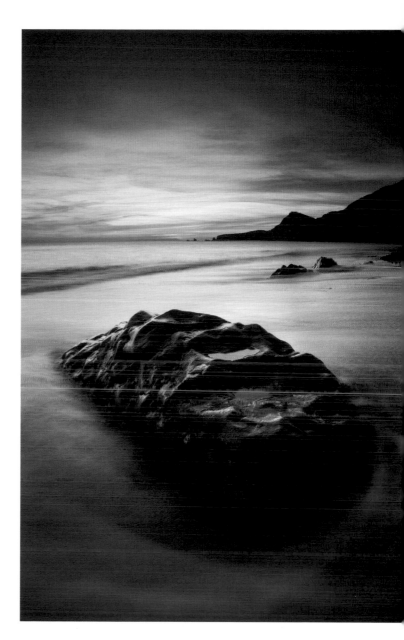

AFTERGLOW
It's hard to resist the strong, saturated colours and dramatic skies of a good sunset.
Canon EOS 1Ds Mk II, 17–40 f/4L (at 20mm), ISO 100, 3.2 sec at f/16, 3-stop ND grad

TECHNIQUE

The main technical challenge when shooting at sunset and dusk is one of contrast – the sky is much brighter than the land/foreground. This is also true when the sun has dipped below the horizon, as the sky will be lit from below, but there is no direct light on the foreground. The solutions are the same as when shooting at dawn (see pages 64–6) – either use graduated neutral density filters or blend two exposures in post-processing.

When sunset slips into dusk, exposure times start to become quite lengthy, and to shoot exposures of more than 30 seconds you'll need to switch to Bulb mode. One result of longer exposures is that a little colour can go a long way – if colourful clouds drift across the scene, the colour will be spread across the frame.

During long exposures there is an increased risk of image noise from underexposure. To keep your images as clean as possible, try exposing to the right (see pages 112–3). It can be tempting to increase the ISO to reduce exposure times, but you will get less noise by shooting longer exposures at a low ISO.

COMPOSITION

The same principles of composition apply at sunset and dusk as at dawn and sunrise. Placement of the horizon will depend on how much interest there is in the sky. Look out for interesting shapes and textures to use as foreground interest, or to incorporate into the shot as silhouettes. Shooting directly into the sun is only really a good idea when the sun is very low to the horizon, or if the sun is sufficiently diffused by cloud or haze. Again, it is very important to remember that looking directly at the sun, especially through a telephoto lens, can cause serious eye damage.

LONG EXPOSURE SEASCAPE
Evening light remains photogenic well into dusk. The light-gathering properties of digital SLR sensors are impressive, and our workshop participants often find themselves shooting until they can no longer see enough to compose a shot.
Canon EOS 5D Mk II, 21mm f/2.8, ISO 100, 4 min at f/16, 2-stop ND grad

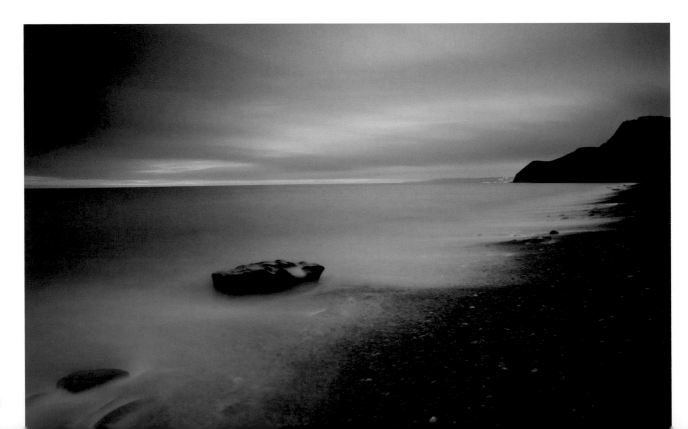

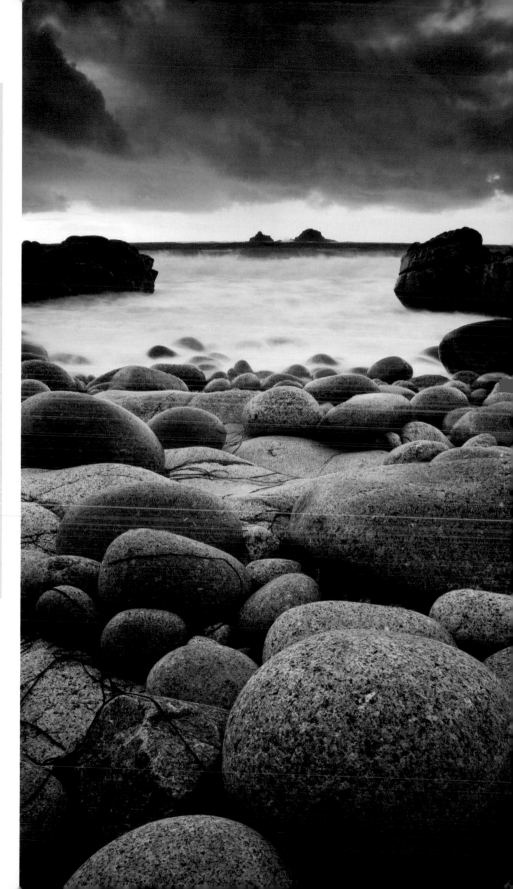

CALCULATING LONG EXPOSURES

Digital SLRs have made calculating long exposures easier than ever before. For exposures longer than 30 seconds, use the following method.

In Aperture Priority mode, increase the ISO until you get a meter reading. Then work out what the equivalent exposure should be at base ISO, switch to Bulb mode and lock the shutter open for that length of time. For example, if the correct exposure at ISO 400 is 30 seconds, the equivalent at ISO 100 would be two minutes. Remember, though, that light levels will be dropping during the exposure, so you will need to add half to one stop of exposure – in this example, that takes the exposure time up to three or four minutes. For shooting at dawn, the opposite is true, and you will need to shorten exposure times by half to one stop.

THREE DIMENSIONS
While beautiful evening light and colour will naturally add drama and impact to your images, good composition is still the key to success. Look for foreground objects that will complement the scene and add a three-dimensional feel to the shot.
Canon EOS 1Ds Mk II, 24–105mm f/4L (at 24mm), ISO 100, 2 sec at f/22, polarizer, 3-stop ND grad

COLOUR THEORY

The colours in a photograph are another important factor that determines the mood of the picture and the viewer's emotional response to it. Colours can be harmonious or contrasting, warm or cool, saturated or muted, calming or unsettling. As landscape photographers we have no direct control over the colours in the landscape, but we do have a choice about what we leave in or leave out of the frame. For example, you might include some wild flowers to add a splash of colour in the corner of the frame, or you might decide that they are a distraction, and exclude them.

HARMONY AND CONTRAST

The two most important relationships between colours are harmony and contrast. Looking at a colour wheel helps us to understand this (see opposite page). Colours that are next to each other on the wheel – for example, blue and green – are harmonious, while those that are opposite – such as blue and yellow – are contrasting. Colours on the 'warm' side of the wheel harmonize with each other, while those on the 'cool' side also harmonize. Harmonious colours are more calming to look at, and blues and greens in particular are very tranquil. Contrasting colours are more dramatic and create tension – blue and yellow is a particularly strong contrast.

COLOUR SATURATION

Technically, saturation refers to the purity of a colour, but in practical terms, it's how intense or strong the colour appears. In combination with the right subjects, strong, saturated colours can make for powerful, dynamic images. Producing saturated images involves more than simply boosting colours in post-processing. There are plenty of options at the picture-taking stage: the time of day has an impact on colour saturation; early morning and late evening light, with the sun low in the sky and less glare, will produce more intense colours than at other times, as will front lighting rather than side- or backlighting. A polarizing filter, by reducing reflections and cutting down on glare, also improves saturation (see pages 76–8).

Of course, it's not always desirable to have vibrant, saturated colours. Muted, pastel tones are more subtle, but can be just as effective with the right subject, creating an atmosphere of calm and tranquillity. Early morning mist will drain colours, and also give a cold, bluish hue to a scene, which you can enhance by adjusting the white balance (see pages 36–7) either in-camera, or, if you're shooting Raw (see page 122), at the conversion stage. It's also possible to make successful compositions using just one colour, or shades of one colour. Certain lighting conditions, such as strong backlighting, can give an almost monochromatic look to a scene.

EMOTIONAL IMPACT

Different colours can create different moods and evoke different responses. They also have symbolic significance, which can vary between cultures.

Red signifies danger and excitement, and can suggest anger and violence, as in the phrase 'seeing red'. Red can dominate a photograph even if it consitutes only a small part of the composition.

Blue is a tranquil, calming colour. It suggests freshness and open space, such as the sea or sky. However, it is also associated with coldness and sadness, as when we talk about 'feeling blue'.

Green is another calming colour, which represents nature and suggests freshness and vitality, perhaps because of its association with spring.

Yellow, is a powerful colour that demands attention. When we see yellow, we often think of happiness. It's the colour of the sun, and can have a similarly uplifting effect.

SEEING RED

Even a tiny splash of red in a picture can dominate the composition – the viewer's eye is instantly drawn to it. The tension and drama in this image is created by the contrasting colours of red and green.
Canon EOS 1Ds Mk II, 17–40 f/4L (at 17mm), ISO 100, 1/8 sec at f/16, 2-stop ND grad

COLOUR WHEEL

A colour wheel helps us to understand the relationships between colours. Colours next to each other on the wheel are harmonious, while opposite colours are contrasting.

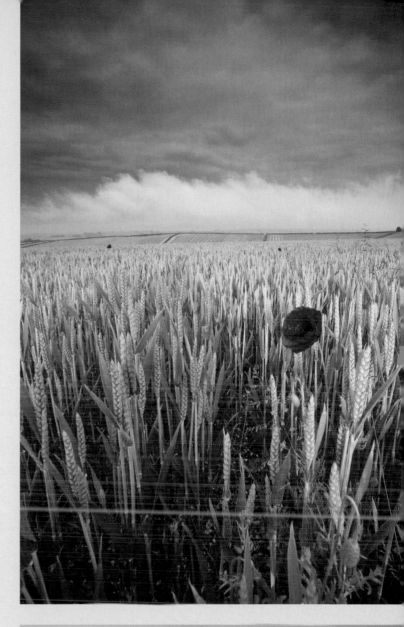

DESATURATED COLOURS

In this image, the light mist has drained much of the colour from the scene, leaving a muted, pastel palette.
Canon 1Ds Mk II, 70–210mm f/4L (at 145mm), ISO 100, 1/20 sec at f/11, 2-stop ND grad

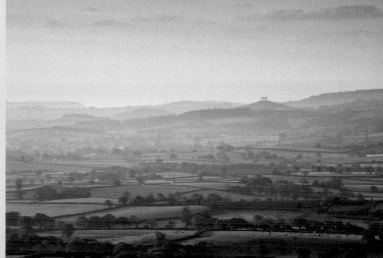

▶ CHAPTER FIVE > **FILTRATION**

When you're on location, the need for filters soon becomes obvious. While some filter types can now be emulated in post-processing, traditional in-camera filters are still essential tools for scenic photography. Polarizing, neutral density and graduated neutral density filters are the key bits of kit you should consider. They are designed for either correction or enhancement, and their effect isn't gimmicky or artificial. Photographers who use slot-in filters will also need to buy a suitable filter holder – it is the hub of any filter system. This chapter offers beginners advice on filter use and which system to buy, and will help existing users realize the full potential of their equipment. Soon you'll be producing beautifully filtered images every time.

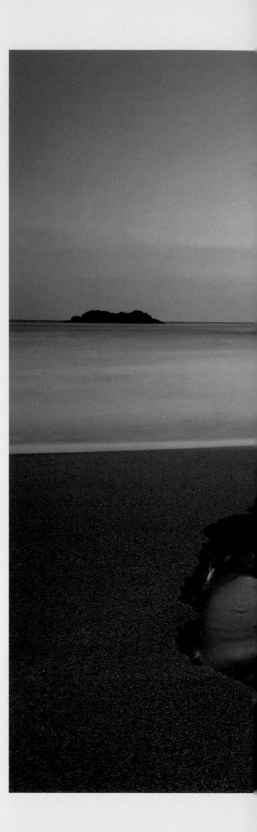

EVENING GLOW
Filtration is an essential tool for the correction and enhancement of landscape photographs. Here, a graduated ND filter and solid ND filter were combined to create an atmospheric image.
Nikon D700, 17–35mm (at 17mm), ISO 200, 30 sec at f/16, 2-stop ND grad, 3-stop solid ND

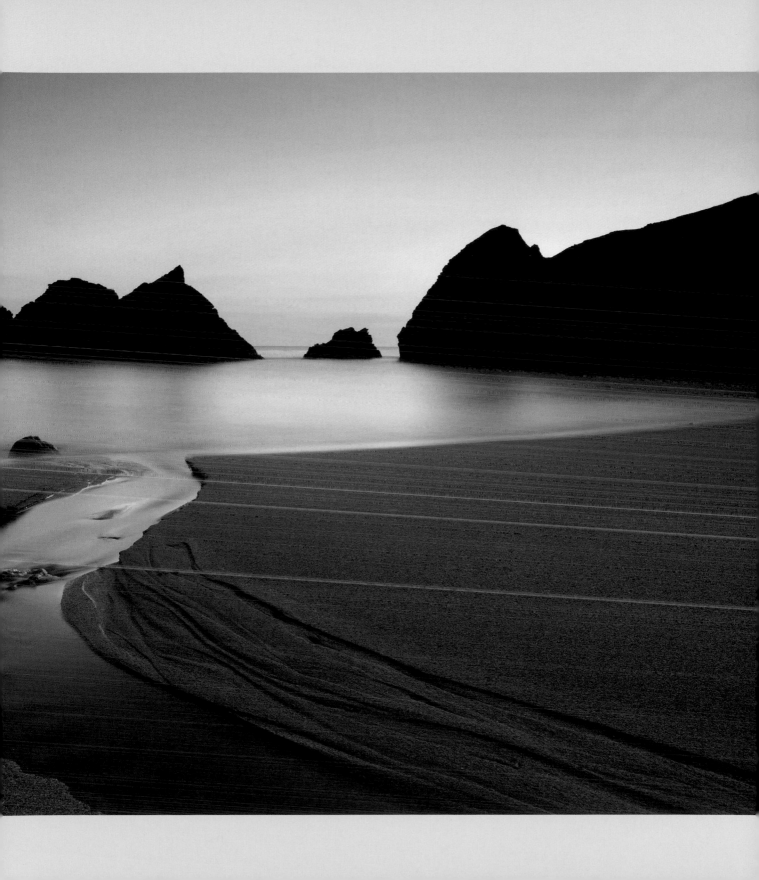

FILTER SYSTEMS

Filters are available in two types – screw-in and slot-in. Screw-in filters are circular in design and attach directly to the front of the lens via its filter thread. Slot-in filters are square or rectangular pieces of glass or optical resin, held in position with a dedicated filter holder. One of the advantages of using a slot-in system is that they make it easy to combine filters; holders are typically designed to hold two, three or even four filters. Graduated filters can only be aligned precisely with the aid of a holder, and a slot-in system allows you to use a collection of slot-in filters on lenses with different diameters, thanks to adaptor rings. Quite simply, a filter holder is an essential accessory for landscape photography.

DOES SIZE MATTER?

You will build your filter system around the brand and size of filter holder you buy, so it is an important decision to make. Typically, slot-in systems are available in three sizes: 67mm, 84/85mm and 100mm. Each has its own advantages and drawbacks, and your choice will be dictated by your individual requirements and budget. To help you make the right choice, let's look at the most common and useful systems on the market.

ADAPTOR RINGS
Using adaptor rings, it is possible to attach your holder and filters to lenses of different diameters. They screw directly onto the lens via the filter thread. A wide range of sizes is available.

67MM – BUDGET SYSTEM

This is the smallest filter system available. It is designed to fit quadrangular filters with a width of 67mm. The most popular system of this size is the Cokin A holder. Cokin produces a range of over 140 different filters in this size alone, so, despite its size, there is no shortage of choice.

This is an entry-level system primarily aimed at photographers using slot-in type filters for the first time. The system is designed for lenses with a diameter no larger than 62mm. To prevent vignetting (reduction in image brightness at the edges of the frame), this system is only recommended for focal lengths of 35mm or more.

The holder and filters are inexpensive, making it a good introductory system. However, its small dimensions will prove restrictive and it won't be long before you will want to combine filters with shorter focal lengths or larger diameter lenses.

84/85MM – AMATEUR SYSTEM

An 84/85mm filter system is a good compromise between cost and versatility and is a popular choice among newcomers to landscape photography. Due to its larger dimensions, this system is compatible with wider focal lengths. Adaptor rings are available up to a filter thread fit of 82mm – more than adequate to cope with the majority of today's larger diameter wide-angles. The risk of vignetting is also reduced. The Cokin P and Hitech 85 holders are the most popular in this size, but other brands like Kood and Singh-Ray also manufacture compatible filters.

Many holders of this size are designed so that a polarizer can be attached directly to the system via an adaptor ring on the front of the holder, or a slot at the rear of the bracket. This makes it possible to combine a polarizer and, say, a graduated filter, while still being able to independently control the position of both – something which isn't possible with smaller systems. Thanks to the popularity of this size, there is a vast range of affordably priced filters to choose from.

100MM FILTER SYSTEM
Lee Filters produces one of the most versatile and popular filter holders on the market. It is customizable and its size means it is compatible with large diameter wide-angles. Due to its quality, the holder, filters and adaptor rings are relatively expensive, but it is an excellent long-term investment.

100MM – ENTHUSIAST SYSTEM

Systems of this size are aimed at the enthusiast, semi-pro and professional markets. Adaptor rings are available to fit large diameter lenses of up to 105mm. Cromatek, Cokin and Hitech are among the manufacturers producing systems of this size. Lee Filters markets one of the most popular 100mm systems, and it is the preferred choice for many scenic photographers. The holder is customizable to suit your own requirements. The filter slots can be adjusted to fit filters either 2mm or 4mm thick, and it is also possible to remove or add slots, up to a maximum of four.

Although vignetting is less likely when using a system of this size, dedicated wide-angle adaptor rings are available; these are designed with a recessed thread to enable the filter holder to be positioned further back. Typically, filter systems of this size will also accommodate a polarizer, either by design or via an optional adaptor ring.

Although more expensive, a 100mm filter system is the most flexible system available and the best long-term investment. If your budget allows, it is highly recommended.

Tip: A larger 150mm system is also now available from the likes of Lee Filters, designed specifically to cater for wide-angles with a protruding front element.

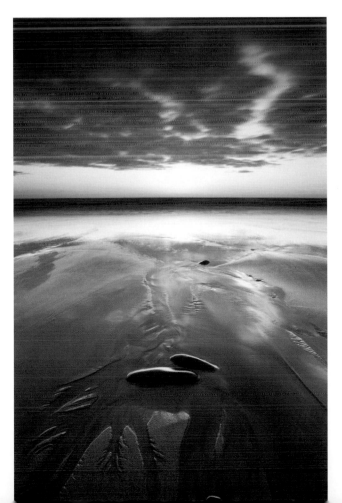

COMBINING FILTERS
A filter holder allows you to combine two or more filters for correction and creativity. In this instance, polarizing and graduated ND filters were used together to photograph this sandy bay.
Nikon D700, 17–35mm (at 20mm), ISO 100, 30 sec at f/16, polarizer, 3-stop ND grad

POLARIZING FILTERS

Polarizing filters are designed to reduce glare and reflections in order to restore natural colour saturation. Their effect is impossible to replicate in post-processing, making them an essential in-camera filter for outdoor photography. Their effect is most pronounced on clear blue skies and foliage, and they are capable of giving your landscape images added vibrancy and life. Quite simply, a polarizer should be at the top of your filter wish list.

HOW DOES A POLARIZER WORK?

Light is transmitted in waves, the wavelengths of which determine the way we perceive colour. Light waves travel in all possible planes through 360°. When they strike a surface, a percentage of the wavelengths are reflected, while others are absorbed. It is these reflected wavelengths that define the colour of the surface. For example, a blue-coloured object will reflect blue wavelengths of light, while absorbing others. Polarized light is different. It is the result of wavelengths being reflected or scattered, travelling in only one direction. It is these wavelengths that cause glare and reflections, reducing the intensity of a surface's colour. The effect is most obvious in light reflected from non-metallic surfaces, such as water, and in light from a clear sky.

A polarizing filter is able to restore contrast and colour saturation by blocking polarized light from entering the lens. Polarizers are circular screw-in type filters, constructed from a thin foil of polarizing material sandwiched between two pieces of optical glass. Unlike other filters, the front of its mount can be rotated. Doing so alters the angle of polarization, adjusting the amount of polarized light passing through the filter. The direction in which wavelengths of polarized light travel is inconsistent, but the point of optimal contrast can be determined by rotating the filter in its mount while looking through the camera's viewfinder. As you do so, you will see reflections come and go and the intensity of colours strengthen and fade. Rotate the filter until you achieve the effect you want.

Some surfaces are unaffected by the polarizing effect – for example, metallic objects, which do not reflect polarized light.

USING A POLARIZER

Two types of polarizing filter are available – linear and circular. If you are using a digital SLR, you should opt for the circular type – the design of linear polarizers affects the accuracy of modern TTL metering systems. They are available in a range of filter thread sizes to suit lenses of different diameters.

Polarizers are best known for their ability to saturate the colour of clear, blue skies. The strength of the effect varies depending on the angle of the camera in relation to the sun's position. The optimum angle (known as 'Brewster's angle') is around 90° to the sun – the area where there is most polarized light. While a polarizer can have a dramatic effect on the colour intensity of images that include blue skies, it has little or no effect on hazy, cloudy skies.

Many photographers invest in a polarizer simply for its ability to intensify blue skies. However, the filter can enhance a wide range of landscapes. By reducing glare reflecting from foliage, it

POLARIZING FILTERS
A Lee polarizer with its filter holder (left) and a Hoya circular polarizer.

is useful when photographing woodland or views of rolling hills or countryside. A polarizing filter will reduce or even eliminate reflections on the surface of water – an effect that can be extremely useful when you are photographing a scene that includes large bodies of water. Equally, you may wish to reduce reflections from wet rocks or sand when shooting coastal images.

WITH AND WITHOUT A POLARIZER
Polarizers don't just saturate the colour of clear skies, they also cut through glare reflected from foliage. A polarizer can make a dramatic difference to an image, giving it vibrancy and life. These two images – without a polarizer (left) and with a polarizer (right) – illustrate the effect.
Nikon D300, 12–24mm (at 14mm), ISO 100, 2 sec at f/20, polarizer (right image only)

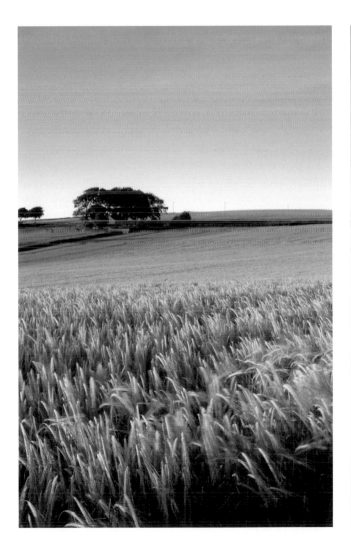

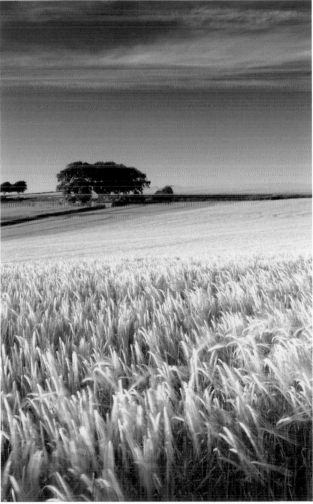

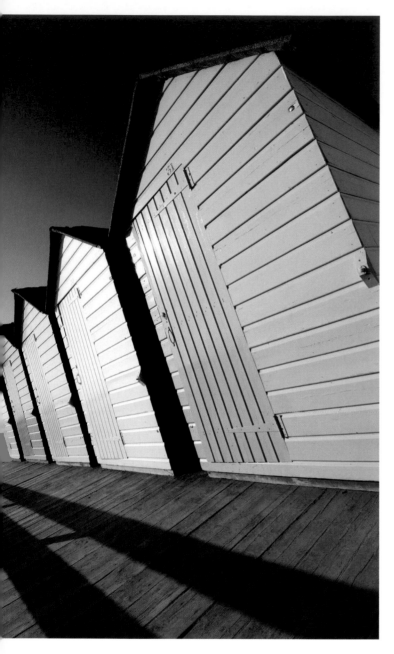

POLARIZATION
The most flattering effect isn't necessarily achieved at full polarization. In this image, the sky looks too dark at the top of the frame. Always use polarizers with discretion.
Nikon D300, 12–24mm (at 12mm), ISO 200, 1/250 sec at f/11, polarizer

POLARIZING PROBLEMS

There are two common problems associated with using polarizers. Both are easy to avoid. Firstly, when you look through the viewfinder, the filter's effect is very seductive – for example, a deep blue polarized sky looks very attractive. However, it is possible to over-polarize a scene. Adjust the level of polarization intuitively, making sure the results look natural. In some situations, a polarizer isn't needed at all, as the sky is already saturated. If you attach one, the sky may look too dark – almost black – in the final image. Over-polarization is a common problem and something we regularly see when critiquing images. Thankfully, you can normally identify the problem when reviewing your images on the camera's LCD screen. Reduce the degree of polarization by rotating the filter and then re-shoot.

The second common problem is uneven polarization. Polarization is at its maximum when facing 90° to the sun and at a minimum at 180°. As a result, when taking pictures at certain angles in relation to the sun, you may find that the colour of clear blue sky will be irregular. The sky in your photograph may darken more noticeably in just one region, because this area of the sky contains more polarized wavelengths. The effect can look rather odd. Wide focal lengths are the most prone to this problem because they capture such a wide expanse of sky. To alleviate the problem, reduce the level of polarization, select a longer focal length or adjust your shooting angle.

Tip: A polarizer has a filter factor (see page 86) of up to two stops of light. Therefore, using the filter will increase exposure length. As a result, it can also be employed as a makeshift Neutral Density filter (see next page).

NEUTRAL DENSITY FILTERS

Neutral density (ND) filters are one of the most useful and creative accessories available, and they are widely used by landscape photographers. They are designed to absorb light, reducing the amount that enters the camera and reaches the sensor. By doing so, they artificially lengthen shutter speeds, allowing photographers to intentionally blur subject motion in landscape shots. When you see their effect and recognize their huge creative potential, you will want to add one to your filter collection.

SOLID NEUTRAL DENSITY (ND) FILTERS

ND filters have a neutral grey coating, designed to absorb all the colours in the visible spectrum in equal amounts. As a result, they should not create a colour cast of any kind – altering only the brightness of light, not its colour. They are produced in a range of densities and are available in both slot-in and screw-in types. The darker the filter, the greater its density and the more light it absorbs. The density is normally indicated on the filter – or mount, if it is a screw-in type. A density of 0.1 represents a light loss of 1/3 stop. Therefore, a 0.3 ND is equivalent to 1 stop. Confusingly, some filter brands mark their ND filters with their filter factor (see page 86) instead. For example, 0.3 and 2× both represent a light loss of 1 stop, 0.6 and 4× are equivalent to 2 stops; while 0.9 and 8× represent 3 stops of light. Higher-density filters generate longer exposures and a more pronounced effect on subject movement. For example, if the camera's original recommended shutter speed is, say, 1/4 sec, exposure time will be lengthened to 1/2 sec, using a 1-stop neutral density filter; 1 sec, using a 2-stop ND filter; or 2 sec by attaching a filter with a density equivalent to 3 stops. This represents a significant shift in exposure, with the potential to drastically alter the look and feel of the final shot. ND filters with higher densities are also available, capable of more extreme effects (see pages 83–5).

MOVEMENT WITHIN THE LANDSCAPE
Neutral density filters are best known for their ability to blur the motion of water, but they can also transform the look of moving cloud. In this instance, I attached a 3-stop ND filter to absorb three stops of light. While this heavily blurred effect is a matter of taste, most landscape photographers agree that a longer exposure will often enhance the original, unfiltered scene.
Nikon D300, 12–24mm (at 20mm), ISO 200, 1 min at f/16, 3-stop ND filter

Neutral density filters are particularly popular among landscape photographers for their ability to blur the movement of running water. Moving water – for example, a waterfall or rising tide – becomes a milky, ethereal-looking blur when you use a long shutter speed. Neutral density filters can also be used to blur the movement of other elements found within the landscape, such as moving cloud, swaying crops and foliage.

Although ND filters affect exposure length, your camera's TTL metering will automatically adjust exposure time to compensate for a filter's density when it is attached.

Tip: ND filters can significantly darken the viewfinder image, making it difficult to compose and focus accurately. Therefore, attach the filter after you have set up your shot.

LONG EXPOSURE NOISE REDUCTION

Image noise consists of randomly spaced, brightly coloured pixels, and is most obvious in images taken at higher ISO sensitivities. However, noise also becomes more pronounced in images taken using long exposures. For this reason, most digital SLR cameras have a Long Exposure Noise Reduction (or Long Exp. NR) function. This is normally accessed via the camera's Set-up menu and is designed for occasions when shutter speeds exceed a certain length, typically 8 seconds. When Long Exp. NR is switched on, images will be processed in-camera to reduce the degrading effect of noise. It works by making a second exposure of the same duration as the first. This can be useful when using ND filters.

BLURRED TREES
An ND filter is useful if you want to blur static subjects by moving the camera during the exposure, creating the impression of motion. This effect can produce striking results, and is best combined with strong, well-defined subjects such as trees. To blur these beech trees, I attached a 2-stop ND filter to lengthen shutter speed and panned the camera up and down during exposure. Nikon D300, 150mm, ISO 100, 1 sec at f/18, 2-stop ND filter

GRADUATED NEUTRAL DENSITY FILTERS

The sky is almost always lighter than the landscape below, and the difference in brightness between the land and the sky can be equivalent to several stops. This contrast in light will often exceed the sensor's dynamic range. As a result, if you meter to correctly expose the sky, the foreground will be too dark; but if you meter for the land, the sky will be overexposed and the highlights will appear washed out. This is a common headache for landscape photographers. The answer to the problem is to use a graduated neutral density filter (often called a 'graduated ND filter' or 'ND grad'). The ND grad is the only in-camera solution to balancing the light in unevenly lit scenes.

ND GRADS

Graduated neutral density filters are half clear, half coated, with a transitional zone where the two halves meet. They work in a similar way to a solid neutral density filters (see pages 79–80). However, a graduated ND filter is designed to block light from only one area of the image, rather than all of it.

ND grad filters are brilliantly simple to use. With your filter holder attached, slide the ND grad in from the top and then, while looking through the camera viewfinder, align the filter's transitional area with the horizon. By using an ND grad of the appropriate density, you can balance the contrast in light and bring the whole

Tip: While coloured grads are also available – including blue, grey, tobacco and coral – their effect can look very unnatural. If you wish to add a colour hue to bland looking skies, it is best done post-capture in Photoshop, where the effect is reversible and can be applied with far more precision.

NO FILTER

1-STOP ND GRAD

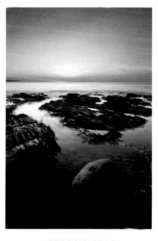
2-STOP ND GRAD

3-STOP ND GRAD

GRADUATED ND COMPARISON
Land is typically darker than sky. For the majority of landscape photographers, the usual method for balancing contrast is to use graduated ND filters. These are available in 1-stop, 2-stop and 3-stop strengths and with either a hard or soft transition, to suit different lighting conditions. Their effect can be better understood by looking at the picture sequence above. In this instance, the 2-stop ND grad produced the correct result.
Nikon D700, 17–35mm (at 18mm), ISO 100, 10 sec at f/16

scene within the sensor's dynamic range – ensuring detail is retained in both the shadows and highlights. The strength of ND grad you require depends on the lighting and effect you desire. (For advice on which density filter to use, see page 79.)

The majority of landscape photographers rely on ND grads for their photography. The alternative is to take two or more differently exposed images of the same scene and blend them together using photo-editing software (see pages 130–3), but this technique involves more time spent at the computer. For those who prefer to get things right in-camera, ND grads are highly recommended.

Like solid ND filters, grads are available in a variety of densities to suit different lighting conditions. Screw-in, circular versions are produced by some manufacturers, but are not recommended. Once screwed onto the lens, the position of their transitional zone is effectively 'fixed', dictating where you place the horizon in your shot and limiting your choice of composition. Slot-in versions are rectangular in design and can be slid up and down in the holder so that you can position the graduated zone precisely, depending on where the horizon is positioned in your photo. Accurate placement of the grad is important – particularly if you are using one with a hard transition. If you inadvertently push the filter too far down in the holder, so that the coated area overlaps the foreground, the landscape will also be filtered and look artificially dark. Equally, if you don't slide the filter down far enough, you will create a noticeable bright band close to the horizon, where the sky isn't filtered. However, positioning the filter correctly is normally straightforward and, with just a little practice, very intuitive.

Tip: ND grads can be combined to create even higher densities; this can be useful when there is extreme contrast between the land and sky. However, although they are intended to be neutral, you may notice a colour cast (typically magenta) when combining budget ND filters.

SOFT- OR HARD-EDGED?

Graduated ND filters are available in two types – hard-edged and soft-edged. Soft ND filters are designed with a feathered edge, providing a gentle transition from the coated portion of the filter to the clear zone, while a hard ND has a more sudden transition. Both are useful, depending on the scene.

Soft grads are better suited to shooting landscapes with broken horizons, as they don't noticeably or abruptly darken objects that break the skyline – such as buildings, mountains or trees. However, only around a third of the filter is coated with its full density before it begins to fade to transparent. This can be a problem, as the brightest part of the sky will usually be just above the horizon, where a soft grad is at its weakest. As a result, to stop this strip of horizon from overexposing, it may be necessary to align the filter lower in the holder so that it overlaps the ground, which isn't ideal.

In contrast, hard grads are designed so that the full strength of their specified density is spread over a greater proportion of the coated area. They can be aligned with far more precision and allow you to reduce the brightness of the sky with greater accuracy than a soft grad. On the down side, they are far less forgiving if you position the filter incorrectly, so use them with care.

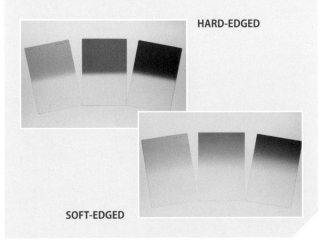

HARD-EDGED

SOFT-EDGED

EXTREME NEUTRAL DENSITY FILTERS

Extreme neutral density filters have quickly become the 'must-have' accessory for landscape photography, with 10-stop ND filters becoming staggeringly popular in a very short space of time. With a filter factor (see page 86) of 10 stops (or 1000×), they enable photographers to slow down exposure to extreme levels – even in bright light, you can employ shutter speeds of a minute or more. The key characteristic of these filters is the effect they have on motion. When you have seen their ability to transform a scene, you too will be placing your order for one.

10-STOP ND FILTERS

By absorbing 10 stops of light, extreme ND filters have the ability to create artificially long exposures, even in good light. In situations where you would normally use an exposure of a fraction of a second, the 10-stop ND filter allows you to use exposures in the minutes. For example, in reducing exposure by 10 stops, a shutter speed of 1/8 sec is increased to 2 minutes with the filter in place. Dramatic changes can take place during a 2 or 3 minute exposure. While the shutter is open, drifting cloud is transformed into brushstrokes of colour; moving water is rendered smooth and glassy, and people or traffic passing through can disappear completely. In fact, extreme neutral density filters are popular among architectural photographers for their ability to capture busy streets and interiors as if they were empty. This is a highly creative filter type; in a word, it will give your images 'atmosphere'.

The density of extreme ND filters is so great that you can see little, if anything, through them. If fact, when you are using one, it is easy to think you've left the lens cap on when you peer through the viewfinder. Therefore, composition, focusing, and any other filtration required, need to performed before the filter is attached. Alternatively, Live View (see page 109) can prove a great aid when using extreme ND filters, often giving a clear enough image on the monitor to allow you to tweak composition and align ND grads without having to remove the filter. This is particularly useful if you are using a circular, screw-in ND, as it prevents you from having to remove the filter before making any adjustments. However, on some camera models, Live View isn't sensitive enough to be of any help. All you can do is try Live View on your camera with the filter in place to see whether or not it will work.

'GREY DAY' FILTERS

Extreme ND filters are often referred to as 'grey day' filters. They work particularly well in constant, overcast light when you are photographing subjects with strong, bold shapes – for example, a pier, lighthouse, groyne or windmill. Even in grey weather, the length of the exposure will transform a textured sky, creating a highly artistic effect that is well suited to monochrome conversion (see pages 134–5). This filter is highly recommended and is one that we regularly use and demonstrate during our workshops.

Tips: Due to the very long exposure required, a sturdy tripod is essential when using 10-stop filters. To prevent shutter speeds becoming impractically long, it is often best to avoid using the lens's smallest aperture – an f/stop of around f/11 is often the preferred choice for this type of extreme exposure.

During such long exposures, light leakage can prove a problem, resulting in ugly flare or strips of light on the image. To minimize the risk, always place slot-in filters in the filter slot closest to the lens and keep the camera's eyepiece covered during exposure.

CALCULATING EXPOSURE

With a huge filter factor of 1000×, calculating exposure and achieving correct results using extreme ND filters isn't always easy. Due to the filter's density, a camera's TTL metering will normally struggle to select the right exposure. Often, the length of the exposure will exceed the camera's slowest shutter speed – typically 30 seconds. Therefore, you may have to do a little basic arithmetic when using extreme ND filters, and you will also need to employ your camera's Bulb setting to keep the shutter open manually.

So how do you calculate the correct exposure? One option is to take a meter reading without the filter attached and then increase exposure time by a factor of 10× – remember, a stop is half or double the exposure value. For example, if the meter reading is 1/15 sec unfiltered, with a 10-stop filter attached it will be 1 min (1 stop is 1/8 sec; 2 stops is 1/4 sec; 3 stops is 1/2 sec, and so on). However, rather than working this out manually, photocopy the chart on the right and keep it in your camera bag. Alternatively, use the calculator on your mobile phone, multiplying the original exposure by 1000. If you own a smart phone, you can even download apps that do all the hard work for you, calculating exposure depending on the strength of the ND filter you are using. NDCalc is one of the most popular – it even counts down the exposure time, sounding an alarm when it is time to end the shot.

For the less technically minded, you can simply take a guesstimated test shot. Review the image and histogram (see page 34) afterwards, and increase or decrease the exposure time accordingly.

FILTER TYPES

Due to the popularity of extreme ND filters, there is a good choice on the market. The most practical type to use is the slot-in version. Lee Filters' Big Stopper is a favourite among professionals. While ND filters of this density are rarely truly neutral, the Lee version only displays a slight cast – typically a cool, blue hue that is easily corrected in-camera using the white balance control, or which can be neutralized in post-processing. Among the circular, screw-in models available, the B+W ND-110 is very good, but the cast is stronger, adding a warm, orange/brown hue to images. Again, it can be corrected relatively easily and the cast is irrelevant if you intend to convert your image to black and white. Not all extreme ND filters have a density of 10 stops. B+W produce a 1.8 ND with a 6-stop density, and 13-stop ND filters are also available. Filter brand Singh-Ray even produces a vari-ND filter – you can alter the filter's density from 2 to 8 stops by twisting the front section of the mount.

UNFILTERED EXPOSURE	EXPOSURE WITH 10-STOP ND
1/500 sec	2 sec
1/250 sec	4 sec
1/125 sec	8 sec
1/60 sec	15 sec
1/30 sec	30 sec
1/15 sec	1 min
1/8 sec	2 min
1/4 sec	4 min
1/2 sec	8 min
1 sec	16 min

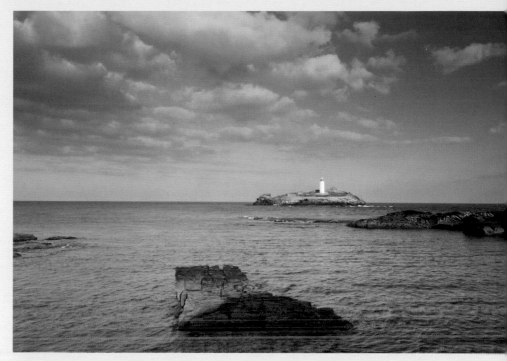

BIG STOPPER

Lee Filters' Big Stopper is one of the most stable and neutral 10-stop filters on the market. It is a slot-in type and is designed with a thin foam gasket stuck to the filter to prevent light leakage during exposure.

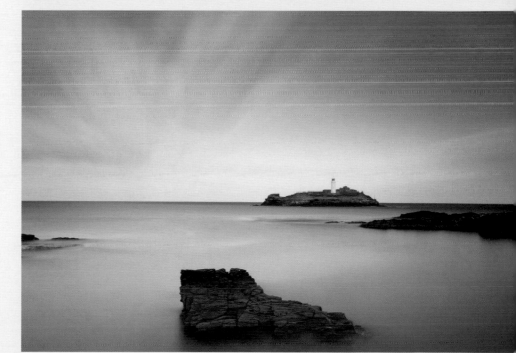

EXTREME EXPOSURES

Ordinary-looking scenes (above right) can be transformed into atmospheric, visually interesting images (right) with the use of 10-stop ND filters. During lengthy exposures, cloud movement is made to look like brushstrokes and even choppy water appears smooth and reflective.
(Above right) Nikon D300, 12–24mm (17mm), ISO 100, 1/8 sec at f/11
(Right) ISO 100, 2 min at f/11, 10-stop ND filter

SKYLIGHT AND UV FILTERS

Although they are subtly different, skylight and UV filters are basically designed to do the same job. Although they appear to be transparent, the filters work by absorbing ultraviolet (UV) light. While mostly invisible to the human eye, UV light can reduce contrast, appearing like a haze in distant landscapes. Although these filters are designed to combat the effects of UV light, in practice they are more commonly used to protect the front elements of valuable optics.

Skylight and UV filters are circular, screw-in filters, which attach directly to the lens via the filter thread. They are designed to block wavelengths of ultraviolet energy that our eyes are unable to detect, producing crisper, clearer images. They are particularly useful when taking images at altitude, when the greater concentration of ultraviolet light wavelengths might otherwise create a cool colour cast. Snow reflects UV light, so these filters are particularly useful in winter and when the atmosphere is cooler.

Although it performs the same task, a skylight filter is tinted with a very weak pink colouring, designed to add a slight warmth to shadows suffering from a weak bluish hue caused by reflected skylight. They are typically available in two strengths, 1A and 1B, with 1B being the warmer of the two grades. Because they are clear, skylight and UV filters have a filter factor of 1× – in other words, they do not reduce the amount of light entering the lens.

PROTECTION

The visual effect of skylight and UV filters is so subtle that they are more commonly employed for protection. As they are clear and relatively inexpensive, they are ideally suited to protecting the front element of lenses from dust, dirt, sand, moisture, greasy fingerprints and scratches, all of which are potentially damaging to the optics and can degrade picture quality. It is much safer to regularly clean a filter than to clean the delicate coated front element of a lens. The UV or skylight filter also offers the front element some protection if the lens is dropped. It is much cheaper to replace a damaged or

UV FILTER
Hoya is among the leading manufacturers of skylight and UV filters. Filters such as this Hoya Super HMC PRO-1 increase resistance to flare and help you to maximize image quality.

scratched filter than to buy a lens, so it can be a wise investment. Many photographers keep a skylight or UV filter permanently screwed onto every lens in their system. However, you should always remember to remove protective filters prior to attaching corrective or creative ones – a polarizer or slot-in holder, for example. If you fail to do this, the risk of vignetting is increased, as the thickness of the skylight or UV filter's mount projects any additional filter further away from the lens. It is also bad practice to attach more filters to your lens than is actually required. By placing several layers of glass in front of your lens, you risk degrading image quality and the likelihood of flare is increased.

FILTER	FILTER FACTOR	EXPOSURE INCREASE
Polarizer	4×	2 stops
ND 0.1	1.3×	1/3 stop
ND 0.3	2×	1 stop
ND 0.6	4×	2 stops
ND 0.9	8×	3 stops
Big Stopper	1000×	10 stops
ND grad	1×	None
Skylight/UV	1×	None

MOORLAND VIEW

Although they are often used simply for protection, skylight and UV filters are designed to reduce atmospheric haze and improve image quality, particularly in the distance. A UV filter was useful for this far-reaching moorland view.
Nikon D700, 21mm, ISO 100, 4 sec at f/16

► CHAPTER SIX > **TYPES OF LANDSCAPE**

For many landscape photographers, the appeal of photographing scenery lies in its huge diversity, with each type of landscape possessing its own individual characteristics and challenges. While many of the same fundamental photographic principles – exposure and composition, for example – can be applied to every type of environment, each has its own unique qualities and requires a different approach. This chapter will ensure that you know what to look for when shooting various different scenes. Whatever the location, the goal is the same: to capture distinctive, original images that communicate the character, essence and atmosphere of the landscape.

LIGHTHOUSE SILHOUETTE
While every landscape type has its own individual qualities and appeal, coastal photography is arguably the most popular. Features like groynes, lighthouses and piers make natural focal points.
Nikon D300, 24–85mm (at 44mm), ISO 200, 1 sec at f/11

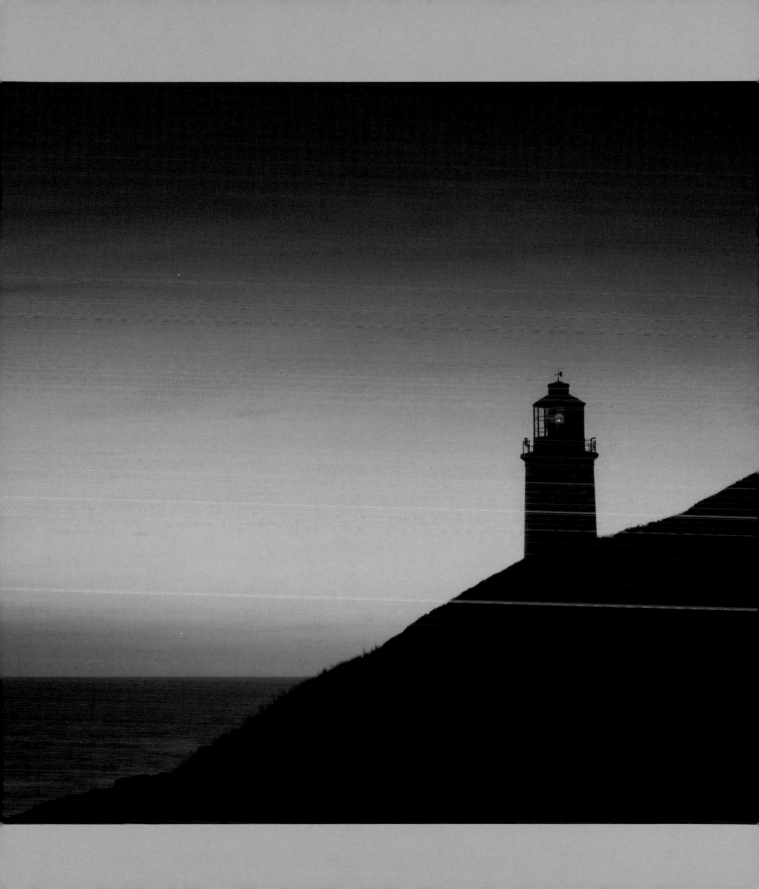

COASTAL

The coastline is a favourite subject for landscape photographers. Its appeal is understandable: water adds motion, depth and energy to photographs, while rocky outcrops, smooth boulders, reflective pools and patterns in the sand create foreground interest. A coastal environment is one of unrivalled picture-taking potential.

When we take workshop groups to the coast, it is interesting to see how photographers interpret the same environment in so many different ways. Some will be drawn to the big vista, while others seek to isolate key detail or interest. The seaside can be photographed in an infinite number of ways. However, that is not to say coastal photography is easy – far from it. When taking photographs in such a large, diverse environment, you will often have to work harder to identify the strongest compositions.

If you live on an island, like the UK, you are never far from the coast. It is a unique environment, which can vary radically within just a short distance. It is a constantly changing landscape – you can visit the same viewpoint again and again, but it will always be different. After each and every high tide, the beach is washed clean, revealing a clean palette for landscape photography.

PLANNING

Plan your visit carefully. First, check the height of the tide. Some locations suit a high or low tide best, and its height will dictate what you can and can't photograph, and from which standpoints. For example, if you know of a certain coastal feature you wish to capture – like a weathered groyne, pier, lighthouse or rocks jutting up through the water – it is important to schedule your visit for a time when the tide is at the right level.

Low tides are normally favoured for photography, revealing large, sandy bays full of picture potential. However, at low tide there is an increased risk of distracting footprints left by walkers, swimmers, surfers and dogs – particularly at popular, easy to reach locations. While a few footprints can be eliminated by adjusting your composition – or removed later using the Healing Brush

THE MINIATURE LANDSCAPE
Don't overlook the 'miniature landscape' when you visit the beach. Swap your wide-angle lens for a standard zoom or short telephoto and isolate the details and textures of rocks, sand, seaweed, pebbles, fishing rope or even driftwood. This type of subject suits low-contrast, overcast lighting and relies almost entirely on good composition, which makes it an excellent discipline. Look for key points of interest that you can place on a dividing third or diagonally in order to create images with depth and impact. Typically, pebbly, rocky beaches provide the most interesting patterns and details. They are also good for capturing atmospheric photographs of water lapping over the shore.
Nikon D300, 150mm, ISO 200, 1/4 sec at f/16, polarizer

POINTS OF INTEREST
Avoid cramming too much into your coastal shots. Locate and isolate key points of interest – for example, a boulder embedded in the sand, wavy sand patterns or reflective pools. To create seascapes that look three-dimensional, use a short focal length and a low viewpoint, and position the camera close to your foreground subject to stretch perspective.
Nikon D300, 12–24mm (at 12mm), ISO 100, 25 sec at f/18, polarizer, 3-stop ND grad

in Photoshop – if there are too many, the picture will be spoilt. Therefore, the best times to photograph the beach are early morning and late evening – and also in autumn and winter. Not only will the beach be quieter, but these times coincide with the best light and conditions for coastal photography. If you're taking photographs in the summer months, when the coast is busy, it is best to visit sandy bays when the tide is decreasing. By doing so, you are guaranteed a clean, photogenic beach, free of footprints.

CAPTURE

The most atmospheric way to capture waves is to use a long exposure. This will blur the water's motion, making it into a milky, ethereal mist. This is easy to do in low light, when exposure time is naturally long. However, it is also possible to artificially lengthen exposure time for artistic effect by attaching a solid ND filter (see pages 79–80). While you should opt for a shutter speed of several seconds if you wish to 'smooth out' the sea, select a faster shutter speed if you want to retain texture in the water. When photographing waves crashing or gushing around foreground rocks and boulders, an exposure of around 1/4 sec is a good choice. At this speed, the water's motion is still blurred enough to look intentional, yet not so milky that the water's texture and detail is lost completely. When taking pictures close to the tide, it is important to push the legs of your tripod firmly into the sand. If you fail to do so, your set-up may move or sink slightly during lengthy exposures, as the tide rushes in and out.

A polarizing filter (see pages 76–8) is useful for eliminating reflections on wet sand – helping to restore its natural colour – and for reducing highlight glare in strong lighting. A polarizer is also handy if you're including rock pools within your composition; rotated correctly, it will help reveal the colour and life within.

Whether you are at the top looking down, or at the bottom looking up, cliffs can make dramatic photographs. They often contain strong colour and texture, and this is emphasized when

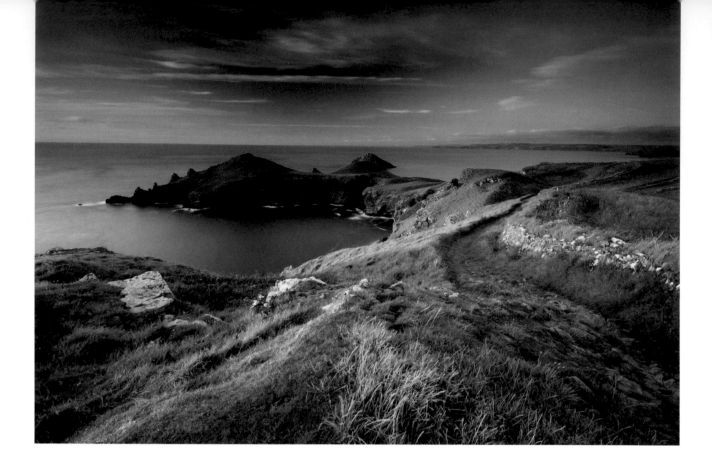

they're illuminated by low, soft sunlight. It can be tempting to always take photographs from the beach, where you are closest to the water and have an array of foreground potential. However, a high viewpoint suits large, far-reaching views of the coastline. Spring is often the best time to shoot from the clifftops, when coastal flowers are in bloom, adding colour and interest to wide-angle views, and headlands look lush and green. Footpaths can be used as a compositional aid, helping to lead the viewer's eye into the photo.

Sea spray and sand are potentially damaging to cameras and tripod legs, so after your visit, remember to clean your kit thoroughly (see pages 20–1). Fine spray can degrade image quality, so while on location you may need to wipe the front element of your lens and filters clean using a dedicated lens cloth. To avoid having to put your camera bag down directly on wet sand, carry a plastic bag to place on the sand first.

CORNISH COASTLINE, UK
While a low tide suits photographs taken from the beach, high tide is better for photographs of harbours, breakwaters and views taken from clifftops. Use a long exposure if you want to 'flatten' the water. A polarizer will help saturate colour. Look for compositional aids, such as footpaths, which can draw the eye into the image.
Nikon D200, 10–20mm (at 10mm), ISO 200, 30 sec at f/18, polarizer, 2-stop ND grad

Tip: For safety reasons, always check tide times before you visit the coastline. Never underestimate the speed, power and force of the sea. It is easy to get stranded on the beach if you're unaware of the tide and are preoccupied by taking pictures. Visit www.tide-forecast.com.

RURAL

The rural landscape is often overlooked by scenic photographers, yet it is full of picture potential. Lush, rolling countryside, picturesque villages, swaying crops, livestock, rustic field-gates and attractive stone walls all add interest and appeal to rural views. However, this is one of the most challenging environments for workshop participants. The best viewpoints tend to be less obvious, and can change dramatically depending on the conditions and time of year.

HARVEST TIME
Harvest is one of the best times of year to photograph rural landscapes. Hay and straw bales make interesting compositional elements and strong shapes, colours and patterns lend themselves to scenic photography. In this image, the warm evening light and stormy sky combine to create an attractive rural scene.
Nikon D300, 12–24mm (at 12mm), ISO 200, 1/4 sec at f/18, 2-stop ND grad, polarizer

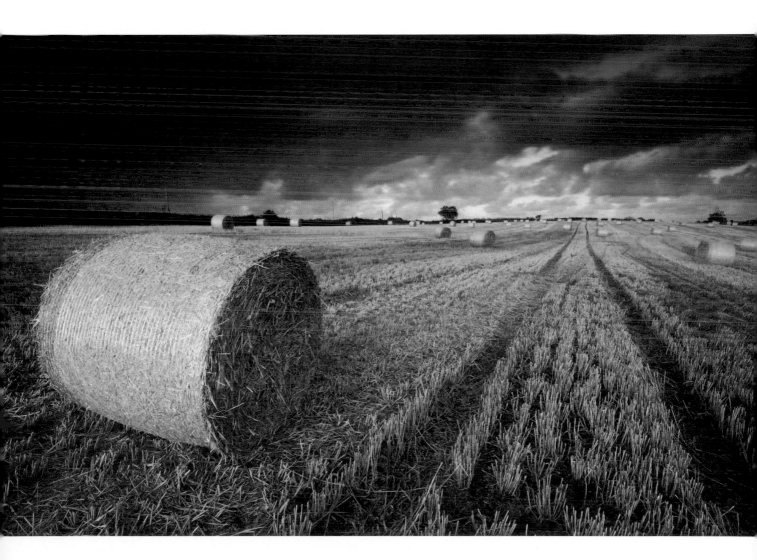

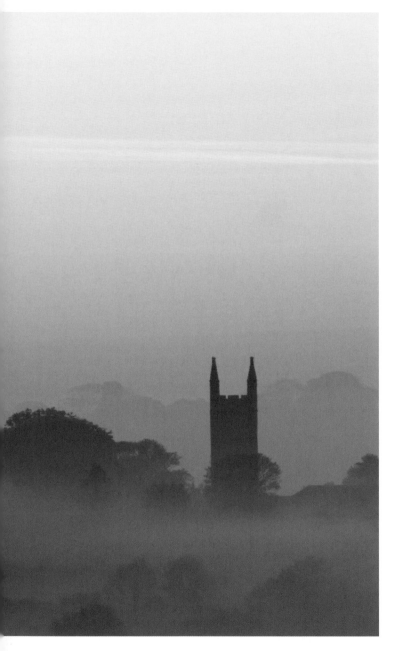

MORNING MIST
*Mist is one of the best weather conditions for rural landscapes,
creating atmosphere and often reducing objects to a simple
silhouette. Look for strong, bold objects within the landscape
– a church tower, skeletal tree or windmill, for example.
Longer focal lengths suit misty conditions best, foreshortening
perspective and allowing you to isolate points of interest.*
Nikon D300, 120–400mm (at 200mm), ISO 200, 2 sec at f/11

THE SEASONS

Arguably, the rural landscape is affected more than any other by the
changing seasons. Awareness of seasonal changes will help ensure
you visit the right location at the most suitable time of year.

Spring is best for colour and new life. Trees are full of blossom
and foliage and young crops are at their vibrant best. Hedgerows
are full of wild flowers and freshly ploughed fields create patterns
that add interest and texture to rural views. After clear, still evenings,
mist may form, filling valleys and hanging atmospherically above
the countryside. Early morning light is crisp, golden and warm – rise
early to capture the best conditions.

Summer is usually considered the worst time of year for
landscape photography. Clarity often drops due to atmospheric haze
and the greens of foliage have lost most of their vibrancy. The days
are long and the light is often poor during daytime. It is best to only
shoot during the 'golden hours' (see page 60). However, summer
flowers, such as poppies, add a splash of colour to rural views. Also,
look for fields planted with oilseed rape, sunflowers, lavender or
corn. Attach a polarizing filter (see pages 76–8) to saturate colour
and, if possible, contrast them against an attractive, blue sky.

The countryside changes dramatically in autumn. Harvest can
be a fruitful time for landscape photography. Fields are scattered
with hay and straw bales. Large, round bales are particularly
attractive, making interesting compositional elements. This type of
graphic, man-made shape is very photogenic. Warm, late evening
light will enhance the scene further, and a short telephoto lens, in
the region of 50–75mm, will help you make the most of it. Later in
autumn, the countryside is transformed again, with foliage changing
from green to warm shades of yellow, red and orange. Include trees
within your compositions to add colour and impact to your images.
In winter, frost and snow transform rural scenes that might look
quite ordinary at other times. Snow or hoar frost clinging to twigs
and branches is highly photogenic, particularly contrasted against
a clear blue sky. Again, a polarizing filter is useful for enhancing
the scene. Snow has a tendency to fool TTL metering systems into
underexposure. Check the histogram screen (see pages 34–5) and
apply positive exposure compensation if required.

COMPOSITION

Regardless of the season or the weather conditions, finding a strong composition is the biggest challenge and the key to successful images. Rural landscapes are often quite busy, chaotic environments, so it is important to keep your images simple by concentrating on just one or two strong elements. Look for subjects within the landscape that will strengthen the composition. Stone walls, roads, tracks and rivers form useful lead-in lines (see pages 44–5). However, make sure that there is also something in the background – like a farm, church steeple or tree – for the eye to settle on. High viewpoints often work best, particularly if there is low-lying mist, as they give you a larger view. Villages nestling in valleys, attractive stone barns, churches, castle ruins, wind turbines and attractive country lanes are ideal subject matter, and help give your shots scale and a focal point. However, while man-made objects often perform a key role in rural scenes, some are better excluded. Pylons and power lines can easily destroy the tranquillity of rural views. Therefore, you will often need to select your viewpoint carefully to ensure you select an angle that excludes unwanted elements. In some instances, changing your lens can solve the problem. Longer focal lengths are suitable if you wish to crop into a scene to simplify composition and leave out unwanted objects. Alternatively, opting for a shorter focal length may be the answer, as a wide angle of view stretches perspective and makes obtrusive objects like pylons appear further away and less distracting in the final shot.

Tip: When photographing crops, attach a solid ND filter to creatively blur their movement as they sway in the breeze. Doing so will add motion and visual interest to your rural views, helping them look less static.

PLANNING

The best landscape photographs rarely happen by accident. Although very occasionally it is possible to go to a location for the first time, chance upon a great viewpoint, discover the light is perfect, and walk away with a great image, it rarely happens that way. The best images are planned and thought through. By researching a locality, visiting potential locations and carefully monitoring the weather, you greatly enhance your chances of succeeding.

Examine maps of the area you wish to photograph and study images of the location – look online and at postcards and tourist brochures from the region. They will give you an idea of the best viewpoints. Try to avoid copying other photographer's viewpoints. When you visit a new location, try to look at it with fresh eyes – ask yourself, what alternative viewpoints are there? If you can, visit and explore an area in advance. Not only will this give you a feel for the location, but it will help you decide on viewpoints and allow you to try different compositions. As a result, you will be able to set up quickly and efficiently when you do visit in the right conditions for photography. Finally, make sure you check the local weather forecast regularly.

When you have researched your location and identified potential viewpoints, you need to time your visit to coincide with the right conditions. The look and mood of a location can alter dramatically in different types of weather. Knowing what the conditions are likely to be will help you decide where and when to go, increasing your chances of returning home with the shots you want.

MOUNTAINS, HILLS AND MOORLAND

If you want to convey a feeling of size, isolation, scale and ruggedness in your landscape images, the best environments to photograph are hills, moorland and mountains. Mountain peaks and large, steep hills look dramatic and imposing in photographs; if you climb to the summit, the far-reaching views they afford can be truly spectacular. Moorland can prove equally photogenic. Again, it is an environment that often boasts large, photogenic vistas, while the windswept, sometimes desolate, scenery helps create images that communicate a true feeling of wilderness.

Mountainous regions offer some of the most spectacular scenery in the world. The Rockies, Alps, Pyrenees and Dolomites are among the most photogenic. Despite the UK's relatively small size, it boasts beautiful mountain scenery – particularly in Scotland, the Lake District and North Wales. For moorland scenery, the Highlands and Dartmoor are favourites among photographers. Today, with travel being so quick and easy, this type of remote landscape is more accessible than ever before.

PLANNING

The best viewpoints often involve long, steep climbs, and it is important to plan carefully. Appropriate clothing and footwear are essential, and never more so than when shooting at higher altitudes. You may be standing around for long periods waiting for the right light – and you are far more likely to be patient and creative if you are warm and comfortable. While dedicated outdoor clothing can be costly, consider it an investment that will benefit your photography. Wearing several thin layers will help keep your body warm, together with a fleece and a windproof jacket. Lined trousers, along with thick walking socks and thermals, will ensure you stay warm in chilly conditions. A hat and gloves are important. Normal gloves are fine while you are walking to or from a location, but they can be too thick to enable you to adjust your camera controls, or attach and position filters. Therefore, when you are actually taking pictures, you may want to wear gloves designed for photography. While they are thinner and not so warm, they will allow you to operate your camera while keeping your fingers covered. Finally, good supportive footwear is vital if you intend to trudge for miles in pursuit of stunning scenery. It needs to be durable, comfortable and able to keep your feet warm and dry. You need footwear that will give your ankles good support if you intend to walk over rough, uneven terrain. Again, it is worth investing in the best you can afford.

If you intend to walk far, carry a detailed map of the area together with a compass, or use a navigational aid such as a handheld GPS unit. Ideally, when taking pictures in remote areas, take someone with you. However, if you are taking pictures alone, always let someone know your location and keep a fully charged mobile phone with you. Also, carry a torch or headlight and a selection of high-energy snack bars in your kit bag.

COMPOSITION

When you reach your desired viewpoint, the skill is to capture images that effectively convey the view's size and magnitude. The best way to do this is to include elements within your composition – such as walkers, a river, a stream or buildings – that provide a sense of scale. While landscape photographers typically try to omit people from their images, a single lone figure, or a couple of walkers, will make the scenery appear more imposing and create a proper sense of perspective. If there isn't anyone available who you can include in the shot, consider moving into the frame yourself, and release the shutter via the camera's self-timer facility. If you do include people in the frame, remember to take images without them too. Then, if you decide you prefer the scene without people in shot, you have left that option open.

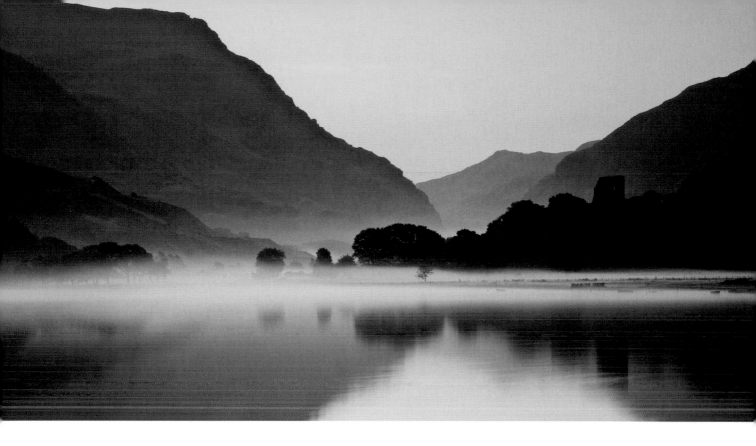

Trees can also add a sense of scale to far-reaching vistas. Windswept trees are particularly photogenic, helping to communicate just how wild the landscape is. Dead or weathered trees are common in moorland, and add a focal point, scale and depth to an image.

TECHNIQUE

When you're shooting from a high vantage point, the weather and lighting will have a big impact on the feel and mood of your images. Side-lighting is often best when photographing mountains and hills, as it emphasizes contours, texture and rugged detail. At higher elevations, the crisp, clear air can create a cool cast, potentially adding a slight blue hue to images. This can be particularly noticeable if there is snow in the shot. Increasing the colour temperature will correct this – you can do this in-camera using the white-balance controls (see pages 36–7) or during processing if you are shooting in Raw format (see page 122).

Hills and mountains often exhibit their own peculiar weather conditions. Thick fog and heavy rain is common, so patience is often required. One of the best times to visit high ground is in winter,

WELSH MOUNTAINS
When photographing hills and mountains, include elements such as people, buildings or trees to help create a sense of scale. This will make the environment appear more dramatic and imposing.
Canon EOS 5D Mk II, 24–105mm (at 105mm), ISO 100, 30 sec at f/11

when there is a covering of snow. Snow needs to be photographed while fresh, clean and brilliant white. Footprints can ruin landscape images, so be mindful of where you walk.

When you are photographing hills and mountains, the use of graduated ND filters (see pages 81–2) to lower contrast is often less practical, as the peaks will break the skyline. If you're shooting an uneven horizon, opt for a grad with a soft transition. Blending exposures (see pages 116–7) may be the most effective way to achieve correct exposures of mountains or hills.

Take care when using a polarizing filter at high altitude. The air is cleaner and the atmosphere thinner, so clear, blue skies will appear naturally saturated. As a result, the risk of over-polarization (see page 78) is far higher.

WOODLAND

Woodland interiors are a popular subject for landscape shots: the light filtering through a canopy of leaves can be dappled, beautifully diffused and atmospheric. However, strong viewpoints that clearly direct the viewer's eye around the image can be difficult to locate. Sometimes you literally can't see the wood for the trees.

COMPOSITION

At first glance, coniferous woodland can look very regimented, with row after row of tall, straight trunks, while ancient woodland seems messy and disorganized, with the woodland floor littered with fallen trunks and stumps. The key is to make use of such elements, organizing them into a composition that has depth and interest. For example, rows of tall, upright trunks can be eye-catching when they fill the frame. A short telephoto or zoom will allow you to crop in tight to the trees, emphasizing their regimented appearance and stature. Results can look graphic and abstract. Mist or fog will soften and diffuse their appearance, adding atmosphere to your images.

Within the woods, you will find a variety of viewpoints, angles and foreground potential. Fallen trunks and branches can act as lead-in lines (see pages 44–5). Rivers and streams can be used as compositional aids, as can tracks and footpaths. Mossy stumps and woodland plants lend themselves to being used as foreground interest – shooting from a low angle with a wide-angle lens will make your foreground look disproportionately large and imposing.

Be creative with your technique and viewpoints. Try moving your camera up or down during the exposure to blur the trees. To do this, select an exposure of around 1/2 sec and move the camera smoothly during exposure. The effect is subjective – you either love or hate the results. It is also a very hit and miss technique, and it can take several attempts to achieve an image you like. Low angles, looking upward, will emphasize the size and height of trees. You can capture striking results by lying on the ground, flat on your back, and using a wide-angle to shoot directly up to capture the leaf canopy and converging tree trunks.

LIGHT

The appearance of woodland varies greatly depending on the light and the time of year. Spring and autumn are usually considered best for woodland photography. Leaves and foliage are at their most vibrant during spring. Swathes of wild flowers, such as bluebells and snowdrops, may carpet woodland floors, adding colour and interest to wide-angle views. Sunlight, bleeding through lush, backlit spring leaves, can bring woodland interiors to life. In autumn, foliage turns from green to a wonderful array of warm hues – it is one of nature's great spectacles. In the UK, the autumnal colours are normally at their peak in late October and early November, but this can vary from year to year and region to region. The window of opportunity, when the colour is at its best, is short.

The best light for woodland interiors is bright, overcast weather. Contrast is low, making it easy to expose correctly. The light is soft and muted and the colours of woodland flowers and foliage are naturally more saturated. That said, the early morning and late evening can also produce magical light for woodland photography. Tall trunks will cast long, dark shadows on the woodland floor, generating foreground interest and depth.

In bright, overhead sunlight, the sun-dappled woodland floor looks attractive to the naked eye. However, the level of contrast in such scenes will often exceed the capabilities of your sensor's dynamic range. With so much contrast, achieving a good exposure can be difficult, if not impossible, which is why it is often better to avoid shooting in midday sun.

Tip: A polarizing filter is the perfect companion for woodland photography. By reducing glare and reflections, it restores natural colour saturation. A polarizer is particularly useful after rainfall, when leaves are wet and reflective.

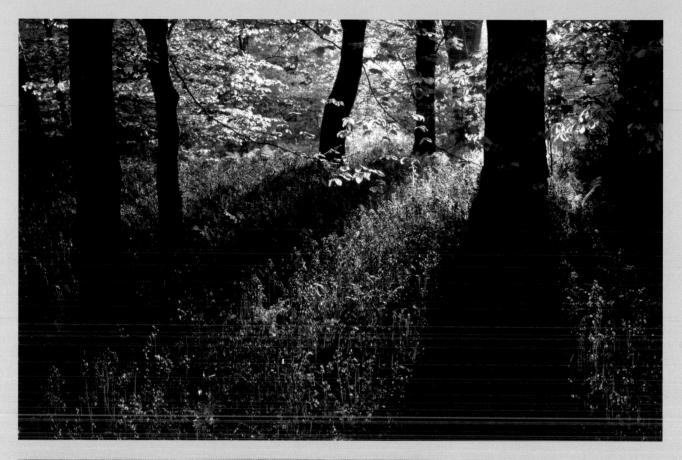

SPRING WOODLAND

(Above) Bright, overcast days suit woodland photography. Contrast levels are naturally low, making accurate metering easier. However, soft, low morning or evening sunlight can add life to woodland images, casting long, dark shadows that give images natural depth.
Nikon D200, 18–70mm (at 46mm), ISO 200, 1/2 sec at f/18, polarizer

FOREST PATTERNS

(Left) Large expanses of trees, growing tightly together, can create interesting patterns. Managed woodland, such as pine and larch, is particularly good for finding vertical patterns.
Nikon D200, 400mm, ISO 200, 1/30 sec at f/11

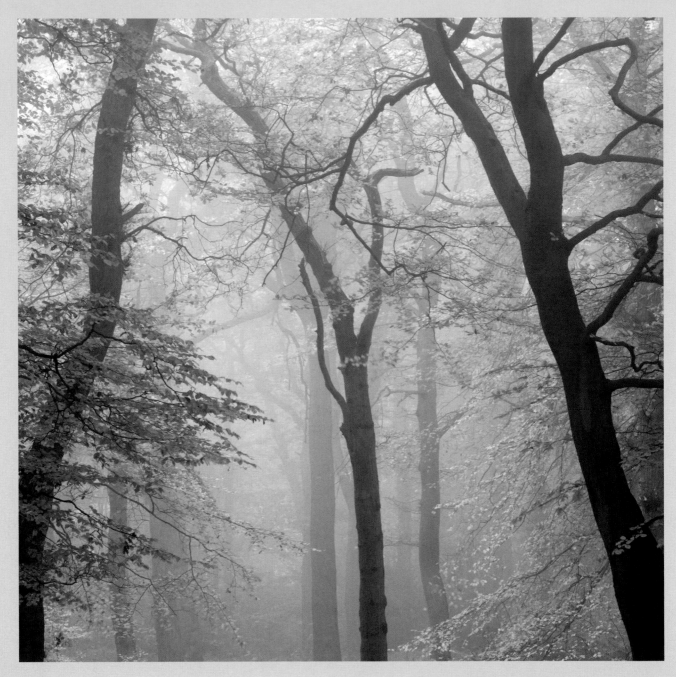

Tip: When photographing autumn scenes, select a warmer colour temperature than is required – this will accentuate warm hues. In daylight, try a Cloudy white-balance setting.

WOODLAND MIST
Mist and fog can really enhance woodland scenes. Longer focal lengths will help you isolate and emphasize the shape and form of the trees.
Nikon D700, 28–70mm (at 70mm), ISO 200, 0.6 sec at f/11

WATER IN THE LANDSCAPE

Water is all around us. It is essential to life, which might explain why we enjoy the sight, sound and feel of it. Landscape photographers are instinctively drawn to water, and rivers, lakes, lochs, ponds, waterfalls and streams all have their unique qualities and appeal. Water has the ability to greatly influence the look and feel of a photograph. It can create a feeling of drama, have a calming effect, or create the impression of motion, while strong reflections create symmetry and entice the eye. It is a compelling subject, which can aid composition and add a different dimension to your images.

You rarely have to travel far to find water within the landscape. In hilly and mountainous regions, waterfalls are common, while rivers and streams meander through the countryside. Waterways and canals are common in rural areas, and large bodies of water, such as reservoirs and lochs, are widespread. Water in all its forms is an important compositional tool. For example, a river or stream, winding its way through an image, will enhance the picture's depth and interest – this works particularly well when you take the shot from an overhead bridge or riverbank. It will form either a lead-in line or an 'S' curve, creating a natural entry point and directing the viewer's eye through the shot to the vanishing point. Arguably, no other subject is quite as effective in doing this.

While rivers, streams and reflective pools work well as a compositional element, larger bodies of water work best as the dominant feature – particularly on calm, still days when water

EARLY MORNING REFLECTIONS
Water provides an obvious entry point to this image. The estuary snakes through the scene and its stillness adds a feeling of tranquillity. The reflections add interest and mood, while the boats add scale and a focal point.
Nikon D700, 150mm, ISO 200, 13 sec at f/13

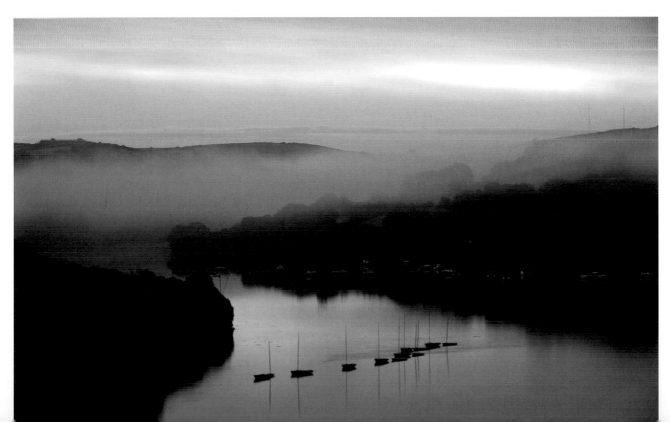

reflects its surroundings. Mirror-like reflections are most appealing when strong colours are evident – a dramatic sunrise or sunset, for example, or when water is reflecting vibrant autumn colour. To add scale and context to images in which water is the main element, try to include foreground objects that balance the scene. Rocks, tall reeds, a jetty or rowing boats all work well.

The rule of thirds (see page 40) states that you should avoid placing the horizon centrally in the frame, but a reflected landscape is one of the exceptions – a centred horizon will produce a more symmetrical result, enhancing the strength of the composition. A calm, windless day is required to shoot reflections and dawn is often the best time. After clear, still nights, mist can form, hanging attractively above the water and adding yet more visual interest and atmosphere to your photographs. Water can look magical in low light (see pages 118–9), so set your alarm for before sunrise.

Tip: Fast-moving, frothy water can appear white, and, in bright daylight, it can 'burn out' (overexpose). Overcast light is often best for photographing water movement. Contrast levels are lower, and it is also easier to select a long enough exposure to blur motion creatively.

WATER MOVEMENT
Arranging your composition so that a river or stream enters from either the bottom-left or bottom-right corner will often create the most effective result.
Nikon D300, 12–24 (at 18mm), ISO 200, 20 sec at f/16, polarizer

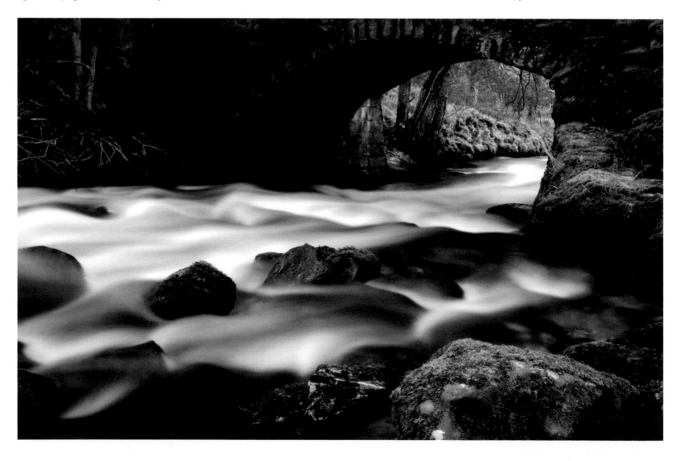

FREEZE OR BLUR?

To freeze the movement of a gushing river or waterfall, you need a shutter speed of 1/500 sec or faster. However, this is rarely practical when shooting landscapes, as you will usually want to prioritize a small aperture and low ISO. Therefore, most photographers go to the opposite extreme and opt for a long exposure to blur the water's flow. Not only is this usually the more practical option, but the effect is considered by most to be more aesthetically pleasing. An exposure longer than 1/2 sec will render moving water as an ethereal, milky white blur. Achieving an exposure of this length is usually easy enough in low light using a small aperture. However, if you need to artificially increase the shutter speed, attach a solid ND filter (see pages 79–80). A polarizer (see pages 76–8) can also be used to lengthen exposure, but be aware of how this filter can affect reflections.

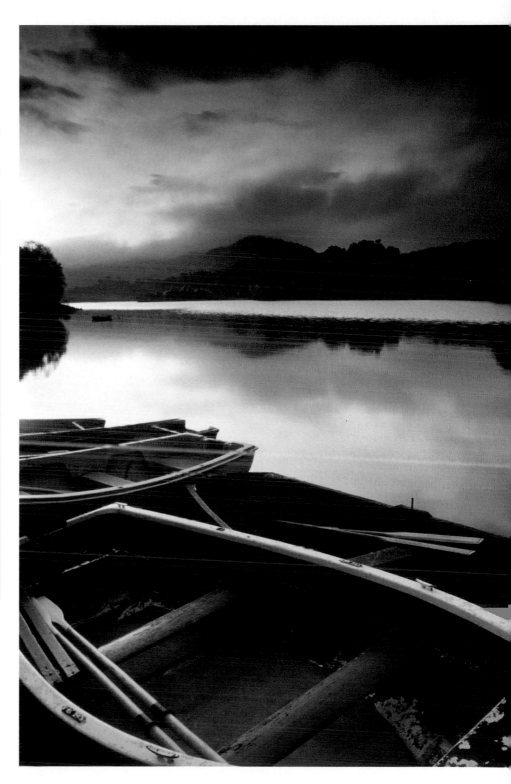

LOCH AND ROWING BOATS
Shoot large bodies of water on calm, still days. The water will be mirror-like, adding a new dimension to your landscape images. Look for foreground objects that add interest and depth, like rocks, a jetty or rowing boats.
Nikon D70, 18–70mm (at 20mm), ISO 200, 1 sec at f/18, polarizer, 2-stop ND grad

BUILDINGS WITHIN THE LANDSCAPE

Buildings are excellent subjects for photography, adding scale and context, interest, character, romance or even nostalgia to landscape images. Urban photography is a popular subject, and both vintage and modern architecture are highly photogenic. However, architectural photography is a completely different genre, in which the buildings, rather than the views, are the main feature. In the context of landscape photography, buildings are usually used to add focal points, interest and depth to vistas.

COMPOSITION

Buildings can be photographed in numerous different ways – for example, in frame-filling close-up, highlighting style and design, or by employing an unusual shooting angle. Alternatively, you can use a telephoto lens to isolate small areas of architectural interest, such as a doorway, window frame or archway. To give buildings context, it is best to include a large slice of their environment in the shot. By doing so, you can convey a true feeling of where they are situated and how they relate to their surroundings.

Certain types of building are more photogenic than others. Old, easily identifiable structures, such as castles and churches, provide an obvious focal point in wide-angle views. Often they don't even need to be very large in the frame to act as a 'harness' within the composition – for example, a church spire somewhere in the distance may be enough to provide the visual interest required. However, if a building is particularly interesting, you may wish to feature it more prominently, making it the main focus of your shot. Of course, the drawback of photographing well-known, photogenic buildings is that many other people will have done so before. Finding original viewpoints can be a challenge; after all, there are only so many ways that you can photograph the same landmark. However, by studying maps and exploring the location by car or on foot, it is often possible to find an original viewpoint.

On the other hand, don't dismiss the most popular viewpoints out of hand. Often, a viewpoint only becomes a cliché because it is the best, most natural, vantage point for photography. Ignoring a popular viewpoint just for the sake of being different is a mistake. You will need to work harder, though – try to include unusual light or use a creative technique to ensure your images stand out from others taken from the same spot. Visit when the light and sky are dramatic, or maybe in visually interesting weather conditions, such as mist or snow. Try using an extreme ND filter (see pages 83–5) to generate an artificially long exposure that will blur cloud movement, so your results don't look static. Shoot in low light or even at night, if the building is floodlit. Small buildings, like follies, mine shafts and ruins, suit the 'painting with light' technique, in which you manually illuminate your subject using a flash or torch during a long exposure in semi-darkness.

LIGHT

Light is an important consideration when photographing buildings. Their appearance will alter as the position of the sun changes, often creating a whole new perspective. Light and shade emphasize a building's shape, form and design. Buildings that are east-facing receive most light in the morning, while west-facing structures will be lit in the afternoon. As with any type of landscape, planning and research are essential to maximize your chances of success. Ideally, visit the location beforehand, and at different times of the day, to observe how the changing light affects the building and its surroundings. The golden hours (see page 60) will often provide the best light, giving buildings a warm, attractive glow.

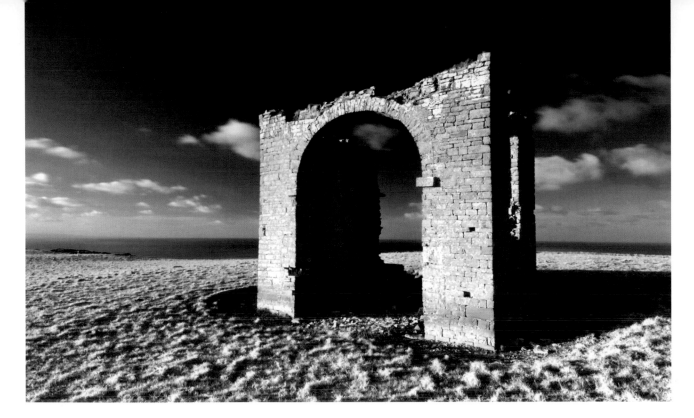

RUINED FOLLY
Images of old, decaying buildings and ruins often suit conversion to black and white. Don't overlook the possibility of converting during post processing (see pages 134–5).
Nikon D90, 12–24mm (at 14mm), ISO 200, 30 sec at f/22, 3-stop ND grad, polarizer

CONVERGING VERTICALS

When using a wide-angle lens to shoot buildings, you may notice a phenomenon known as converging verticals – a type of perspective distortion which can result in structures appearing to lean unnaturally. You can minimize the effect by keeping the camera parallel to the subject – which may require you to move further away and use a longer focal length – or by using a perspective control (or 'tilt and shift') lens. Often, neither option is practical or possible. Thankfully, this type of distortion can be corrected in post-processing. Most Raw image converters include a Lens Correction Filter, which is quick, easy and intuitive to apply; the Transform tool in Photoshop is also very effective. The method for using the latter is as follows:

1 Open the file in Photoshop and select the entire image by clicking Select > All.

2 Display the grid by clicking View > Show > Grid.

3 Go to Edit > Transform > Perspective. Eight small squares will appear around the edges of the image. Click and drag the corner squares until the sides of the building appear parallel and 'natural'.

4 When you're happy with the correction, press Enter or double-click on the image to apply the changes.

Tip: You may need permission to photograph certain buildings. If you want to take pictures on private property, always obtain permission first – particularly if you intend to market the results. Avoid including government or military buildings in your shots, and take particular care when photographing buildings in a foreign country.

ADVANCED TECHNIQUE

As you gain experience and expertise, your demands as a photographer increase. You become more selective, taking fewer images as you wait patiently for the ideal conditions and seek out the perfect composition. And as your standard improves, you look for new ways to refine your photography. You will want to learn and apply techniques that help maximize image sharpness and optimize picture quality – such as exposing to the right (see pages 112–3). You may also want to be more creative, perhaps experimenting with black and white (see pages 114–5) or shooting in low light (see pages 118–9). In this chapter we will introduce you to a range of advanced techniques. They are primarily aimed at more experienced photographers, so if you don't yet feel you are ready, skip this chapter and return to it later.

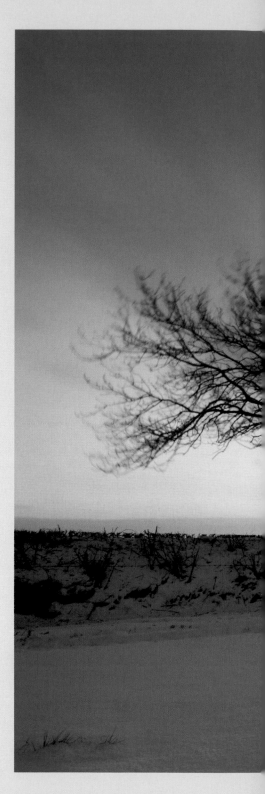

WINTER EVENING
Good technique will help you make the most of every picture-taking opportunity. Exposing to the right and using the hyperfocal distance help to maximize image quality.
Nikon D700, 17–35mm (at 17mm), ISO 200, 20 sec at f/16, solid ND filter

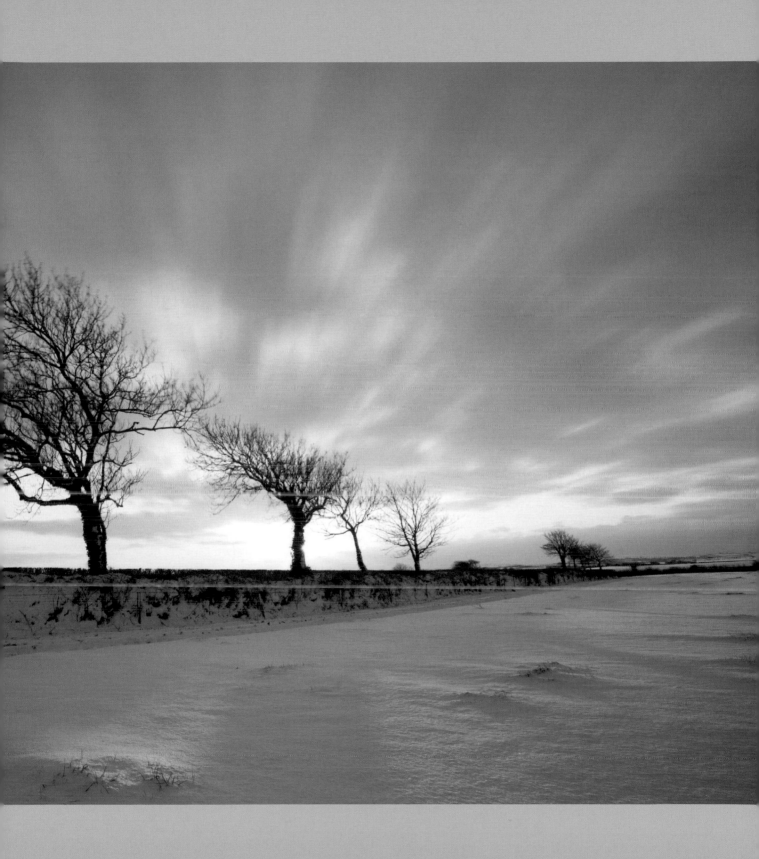

HYPERFOCAL DISTANCE

The hyperfocal distance technique is used to maximize the available depth of field at any given combination of aperture and focal length. Careful use of the technique will ensure that you never waste any of the depth of field that is available to you.

USING HYPERFOCAL DISTANCE

A lens can only focus precisely at one given point; sharpness gradually decreases either side of this distance. Depth of field extends approximately one-third in front of this point of focus and two-thirds beyond it. If you're new to photography, it is normally enough just to focus approximately one-third of the way into the scene. However, more experienced photographers who wish to leave nothing to chance – and who require the maximum depth of field possible – should always try to focus on the hyperfocal distance. The hyperfocal distance is the precise focal point at which the depth of field is maximized for any given aperture. When a lens is correctly focused on the hyperfocal point, depth of field will extend from half this distance to infinity.

This technique is not as complicated as it might seem. In fact, if you are using a prime lens with good distance and depth-of-field scales on the lens barrel, it could hardly be easier – you simply align the infinity mark against the selected aperture. However, few modern lenses, particularly zooms, are designed with adequate scales, so photographers have to calculate and estimate distance themselves. Thankfully, there are several depth-of-field calculators and hyperfocal distance charts available online (see page 172), which make this process far easier. You can even buy hyperfocal distance apps for smart phones – simply enter the f/number and focal length and the app will calculate the distance for you.

Alternatively, on the opposite page are two hyperfocal distance charts that cover a range of the most popular focal lengths, at various apertures, for both full-frame and APS-C sensors. Copy the chart relevant to your camera type, laminate it and keep it handy when composing and focusing your shots.

DISTANT ISLAND
I took this image using a 12–24mm zoom lens at 15mm, on a camera with an APS-C sensor, at f/16. Using the chart opposite, I knew the hyperfocal distance for this combination was 2.5ft (0.8m). I focused the lens manually to this distance and took the shot, confident that everything from half this distance to infinity would be recorded in acceptably sharp focus.
Nikon D300, 12–24mm (at 15mm), ISO 200, 10 sec at f/16, 2-stop ND grad, 3-stop ND grad

HYPERFOCAL DISTANCE CHARTS

These charts show the hyperfocal distance for each given sensor type, focal length and aperture. When you have focused on the predetermined distance, do not adjust focal length or aperture until you have taken the shot – if you do so, you will need to recalculate. Using this technique, everything from half the hyperfocal distance to infinity will be recorded in acceptably sharp focus.

HYPERFOCAL DISTANCE (ft/m) – APS-C SENSORS

	12mm	15mm	17mm	20mm	24mm	28mm	35mm	50mm
f/8	3.2/1	5/1.5	6.4/2	8.9/2.7	12.6/3.8	17/5.2	27/8.2	55/16.8
f/11	2.3/0.7	3.5/1.1	4.5/1.4	6.2/1.9	9/2.7	12/3.7	19/5.8	39/11.9
f/16	1.7/0.5	2.5/0.8	3.3/1	4.4/1.3	6.4/2	8.6/2.6	14.5/4.4	27/8.2
f/22	1.2/0.4	1.9/0.6	2.3/0.7	3.2/1	4.5/1.4	6/1.8	9.5/2.9	19.2/5.9

HYPERFOCAL DISTANCE (ft/m) – FULL FRAME SENSORS

	16mm	20mm	24mm	28mm	35mm	50mm
f/8	3.8/1.2	5.6/1.7	8/2.4	11/3.4	17/5.2	35/10.7
f/11	2.6/0.8	3.9/1.2	5.8/1.8	7.8/2.4	12/3.7	25/7.6
f/16	1.9/0.6	2.9/0.9	4/1.2	5.5/1.7	8.5/2.6	17.5/5.3
f/22	1.4/0.4	2/0.6	2.9/0.9	3.9/1.2	6/1.8	12.5/3.8

Frustratingly, even when you have calculated the hyperfocal distance, it can be difficult to focus your lens to a specific distance because many modern lenses have rather perfunctory distance scales – for example, a lens may only have 0.3m, 0.5m, 1m and infinity marked on its distance scale. This is inadequate and, as a result, photographers often have to employ a degree of guesswork when adjusting focus. However, the hyperfocal point is often less than 12ft (3.7m) away, and many people can judge distance fairly accurately within this range. Therefore, if you know the hyperfocal point is at, say, 6.4ft (2m), look for an object which is approximately that distance away, focus on it, and then don't adjust your focus until after you've taken the shot. While this method isn't 100% precise, it is close enough. When selecting the hyperfocal distance, it is worth allowing a little margin for error, by focusing slightly beyond the exact hyperfocal point.

It is good practice to employ hyperfocal focusing whenever possible. It is particularly important when shooting images that include nearby foreground interest. However, the technique is less relevant if there is nothing in the immediate foreground.

LIVE VIEW

Live View is an increasingly common function on DSLRs. Put simply, it allows you to use your camera's LCD monitor as a viewfinder. This is made possible by the camera continuously and directly projecting the image onto the screen, via the sensor. This aids composition and focusing. You can also zoom into specific areas of the projected image to fine-tune focus. This is ideal when you want to position your point of focus with maximum precision – when focusing on the hyperfocal distance, for example. Live View is also useful when composing images from a high or low viewpoint, when it isn't easy or practical to look through the viewfinder itself. Also, in combination with the use of your camera's depth-of-field preview button (see page 30), Live View allows you to accurately review the extent of depth of field achieved at any given aperture.

MAXIMIZING IMAGE SHARPNESS

Newcomers to landscape photography are commonly advised to select a small aperture and use a tripod in order to capture consistently sharp images. It is good advice, but this alone will not maximize image sharpness. As your demands as a photographer grow, you become more discerning. Capturing images which are simply 'in focus' just isn't enough – you require critical sharpness, particularly if you want to enlarge your images for printing or hope to have them published. By selecting the lens's optimum aperture, and releasing the shutter remotely using the camera's Mirror lock-up facility, you will achieve the level of sharpness you crave.

LENS DIFFRACTION

It is often presumed that by selecting the smallest available aperture – typically f/22 – you will produce the sharpest result, due to the enhanced depth of field. It is a logical assumption and the reason why some landscape photographers instinctively shoot all their scenic images using their lens's minimum (smallest) f/stop. This is a mistake, though. An optical effect known as diffraction softens the overall image quality of photographs taken using very small apertures. Why? Well, when image-forming light passes through the aperture, the light striking the edges of the diaphragm blades tends to diffract, or scatter. This reduces image sharpness. At larger apertures, the amount of diffracted light is only a small percentage of the total amount striking the sensor. However, as the aperture is stopped down (reduced in size), the percentage of diffracted light effectively grows much higher. Therefore, even though depth of field increases, image sharpness deteriorates.

To maximize image sharpness, we encourage photographers to employ their lens's optimum aperture – the f/stop that suffers least from diffraction. To some extent, this will vary depending on the quality of the lens itself. The more perfect the aperture 'hole', the less light will be dispersed – do your own lens tests by shooting a series of images, taken at different apertures, and enlarge a small segment of each to compare them.

MIRROR LOCK-UP

Using your camera's Mirror lock-up function is another way to ensure that your images are as sharp as they can possibly be. Mirror lock-up works, as the name suggests, by locking up the reflex mirror before the shutter is fired. This eliminates any internal camera movements that may be caused by the mirror swinging abruptly up, and out of the light path, just prior to the shutter opening. The internal vibrations generated by 'mirror slap' can degrade image sharpness, so it makes sense to lock up the mirror first, wait briefly for any vibrations to fade, and then fire the shutter.

When you use Mirror lock-up, two presses are required to take the picture – the first press locks up the mirror; the second takes the image. When the mirror is in the locked-up position, the subject will no longer be visible through the viewfinder. Therefore, composition and focusing must be completed before the function is activated. Although not all entry-level models have this facility, Live View can be employed to do the same job – when Live View is activated, the mirror is placed in the 'up' position. Used in conjunction with a remote cord (see page 18), the Mirror lock-up function will give you the sharpest images possible.

MIRROR LOCK-UP
On some DSLRs, the Mirror lock-up function is accessed via a dedicated button or dial setting (as shown here); on others, via a menu setting.

The effects of diffraction create a conflict of interest for scenic photographers. Traditionally, when shooting landscapes, you prioritize a small aperture to generate front-to-back sharpness. However, while an f/stop of f/22 or f/32 will maximize front-to-back sharpness, it exaggerates the effects of diffraction. The gain in depth of field will often not be sufficient to offset the enhanced level of diffraction. Therefore – as is often the way in photography – you have to compromise.

On cropped-sensor digital SLRs, f/11 is generally considered to be the smallest aperture that remains diffraction-free. If you are using a full-frame model, you can normally stop down to f/16 without the effects of diffraction becoming too apparent. An aperture in the region of f/11 or f/16 should still provide sufficient depth of field for the majority of scenes, particularly if you use the hyperfocal focusing technique (see pages 108–9). However,

as always, assess every opportunity individually. For example, if a foreground object is positioned very close to the lens, you may have to prioritize a larger depth of field. Equally, if you wish to generate a lengthy exposure in order to create subject motion, you may want to select a very small aperture. It is a trade-off; only you can decide what your priority is in any given situation. However, in order to maximize image sharpness, always employ your lens's smallest 'diffraction-limited' aperture.

MAXIMIZING SHARPNESS
To consistently capture bitingly sharp results, use a tripod, focus on the hyperfocal distance, select your lens's smallest diffraction-limited aperture, attach a cable release and use your camera's Mirror lock-up function (see box).
Nikon D200, 12–24mm (at 12mm), ISO 100, 1/2 sec at f/14, polarizer, 2-stop ND grad

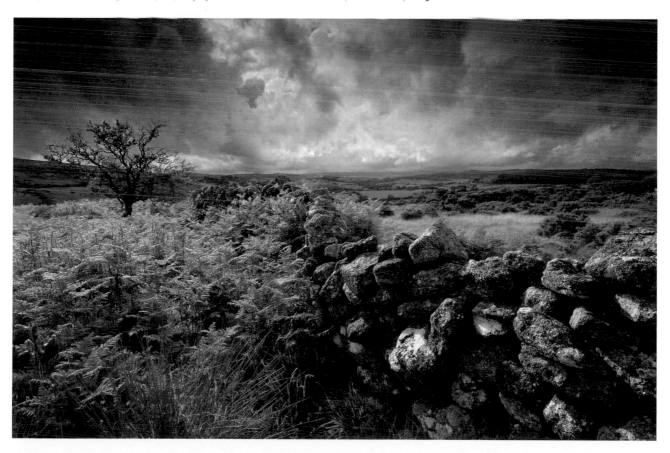

EXPOSING TO THE RIGHT

With digital technology, achieving the correct exposure is easier than ever before. Metering systems are becoming more intelligent, and the ability to review an image – and its histogram (see pages 34–5) – immediately after capture allows you to quickly correct exposure errors such as clipping and blown-out highlights. However, when you shoot in Raw (see page 122) – which is the format we recommend – there is another technique known as exposing to the right (ETTR), which squeezes even more image quality from your camera's sensor, generating larger, higher-quality Raw files.

MAXIMIZING FILE QUALITY

ETTR is a relatively straightforward technique, though applying it precisely requires care. Put simply, it requires you to expose a scene so that the histogram is pushed up as close as possible to the right side – but not so far that the highlights become clipped. Doing so will produce a file that contains more tonal information and which suffers less from the degrading effects of noise (see page 80). To understand how this is possible, you first need to understand a little more about the properties of digital imaging sensors.

CCD and CMOS chips are linear devices, and this has important implications for exposure. Typically, a digital camera is able to capture six stops of dynamic range. The majority of today's digital SLRs can capture a 12-bit image file, capable of recording 4,096 tonal levels – the higher the number of tonal levels available, the smoother the transitions between the tones in an image will be. However, these tones are not spread evenly throughout the brightness range of the sensor. While you might assume that each stop in the six-stop range would record an equal number of tones, this is not the case. In fact, each stop records half the light of the previous one. For example, half the tonal levels are devoted to the brightest stop (2,048); half of the remainder (i.e., 1,024 levels) are devoted to the next stop, and so on. As a result, the last and darkest of the six stops only contains 64 brightness levels. Therefore, if an image is underexposed, and you brighten the image

in processing, the tonal transitions will not be as smooth and the risk of posterization (abrupt changes in tone and shading) is greatly increased. However, if you record more data in the brighter stops, you will capture far more tonal information. This is easy to illustrate by simply taking two images – one taken at a 'normal' exposure and the other exposed to the right. Compare the file size: the difference can be several megabytes. The ETTR image is larger because it contains more data.

To get the most out of an ETTR file, good processing technique is essential (see pages 128–9). The unprocessed ETTR Raw file will seem very bright and will often lack contrast. In fact, the image can look awful when reviewed on the camera's monitor – but don't let this put you off. When the exposure, brightness and contrast are adjusted in your Raw processing software, the image will look correct. While ETTR requires more time, thought and effort, the final result is an image that contains more tonal information and displays smoother tonal transitions.

Another key benefit of ETTR is that it produces cleaner, less noisy images. To some degree, noise is present in all digital images, even those taken at low ISOs. However, it is most obvious in the shadow areas. By biasing the exposure towards the highlights, noise is kept to a minimum.

Tip: Very bright highlights, such as the setting sun, or bright, reflected 'specular' highlights, will blow unless you severely underexpose the whole image. Therefore, it's best to ignore them and push exposure in the rest of the scene to the right to capture as much picture information as possible.

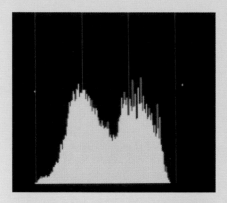

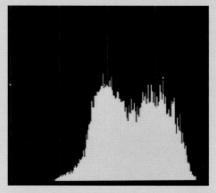

HISTOGRAM COMPARISON
(Far left) A normal 'centred' histogram, with the majority of the information in the centre of the scale.
(Left) A histogram from an ETTR image shows more information on the right side, but does not go over the right-hand edge.

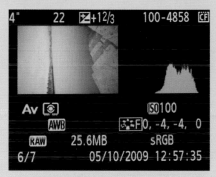

PARAMETERS
Same scene, same lighting, same exposure, but the histograms are radically different. The first image (far left) is the histogram generated when all processing parameters (saturation, contrast, etc) were boosted. The second shot was taken with these parameters at their lowest settings. The histogram for the first image incorrectly indicates overexposure.

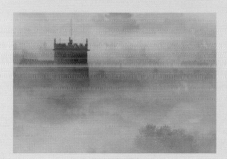

MISTY MORNING
Shot within seconds of each other, the crops from these two pictures help illustrate the benefits of ETTR. The first image (far left) was exposed to give a centred histogram, while the second was exposed to the right. Both images were processed to look as similar as possible, but the ETTR image (left) displays less noise, smoother tones and greater detail.
Canon EOS 5D Mk II, 24–105mm (at 105mm), 1/125 sec at f/11, ISO 100

SHOOTING PARAMETERS

To expose to the right successfully, you need to interpret the histogram displayed on your camera's review screen. However, this histogram is not based on the Raw data, even when you are shooting in Raw mode – it is based on a simulated JPEG. Therefore, it reflects the shooting parameters set on the camera. This can be misleading – often a histogram which indicates that you can't push exposure any further without clipping the highlights can actually be pushed further still. To achieve a histogram that most closely reflects the Raw data, you need to turn the camera's processing parameters to their minimum levels. The resulting images will look poor on the LCD screen, lacking contrast and colour saturation. However, the aim of ETTR is not to produce images that look good on the back of the camera, but to produce files that can be processed to create a superior end result.

VISUALIZING BLACK AND WHITE

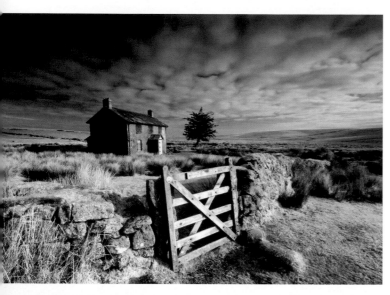

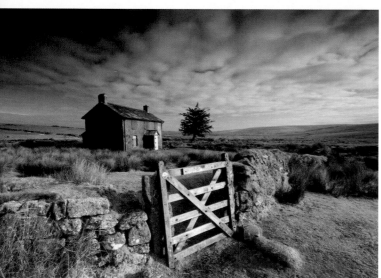

DESERTED FARMHOUSE
Black and white is a fantastic medium for conveying mood and drama. An active sky is important and buildings and dereliction are particularly well suited to mono. I took this image of an old, deserted farmhouse with the intention of converting the Raw file to black and white. I much prefer the mood and simplicity of the mono version.
Nikon D300, 10–20mm (at 11mm) 8 sec at f/18, polarizer, 3-stop ND grad

With so much time and money invested in producing digital sensors capable of reproducing colour with brilliant accuracy, you might question why anyone would want to convert their images to monochrome. However, the appeal of black and white photography is enduring. In conjunction with the appropriate scene and lighting, black and white photographs can often convey drama and mood more effectively than their colour counterparts. Digital capture has introduced a new generation of photographers to this powerful medium – the ease with which it is possible to convert digital files to black and white (see pages 134–5) is encouraging more and more landscape photographers to dabble, and black and white photography is more accessible than ever before. Capturing suitable shots shouldn't be left to chance, though. If you wish to consistently capture good black and white images, you need to be able to visualize the final shot at the point of taking the picture.

'SEEING' THE PICTURE

'Seeing' in black and white comes more easily to some than others. Many photographers struggle to visualize how colour will translate into greyscale. While a colour image relies on colour relationships for much of its impact, a black and white shot relies on tone, contrast and shapes. You need to be aware of how colour will appear when converted – for example, red and green, when converted to mono, can look very similar. Removing colour from a scene helps eliminate distractions, placing emphasis on shape and form, composition and light. One of monochrome's greatest strengths is its simplicity – black and white images can seem truthful and timeless.

While it is impossible to state categorically what will, or will not, make a successful black and white landscape image, there are key qualities to look for. Firstly, look for an 'active' sky – one with interesting clouds and drama. This will give your images more depth and impact. A scene with good contrast, boasting both shadows and highlights, will also often translate well into mono. Look for viewpoints that will create a good level of separation between

foreground and background subjects – this will help to prevent key points of interest from merging together. This lack of separation is more likely to occur in scenes with insufficient colour contrast, and it can greatly reduce the overall impact of the final image.

In the absence of colour, you need to work even harder to achieve strong compositions. This is why we encourage our workshop participants to 'think' in black and white – it is a good discipline for developing compositional skills. Without the distraction of colour, the viewer's eye will be more focused on other aspects of the image, such as shape, form, lines and texture. Bold, structural objects within the landscape work particularly well – for example, piers, lighthouses, weathered groynes, lone trees, buildings, dry stone walls, boats, steps and pathways. So-called 'scruffy' locations – sand dunes, ruins and decaying mine shafts, for instance – also translate well into monochrome, so look for this type of scene when you're shooting for black and white.

Weather is another key factor in creating successful mono images. Bad weather is particularly well suited to black and white photography – after all, it is a medium that is very effective for conveying mood and atmosphere. Dark, stormy skies convert especially well. Even in dull weather, it is possible to capture beautiful landscapes. While black and white images may be unable to capture the intricacies of light in the way a colour image can – for example, the warmth of morning or evening sunshine – it is able to capture far better results in overcast weather. During a workshop, the weather will not always be ideal. So, if the light is dull or flat, we encourage participants to take pictures with the intention of converting them to mono. Assuming there is texture in the sky, a long exposure will help to generate drama and interest by blurring cloud movement. This is one reason why extreme ND filters (see pages 83–5) are a great favourite among black and white enthusiasts. As you gain experience in landscape photography, you will soon learn to recognize the scenes and conditions that are best suited to black and white.

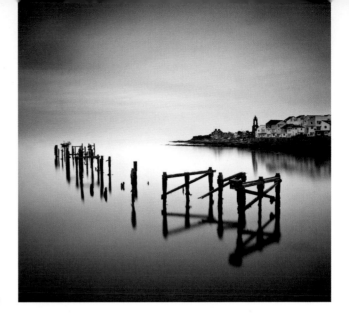

RUINED PIER
This image was shot on a drab, overcast day. Thanks to the simplicity of black and white and the length of the exposure, the result is striking. Don't be afraid of cropping your images – it is all part of the compositional process. Black and white images often suit a square format, as results appear more balanced and symmetrical.
Canon EOS 5D Mk II, 17–40mm (at 21mm), ISO 100,
5 min at f/16, 10-stop ND

CAPTURING BLACK & WHITE IMAGES
Most digital SLRs have a monochrome or greyscale setting that allows you to capture black and white images in-camera. This is normally best avoided. Considerably more tonal detail and information are recorded by shooting in colour – so, to maximize image quality, it is best to shoot in colour and convert during processing (see pages 134–5). This also gives you more options – you can convert a colour image to black and white, but you can't convert a mono image to colour.

Nevertheless, the camera's monochrome setting can be useful. If you struggle to 'see' in black and white, you can use it to preview the way in which colours will translate into greyscale. Using your camera's monochrome setting, it is even possible to see the projected Live View (see page 109) image in black and white.

EXPOSURE BLENDING

One of the biggest challenges in scenic photography is correcting the contrast between the sky and the landscape. The sky is typically brighter than the land below, so unless the imbalance in light is corrected, images will either suffer from foregrounds that are too dark, or skies that are too bright and washed out. The answer in most situations is to use a graduated neutral density filter (see pages 81–2). However, using grads is only practical when the horizon is relatively even. If the skyline is broken – by a tree, building, mountain peak or landmark, for example – that object will also be artificially darkened due to the filter's ND coating. One solution is to take differently exposed images of the same scene – this is known as exposure bracketing. The bracketed exposures are merged using appropriate software to achieve a perfectly exposed result.

EXTENDING DYNAMIC RANGE

By merging bracketed exposures together, you are effectively extending the dynamic range of your camera's sensor. High Dynamic Range (HDR) photography is a popular digital technique designed to capture the full range of intensity levels found in high-contrast images. The results exhibit remarkable detail throughout the image, often with slightly artificial-looking but eye-catching results, and are not to everyone's taste. HDR doesn't normally suit traditional landscapes, as the results look too 'fake' for most scenic photographers. However, the principle of using two or more differently exposed images to extend dynamic range is a useful one.

By blending exposures, it is possible to achieve natural-looking results, even with awkward, high-contrast scenes. Often, you only need two images – one correctly exposed for the sky and another for the land. Combined, the two images contain all the data you need to create one correctly exposed result. The images need to be identical in order to do this, so a tripod is essential. We also recommend you shoot using Mirror lock-up (see page 110) and trigger the shutter using a remote or cord to eliminate even the smallest movement. The aperture should remain constant – only the length of the exposure should change. Unless you are working in Manual exposure mode (see pages 32–3), do this using your camera's exposure compensation facility.

For very high-contrast scenes, you may need to capture a series of three or more different exposures. Many digital SLRs have an Auto Bracketing mode, programmed to take a series of images at exposures either side of the recommended setting. When you have selected the exposure increment and the number of frames, the camera varies exposure shot by shot. Therefore, if you dial in a bracketed sequence of five images at increments of 1 stop, and your original exposure length was 1/60 sec, the camera will capture images at 1/15 sec, 1/30 sec, 1/60 sec, 1/125 sec and 1/250 sec. If your camera doesn't have a bracketing function, you can adjust the shutter speed manually after you take each frame.

When you have captured your sequence, you can blend the images together to produce a single, seamless result. There are various ways to do this, using different techniques and software. For relatively straightforward blends, involving just two images, Photoshop is the most popular. Place one exposure on top of the other in the Layers palette and then, using a soft-edged brush, 'paint' sections out of the top image to reveal the detail below (see pages 130–3 for more on blending exposures in Photoshop).

Although it is more time-consuming, some photographers prefer blending to filtration. This is because placing a filter in front of your lens will inevitably degrade image quality to a small degree. By blending exposures, you are able to retain the maximum optical quality of your lens.

Tip: Exposure blending is a useful alternative to filtration in situations when you have to work quickly – for example, in rapidly changing light, when selecting the right filter type and density, and then positioning the filter, may take too long.

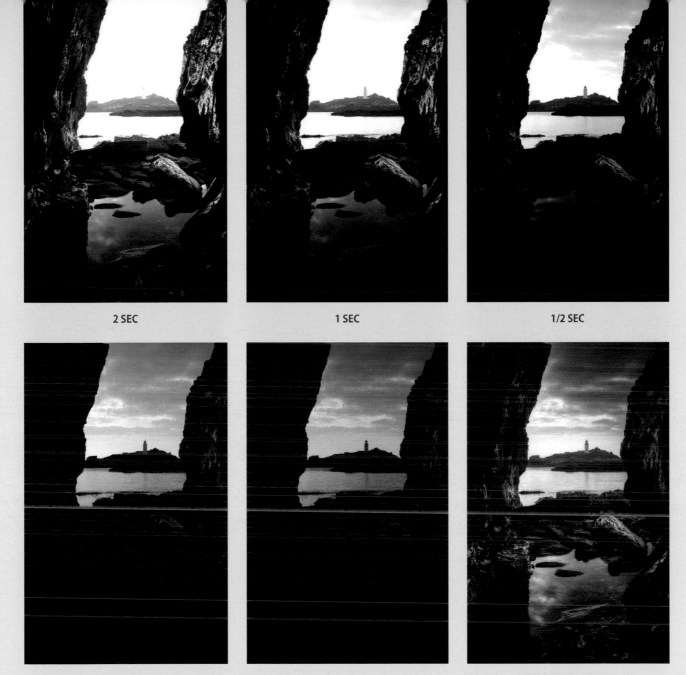

2 SEC

1 SEC

1/2 SEC

1/4 SEC

1/8 SEC

EXPOSURE FUSION

BLENDING WITH EXPOSURE FUSION

Using graduated filters to balance the light is not always practical. In this instance, I wanted to use the sides of a collapsed cave to frame the lighthouse beyond. I couldn't use an ND grad to lower the high level of contrast, as it would also artificially darken the cave walls. My only option was to shoot a bracketed sequence. I took a series of five shots at increments of 1 stop. Later, I blended the images in Photomatix Pro using the Exposure Fusion option. Exposure Fusion is a relatively new concept, designed to produce Low Dynamic Range (LDR) images from bracketed sequences. It is designed to take the best tonality from each image in the series and combine this information into a single image. During the fusion process, it assigns weights to the pixels within the images according to luminosity, saturation, and contrast and then carefully balances the three to create a natural-looking result. PTGui Pro and Enblend/Enfuse are other good exposure blending programs.

Nikon D700, 17–35mm (at 35mm), ISO 200, f/18

LOW-LIGHT PHOTOGRAPHY

When the sun disappears behind the horizon, don't immediately pack your camera away. Sunset shouldn't signal the end of your day's photography. In our workshops, we encourage photographers to continue shooting until colour finally vanishes from the sky. On good, clear, colourful evenings, it can be possible to keep shooting for anything up to an hour after sunset. There can be a surprising amount of colour in the twilight. While our eyes don't always have the colour sensitivity to recognize it, a digital sensor will reveal it. However, achieving correctly exposed results in low light can be challenging. Exposure times will often exceed the camera's longest setting, so you will need to switch to Bulb mode and manually calculate or 'guesstimate' exposure length.

COMPOSITION

In the right conditions, the sky's colour is at its most naturally saturated during the 30 minutes before sunrise, and in the hour or so following sunset. The sky can glow, resonating in a display of pinks, purples, oranges and reds, which fade into enigmatic blues. Low-light conditions can provide spectacular photo opportunities, which you risk missing if you pack up too early or arrive too late. However, before worrying about the technical aspects of shooting in low light, you need to consider which scenes are suitable.

While the colour of the sky will often be at its best during twilight, without direct light to shape and highlight the land, you have to be far more selective with viewpoints. Generally speaking, it is best to opt for views that include reflective subjects – particularly water. Water will reflect the colour and light of the sky, so it is a good choice for the foreground. Coastal scenes and views that include lakes, ponds or pools are often a good choice.

If you are shooting before sunrise, allow sufficient time to reach your viewpoint and set up ready to capture the pre-dawn glow. A torch is handy when setting up, particularly if you're trying to locate and attach filters and adaptor rings in semi-darkness. Timing is essential – the window of opportunity, when the sky is at

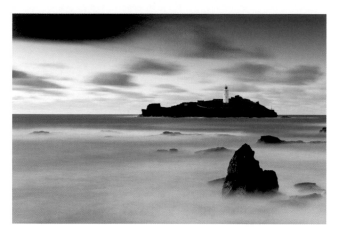

NATURAL BLUR
Avoid using solid ND and polarizing filters when shooting in low light. Exposure time is naturally long, so subject motion – such as clouds and water movement – will blur without the need for filtration.
Nikon D700, 17–35mm (at 35mm), ISO 200, 90 sec at f/14, 3-stop ND grad

its best, is small. It is better to be in position too early, rather than too late – once the sun appears, its intensity will often exceed the sensor's dynamic range and you will need to alter your viewpoint to exclude the sun from shot.

Evenings are generally favoured for low-light photography. The afterglow can last for an hour or longer and it is easier to work out exposure settings in decreasing light. At dawn or dusk, the point at which the sun will appear or disappear is where the sky will be brightest and most colourful. Shoot in the direction of the glow to capture the best of the colour. Objects within your composition will often appear silhouetted – for example, rocks, trees or rushes growing close to the water's edge. Silhouettes (see page 59) can be striking when they are contrasted against a colourful sky, or a body of water. Therefore, look for subjects with strong, bold outlines that you can feature in your composition – silhouettes often play an integral role in low-light images.

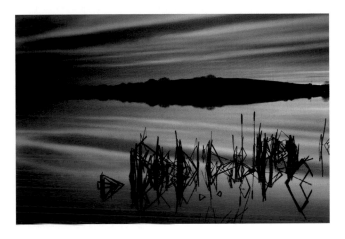

EARLY MORNING GLOW
Low light provides some of the best conditions for landscape photography. Often the best, most intense colours can be captured before sunrise or after sunset. Water and reflections are ideal subjects. In this instance, I arrived at a local reservoir around 40 minutes before sunrise, which allowed me to capture the amazing pre-dawn glow.
Nikon D300, 12–24mm (at 12mm), ISO 200, 1 min at f/14, 3-stop ND grad

TECHNIQUE

In low light, digital sensors are capable of recording colour and detail that our eyes can't see. In order to do this, the shutter needs to be open for seconds, or even minutes. Therefore, stability is key – a good, sturdy tripod is essential. Most modern metering systems will perform well in low light, determining the correct exposure right up to the point at which it calculates that the light is insufficient. Frustratingly, most digital SLRs are only capable of shutter speeds of up to of 30 seconds – which, for low-light photography, often isn't enough. To increase exposure, you could select a higher ISO sensitivity or set a wider aperture, but this is not recommended. Increasing ISO significantly will introduce extra noise (see page 80) to your shots, while a larger aperture limits depth of field. The best option is to switch to Bulb mode. This allows you to hold the shutter open – using a remote cord – for the length of exposure you require. When using Bulb, a degree of trial and error is often

required. Use the histogram screen (see pages 34–5) as a guide to how much more, or less, exposure, is required. For example, if, after an exposure of 30 seconds, the histogram suggests the image is underexposed by 1 stop, take a new exposure timed at 1 minute.

Focusing can be challenging in low-light conditions. Autofocus will rarely work effectively, although if you are using the hyperfocal distance technique (see pages 108–9), you will be setting focus manually anyway. Lenses with fast maximum apertures are best suited to low-light work, as they provide a brighter viewfinder image. Live View (see page 109) is useful for checking composition and fine-tuning focus.

REDUCING NOISE IN LOW LIGHT

When shooting in low light, there is an increased risk of image noise caused by a long exposure. As you attempt longer and longer exposures, random electronic fluctuations can accumulate and appear as noise. Many digital SLRs have a Long Exposure Noise Reduction function (see page 80) to correct this. This works via dark frame analysis: the camera captures a second shot of equivalent length, but by keeping the shutter closed, it can produce a map of the noise pattern in order to compensate for it. This doubles the time you have to wait before you can take another shot, so noise reduction software is often a more practical option.

When you take multiple long exposures, the sensors can become quite warm, and this will amplify signal noise. Try to push your exposure as far to the right (see pages 112–3) as possible to maximize image quality.

Live View (see page 109) is a useful tool in low light, but avoid using it for long periods – doing so will heat up the sensor, increasing noise levels in the image.

▶ CHAPTER EIGHT > **POST-PROCESSING**

Some photographers believe that post-processing is either 'cheating' in some way, or that they can take a mediocre image and turn it into something outstanding in Photoshop. Neither of these viewpoints is true. Skill behind the camera remains paramount, but post-processing is an important part of the image-making process. Users of black and white negative film have traditionally spent hours in the darkroom, dodging, burning and experimenting with paper grades to obtain the best possible rendition of their images. In the same way, digital images require careful processing to fully realize their potential. This chapter will examine the fundamentals of post-processing and set you on the road to getting the best out of your landscape photographs.

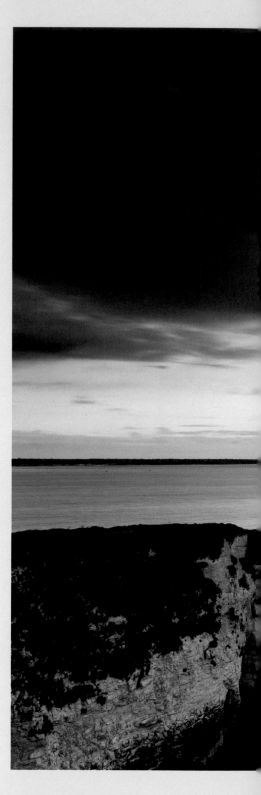

IMAGE MAKING
Post-processing is a key part of the image-making process. This image was shot in Raw, and I made several adjustments to it before converting it to a TIFF – yet it doesn't look fake or unnatural. Some selective lightening – the digital equivalent of darkroom 'dodging' – was carried out in Photoshop.
Canon EOS 5D Mk II, 18mm f/3.5, ISO 100, 13 sec at f/22, 3-stop ND grad, 4-stop solid ND

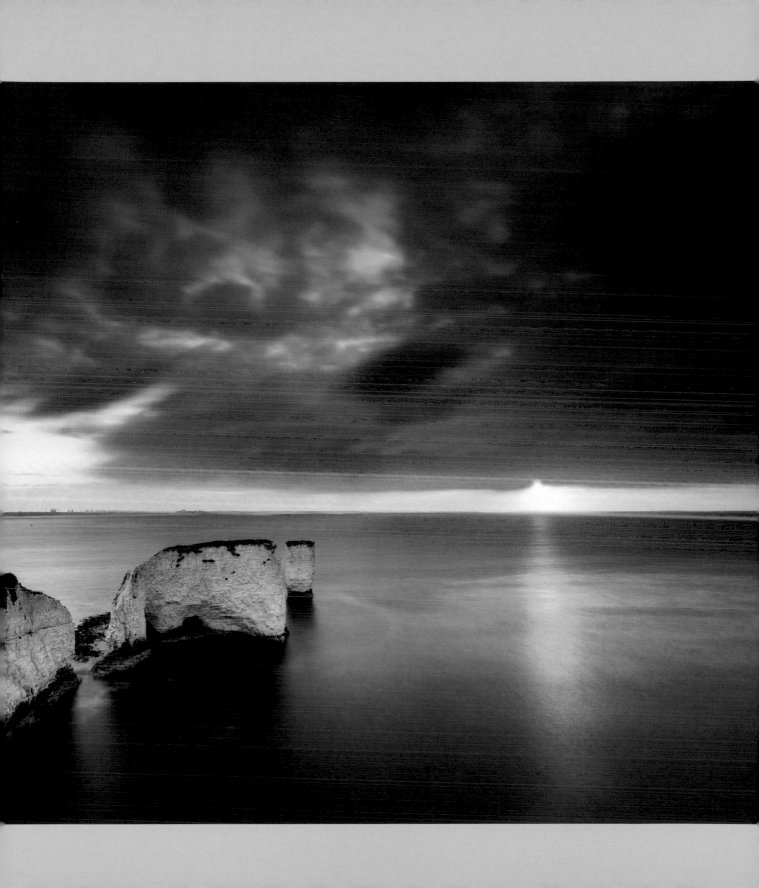

FILE FORMATS

Post-processing is an important part of the image-making process, and in order to minimize the amount of time spent in front of the computer, rather than behind the camera, it's important to have an organized workflow. Our suggested workflow assumes that you are working on a Raw file – and this is what we recommend – but there are other options. There are various file-format options when saving your processed file, so, before going any further, we will examine the most common file types used by photographers.

FILE TYPES COMPARED

JPEG (JOINT PHOTOGRAPHIC EXPERTS GROUP)

JPEG is the most common and convenient file format used by photographers, for both capture and storage. It is a compressed file format, and its small size is both an advantage and a disadvantage – the small file size is convenient, taking up less space on your cards and hard drives, but the compression results in a degree of reduction in image quality. The greater the compression, either at the picture-taking stage or the editing stage, the greater the loss of image quality – and the more likely you are to see 'artefacts' in your photographs, such as poor edge definition (also known as 'jaggies'), poor tonal transitions and posterization. Furthermore, JPEG is a 'lossy' file type, which means that each time you re-save a JPEG you will lose some of the original image data.

RAW FILES

Raw files are essentially 'undeveloped' digital data, and they need to be processed before they can be viewed or printed. Many people think of Raw files as being a kind of 'digital negative' in that they have all the information required to create an image, but are not directly usable. Alterations need to be made to create the final picture, just as adjustments are made to a negative at the printing stage. The advantage of Raw is that it is a very flexible format – changes are non-destructive and not applied directly to the Raw file, so quite substantial adjustments are often possible with very little impact on image quality.

Compared to JPEG, in which image data is discarded during in-camera processing, Raw files contain more information, a wider level of tones, have a greater dynamic range and are more tolerant to error. It is a more versatile and forgiving format and the best option if you wish to maximize image quality.

Most camera manufacturers have a proprietary Raw format, so dedicated software is required to convert your images – you can use the software provided by the manufacturer, or opt for a third-party Raw converter such as Adobe Lightroom. Because of its flexibility, and the fact that you are in complete control of the processing parameters, we strongly recommend that you capture images in Raw format.

JPEG SETTINGS

All digital SLRs can capture images in both Raw and JPEG formats. When shooting in JPEG, you can capture images at different sizes and quality settings. You can normally opt for Small, Medium or Large JPEG, which refer to the dimensions of the picture itself. Choose Large to record the most detail. You can also dictate the level of compression by selecting Basic, Normal or Fine. Again, to maximize image quality, choose Fine. When capturing JPEGs, the pre-selected shooting parameters – such as white balance, tone and sharpness – are applied in-camera. So, when the file is transferred from the camera's buffer to the memory card, it is the finished article – ready to print or use immediately after download.

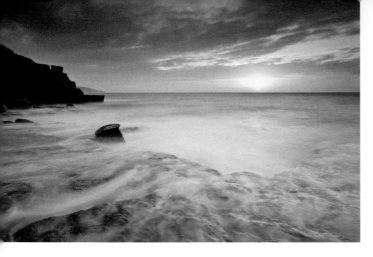

THE RAW ADVANTAGE
Raw files contain more tonal information and have a wider dynamic range than JPEGs. Raw is the recommended file format for capturing landscape images, especially for scenes that contain a wide range of contrast.
Canon EOS 5D Mk II, 21mm f/2.8, ISO 100, 10 sec at f/22, 4-stop solid ND, 3-stop ND grad

TIFF (TAGGED IMAGE FILE FORMAT)

When you convert images from Raw format, TIFF is one of the output options you are given. TIFF is a 'lossless' format, so there is no loss of image quality when re-saving. It is possible to create a 16-bit TIFF file (as opposed to the 8-bit JPEG) which means that if any further adjustments are made to a TIFF after conversion, the impact on image quality is reduced. Because of this, and the fact that it is the file type most commonly requested for publication, we recommend saving files as TIFF at the conversion stage.

TIFFs are not normally compressed, although you do have the option of using LZW, a form of lossless data compression. Some cameras will allow you to capture images as TIFFs, but because of the large file size and longer data writing times, most photographers avoid this option.

WORKFLOW

Although shooting Raw and converting images is more time-consuming than shooting JPEGs in-camera, the file quality is better, and, with practice, your pictures will be much closer to the results you envisaged at the taking stage. Furthermore, with an efficient workflow, it is possible to process large numbers of images fairly quickly and apply adjustments to multiple images simultaneously – this is known as batch processing. There is no definite right or wrong way of doing things, and individuals develop their own routines. Our suggested workflow is outlined in the next few pages.

COLOUR SETTINGS FOR PHOTOSHOP

When you need to edit your TIFFs or JPEGs, the industry standard software is Adobe Photoshop (although there are other options available). When working in Photoshop, it's important that your system is profiled and your colour settings in Photoshop are correct. For detailed information on profiling and calibrating your monitor, see pages 142–3. To check the colour settings in Photoshop, go to Edit > Colour Settings to bring up the Color Settings dialog box. The recommended settings are shown in the screengrab below.

PROCESSING A RAW FILE PART 1

To process a Raw file, you need dedicated software. Each camera manufacturer has its own program, which is often supplied free with the camera. Although these programs produce good quality conversions, the user interface can be a little awkward, and they tend not be as fully featured as some third-party programs. As a result, many photographers invest in a third-party Raw converter.

THIRD-PARTY RAW CONVERTERS

There are many Raw converters available, but three of the most popular are Adobe Photoshop Lightroom, Apple Aperture and Phase One Capture One. Lightroom and Aperture both combine Digital Asset Management (DAM) features with a Raw converter, and feature a wide range of tools which go beyond the basics of white balance, exposure and colour correction, allowing you to correct lens distortion and make local adjustments to contrast, colour, exposure and sharpness. Users of Adobe Photoshop and Photoshop Elements have the Camera Raw plug-in, which features all of Lightroom's Raw conversion tools, but lacks the DAM capabilities. Aperture is only available for Apple computers, but has proved very popular with Mac users.

Capture One has an good range of easy-to-use tools, a reputation for superb quality and excellent batch-processing features. It is available in a full (Pro) or limited edition (LE) version, which omits some of the non-essential features.

RAW WORKFLOW

Raw software is very powerful, and when you've decided which package to use, we recommend buying a detailed manual for that program, which will provide a much fuller description of all the tools available than is possible here. Whichever software you decide to use, however, the basic tools – and therefore your workflow – will be very similar. Our suggested workflow is as follows:

IMPORTING IMAGES

First, you must download your images from your camera to your computer and import them into the Raw converter. The process varies according to the software package you are using, but this is usually done as a single step. Select the images you want to work on – most programs have a 'star rating' system, which is a useful way to classify your photographs . At this stage, we recommend making backup copies of the 'keepers' on a separate drive.

DOWNLOADING AND BACKUP

It's easy to download images onto your hard drive and load them into your chosen software. You may find using a card reader more convenient than connecting your SLR to the computer. As hardware can fail, it's also worth making backup copies of your images at this stage. There are various options for backup, but external hard drives offer the best value and are probably the most efficient way to store backups.

CARD READER
Card readers such as this Lexar model make it even easier to download and back up your precious images.

CROPPING

Cropping enables you to remove distracting features at the edge of the frame, or magnify the subject in the frame if you weren't able to obtain the desired composition in-camera. You can also change the aspect ratio of the image if your subject doesn't suit the standard 3:2 ratio of most DSLRs, or crop your picture to a square or panoramic format. If you enjoy creating panoramic images, you may also want to consider stitching pictures (see pages 136–7). Most Raw converters allow you to 'lock in' a particular aspect ratio (or create your own custom ratios). Alternatively, you can unlock the aspect ratio and crop to the shape you think best suits the image.

WHITE BALANCE

Before making any adjustments to exposure and contrast, it is best to adjust the global colour of the image using the white balance control – you can always tweak it again later if necessary. You have the usual choice of presets, such as Daylight and Cloudy, or you can manually adjust colour temperature (to give a warmer or cooler look) and tint (the amount of green or magenta). You can also use the Eyedropper tool to click on an area of neutral colour, which will set the white balance accordingly.

With landscape photography, the aim is not necessarily to produce the most accurate colour, but to create pleasing colour, so setting white balance to taste is usually the best option, as long as you avoid the extremes.

SETTING THE BLACK AND WHITE POINTS

Setting the black and white points ensures that the tones in the image are spread across the full range of the histogram – if there are gaps between the right and left limits of the horizontal axis, the image is not utilizing the full range of tones and it may lack contrast. The black and white points are set using the Levels control.

The histogram will be displayed alongside the image when the image is opened in the Raw converter. Beneath the histogram are three sliders. The pointer on the far right represents white (255); the pointer to the far left, black (0); and the middle pointer represents the mid-tone (128). To set the black point, move the black point

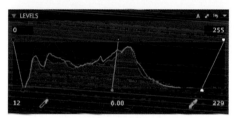

BLACK AND WHITE POINTS
(Top) The image-editing screen in Capture One. Set the black and white points using the sliding arrows under the histogram in the Levels pane (above).

slider to the right, to the point just in front of the beginning of the histogram. The image will grow darker. To set the white point, drag the white point slider to the left, to the point just after the end of the histogram. The image will become lighter. Be careful not to increase contrast too much. A slight clipping of the shadows is acceptable, but clipped highlights rarely look right.

Now use the middle slider to adjust the mid-tones – pushing it to the left will brighten the image, and moving it to the right will darken it. The black and white points remain unaffected.

Every image, and its corresponding histogram, is unique, although the basic object remains the same: to obtain a full range of tones across the histogram.

PROCESSING A RAW FILE PART 2

FINE-TUNING YOUR IMAGE
USING CURVES FOR FURTHER CONTRAST ADJUSTMENTS

After setting the black and white points (see pages 124–5), you may need to make further adjustments to the image contrast. You can use the Contrast slider, but for greater control, use the Curves control. The Curves box shows a graph with a straight diagonal line, representing tones from pure black at the bottom to pure white at the top. To increase overall contrast, add an S-shaped curve, by pulling down the 'quarter tones' slightly and pushing up the 'three-quarter tones'. You can also make adjustments anywhere along the curve, to alter any of the tones in the image.

> **Tip:** Some Raw converters, such as Adobe Lightroom, have targeted adjustment tools. These enable you to hover the cursor over the image tones you want to adjust, then click and drag up or down to adjust the tones. The changes will be reflected in the Curves pane.

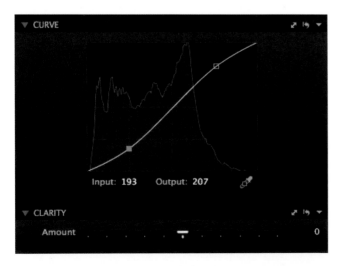

BOOSTING COLOUR WITH SATURATION AND VIBRANCE

The colours in unprocessed Raw files often look a little weak. This will improve when Levels and Curves have been adjusted, but the colours may need a further boost. This is where the Saturation and Vibrance controls come in. Not all Raw converters have both – some only have Saturation – but the difference is straightforward. Saturation is linear, and boosts all colours equally. Vibrance is non-linear and gives the less saturated colours more of a boost. It also protects skin tones, though this is not of great interest to most landscape photographers – however, we find that Vibrance usually produces more natural-looking results. There is no magic formula for adjusting Saturation or Vibrance. Simply increase or decrease to taste, but be cautious – it's very easy to overdo the effect and you can't make an inherently dull scene more interesting just by adding lots of saturation.

LOCAL COLOUR ADJUSTMENTS

With many Raw converters, it's possible to fine-tune the hue, saturation and lightness of individual colours, either using a colour wheel or colour picker, or a targeted adjustment tool. Again, this should be done to taste, with the idea of keeping things looking as natural as possible.

ADDING AN 'S' CURVE
Using the Curves control, create an 'S' curve to increase the overall contrast in your image.

DUST-SPOTTING

Even brand new sensors with automatic cleaning systems are prone to dust spots, and because landscape photographers often work at small apertures with wide-angle lenses, these spots can be very noticeable. Most Raw converters incorporate a Clone tool, which allows you to remove the dust spots, though you may find that the equivalent tools in Photoshop are more flexible.

CAPTURE SHARPENING

Digital images have an inherent degree of softness, which is introduced at the capture stage by the anti-aliasing filters used by digital SLRs to reduce artefacts. To counteract this, it's worth adding a little capture sharpening at the Raw conversion stage. The image will then need to be sharpened again for output, depending on the medium you are printing onto (see page 150). How much capture sharpening is needed varies from camera to camera and even from image to image, but the Raw converter's default settings are a good starting point. With images that contain a lot of fine detail – such as landscapes – it's better to use a small radius, if you have that option.

NOISE REDUCTION

All digital images contain a certain amount of noise. Exposing to the right helps to reduce this (see pages 112–3), but you may need to use some noise reduction at the conversion stage. The amount will depend on the individual image, but as noise reduction can also destroy image detail, try not to be too aggressive. A certain degree of luminance noise is generally acceptable to the eye – it can resemble film grain – but colour noise is usually very ugly.

CONVERSION FOR EDITING AND OUTPUT

With processing completed, you are ready to convert the image to your chosen file format. We normally recommend converting to TIFF, as this is the best option if you are going to do any further work to the image in Photoshop. When you are sure the image is completely finished, you can convert it to JPEG, to save storage space.

You will be given various options during the TIFF conversion process. Save your TIFFs at the 16-bit setting, to preserve image quality when making additional adjustments. Save your image to the required size at 300 pixels per inch, as this is the resolution required if you are submitting images to image libraries or for publication. Finally, you will need to select the colour space. There are generally three options – sRGB, Adobe RGB and ProPhoto RGB. sRGB is the smallest colour space and is best avoided except for web use. ProPhoto RGB is the largest, and the best one to use if you intend to do any further editing or are preparing images to print using your own inkjet – although many of the colours will be out of the printer's gamut, with modern ink sets you will still be able to reproduce more colours than you would in Adobe RGB. However, if you are sending files for publication or to libraries, use Adobe RGB, which is the industry standard.

BEFORE AND AFTER
Straight out of the camera, the unprocessed Raw image looks a little flat and dull (below left). By setting the black and white points, increasing contrast with Curves and increasing the Vibrance, the image comes to life (below right).
Canon EOS 1Ds Mk II, 24–105 f/4L, ISO 100, 1 sec at f/11, 2-stop ND grad

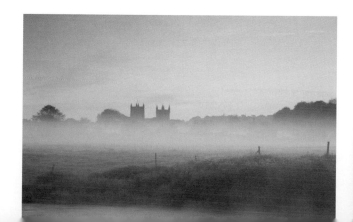

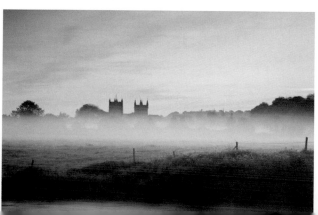

PROCESSING 'EXPOSED TO THE RIGHT' IMAGES

Exposing to the right (see pages 112–3) will usually produce excellent results. However, the processing stage is as important as the taking stage, because although ETTR files contain more information, they can also look pretty dreadful when you first open them in your Raw converter.

Depending on the dynamic range of the scene, the ETTR image you have captured may look too bright, washed out and lacking in contrast. Its histogram will be pushed up to the right. To rectify this and achieve the result you want, you need to spread the data across the histogram, using a combination of the following tools: the black and white sliders in Levels, the Exposure, Brightness and Contrast sliders, and Curves. You may also decide to adjust the Saturation and/or Vibrance.

The following example uses Adobe Lightroom, but the techniques described will work with all Raw converters.

HOW FAR CAN YOU PUSH IT?

When you open an image in your Raw converter, don't automatically discard images that show clipped highlights. Sometimes, minor adjustments – such as using the Recovery slider in Lightroom – can recover all the highlights, revealing full detail. Remember that the histogram shown on your camera's monitor is not a true reflection of the range of tones contained in a Raw image (see Shooting Parameters, page 113). With experience, you will get to know how far into overexposure you can push an image – though if in doubt, it's better to err on the side of caution, and, if possible, bracket your exposures (see page 116).

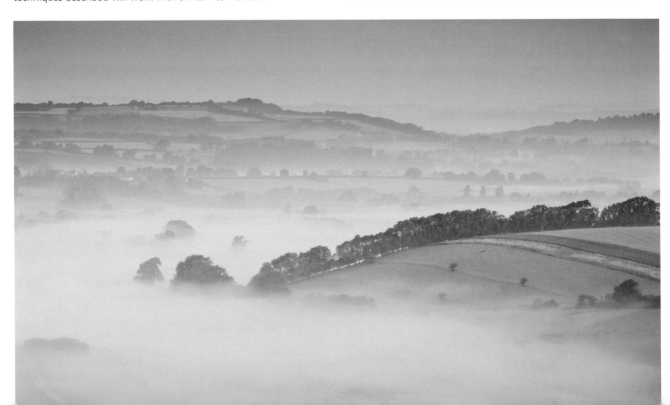

ETTR PROCESSING IN ADOBE LIGHTROOM

STEP 1 – WHITE BALANCE

The imported image (left) looks a little bright, washed out and lacking in contrast. The first step is to adjust the white balance, as this can also affect the exposure. Although it's possible to set a white balance that is technically 'correct' – by clicking the Eyedropper tool onto a neutral tone – I prefer to set the white balance to taste. In this case, I started with the Daylight white-balance setting and then added a touch of magenta to enhance the dawn hues. With Raw files, you can always adjust the white balance again later if you need to.

STEP 2 – BLACK AND WHITE POINTS

Setting the black and white points (see page 125) created an instant improvement. It's a misty scene, so I didn't set the black point too aggressively, as this would have destroyed the atmosphere by making the scene unnaturally contrasty.

 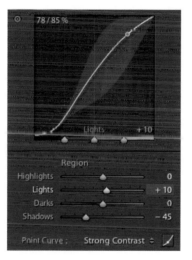

STEP 3 – MID-TONES

Next, I adjusted the mid-tones – this affects the overall brightness of the image. There is no magic formula for adjusting the mid-tones in an ETTR image – simply adjust until you achieve the result you want. In this case, the mid-tones needed to be lighter to preserve the look of the original scene.

STEP 4 – CURVES

At this stage you may find that the image needs a bit more punch. You can increase the overall contrast using the Contrast slider, but this is rather a blunt instrument. Making local adjustments in Curves gives a much more refined result. Again, there is no right or wrong way of doing this – simply adjust to taste on an image-by-image basis. In this case, I pulled down the 'toe' of the curve slightly to help the trees and hills stand out a little against the mist, and then pushed the 'shoulder' up to lighten the mist.

STEP 5 – CROP

If necessary, you can now adjust the Saturation and Vibrance sliders. In this case, I felt that no adjustment was necessary – this is often the case with ETTR images, which capture a full range of colour and tonal information. However, I did crop the image slightly to remove a distracting darker blue area from the top of the sky.

THE END RESULT

(Facing page) After following all the steps above, I saved the image as a TIFF, opened it in Photoshop to make a few additional minor adjustments – mainly dust-spotting – and the image was finished.
Canon EOS 1Ds Mk II, 70–200mm f/4L (at 110mm), ISO 100, 1.3 sec at f/16

EXPOSURE BLENDING TUTORIALS

Although it is often preferable to use ND grad filters to reduce the contrast between the sky and the landscape (see pages 81–2), there are some situations in which this just doesn't work – for example, where the horizon is broken or if the contrast range is so great that filtration is impossible. We have already looked at using software that automatically blends a series of bracketed exposures (see pages 116–7) and now we are going to look in more detail at manually blending two shots – one exposed for the sky and one for the land.

Both examples use Adobe Photoshop, though the process is similar in other image-editing applications. The first example demonstrates the simplest method. The second is slightly more complex, but offers more precise control.

BLENDING HIGH-CONTRAST SCENES

This dawn scene at St Aldhelm's Head in Dorset, UK, shows how great the contrast range can be at this time of day, when clouds are lit from below but there is no direct light on the land. Although in-camera filtration would have helped to solve the contrast problem, a graduated filter would have created an obvious transition line cutting into the building.

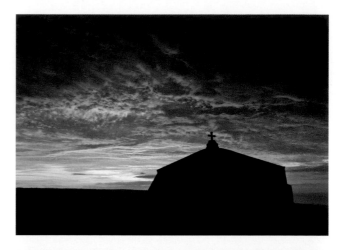

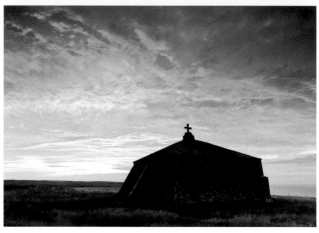

STEP 1 – PROCESS THE IMAGES
I made two exposures, four stops apart. In the first, the sky was correctly exposed, without losing any highlights. The second shot was exposed for the land so that there was plenty of detail in the land and building. I converted both images to TIFF format and opened them in Photoshop.

Tip: For images with less complex skylines, you can use Photoshop's Polygonal Lasso tool to make the selection of the sky (see step 3, opposite). This will usually be quicker and easier than using the Magnetic Lasso tool.

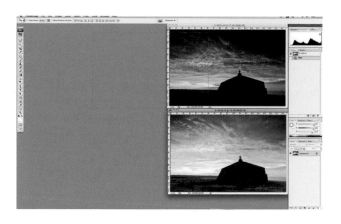
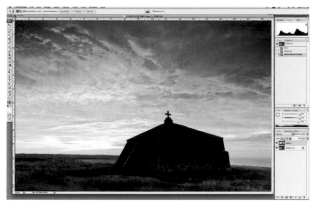

STEP 2 – ALIGN LAYERS
With both pictures open, click on the lighter of the two images. Select the Move tool from the Tools palette. Drag the lighter picture over the darker one and drop it onto the darker image. The lighter image is added as a new layer in the Layers palette, on top of the darker image. Hold down the Shift key while dragging to ensure that the two images line up precisely.

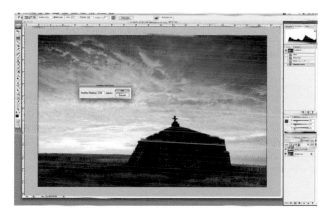

STEP 3 – SELECT THE SKY
Click on the Magnetic Lasso Tool in the Tools palette and use it to select the sky. In this example, I feathered the selection by 150 pixels so that there would be a smooth blend between the two layers in the next step. To do this, right-click the mouse and select Feather > Feather radius. Enter the desired value and click OK. I find that a radius of between 100 and 250 pixels usually works well.

STEP 4 – BLEND LAYERS
Select the Eraser tool from the Tools palette, set a large brush size and use the brush to erase the top (lighter) layer, revealing the darker sky beneath. Continue to selectively erase the top layer until you are satisfied with the result, then flatten the layers (Layer > Flatten Image). Remember that you can no longer make adjustments to the individual layers after you have flattened them.

STEP 5 – FINISHING TOUCHES
The blending process is finished, but you may want to make some further alterations to the image as a whole. In this case, I made a slight adjustment to Levels and Curves, to get the overall contrast of the blended picture looking right. I also selectively lightened the top of the building – because I'd feathered the selection heavily, it had become a little darker than I wanted.

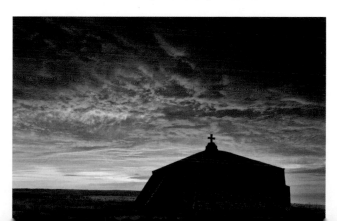

COMPLEX BLENDING WITH LAYER MASKS

For this shot, although I had been able to capture enough detail in both the sky and the foreground by using a graduated ND filter (see pages 81–2), there was nothing I could do to stop the white cliffs in the middle distance from recording as dull grey. I therefore shot two exposures, with the intention of blending them in Photoshop, using layers and Layer masks.

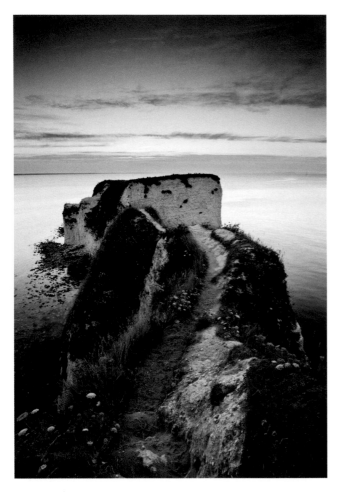

THE END RESULT
Photoshop's Layer masks give you very precise control when blending two different exposures, enabling you to create images that would not be possible using only in-camera filtration.

STEP 1 – PROCESS THE IMAGES
First, I converted the two images to TIFF format and opened them in Photoshop. As in the previous example, I layered one image on top of the other. This time, though, I placed the darker image on top of the lighter image. Then, with the top (darker) image layer active, I clicked on the Add Layer Mask icon in the Layers palette.

Tips: To reverse the Layer mask edits, press the X key to switch the Foreground and Background colours, and paint with white to bring back the darker layer.

To quickly adjust the size of the brush, use the [(left bracket) and] (right bracket) keys.

STEP 2 – BRUSH TOOL SETTINGS

Choose the Brush tool from the Tools palette and set the Opacity to 50%. Select a medium-sized soft-edged brush. Set the foreground colour to black. Painting black on the layer hides it, and painting white reveals it.

STEP 3 – PAINT

Use the Brush tool to 'paint in' the lighter areas on the cliff, hiding the top, darker layer. Use multiple strokes to gradually reveal the lighter layer below and build up the effect slowly. As I approached the edges of the cliff, I chose a smaller brush size for more precise control.

STEP 4 – DETAILS

I wanted to to lighten the flowers in the bottom left of the image, but this required a more subtle effect than I had used on the cliffs, so I set the Opacity to 20% and painted over this area.

STEP 5 – FINISHING TOUCHES

Compare the original image with your blended image. In this example, the difference is subtle but effective. When you're happy with the result, flatten the layers (Layer > Flatten Image). You may want to make a few final tweaks to the flattened image – I adjusted the contrast using Curves, and made sure the horizon was completely straight.

PROCESSING BLACK AND WHITE IMAGES

Even if you know you want the final image to be black and white, we always recommend that you shoot in colour and convert your colour images to black and white in post-processing. By doing so, you retain the maximum level of flexibility.

You can convert an image to monochrome either at the Raw processing stage, or save it as a TIFF and perform the black and white conversion in Photoshop. The latter option gives you more options and a greater level of control. You will get better results if the image has a neutral white balance, with no colour casts, so that the colours are purer. When setting the white balance in your Raw converter, use the Eyedropper tool to select an area of neutral colour. Be careful not to oversaturate the image, as this can produce artefacts when you convert it to black and white.

CONVERTING A TIFF TO MONO

There are a number of different ways to convert images to black and white in Photoshop. The simplest is Image > Adjustments > Desaturate, but this offers no control over the result. One of the most popular methods is to use the Channel Mixer (Image > Adjustments > Channel Mixer). This allows you to mix the three colour channels – red, green and blue – to simulate the effects of colour filters. Even more control is given in later versions of Photoshop, with the Image > Adjustments > Black and White tool – this is the technique used in the step-by-step example on the opposite page. (Note: The instructions given here refer to Adobe Photoshop, but other programs, such as Corel PaintShop Pro, have similar features.)

Tip: For non-destructive editing, the Black and White tool in Photoshop can also be used as an adjustment layer.

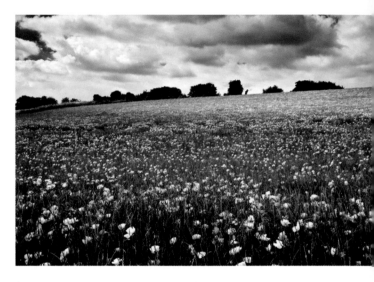

COLOUR FILTERS IN BLACK AND WHITE PHOTOGRAPHY
Red filters darken blue tones, adding drama to skies, and lighten red tones, increasing contrast in other parts of the scene. In this image, the red filter helps the red poppies stand out from the background.
Canon EOS 5D Mk II, 24–105 f/4L (at 45mm), ISO 100, 1/8 sec at f/16, polarizer

BLACK AND WHITE FILTRATION

Ironically, black and white film photographers make frequent use of colour filters in front of the lens. When colours are replaced by a series of tones, it can sometimes be hard to differentiate one hue from another; in a monochrome image, a red flower may look very similar to a green leaf. Colour filters are used to block some colours while allowing others to pass through. The filter will let its own colour through, so the grey tone of subjects with that colour will be lighter, and the tones of contrasting colours will look darker. By representing specific colours as either lighter or darker tones in black and white images, they can make a subject stand out from its surroundings, rather than merge into them. The same effects can be obtained in software by increasing or decreasing selected colours.

STEP 1 – ASSESSMENT
This is the original colour TIFF. A contrasty black and white conversion would increase the drama by focusing attention on the bold, graphic composition.

STEP 2 – BLACK AND WHITE DIALOG
Click on Image > Adjustments > Black and White. There are various options in the dialog box – you can click Auto and let Photoshop make all the decisions, or you can adjust the individual colour channels yourself. There are also a number of useful presets.

STEP 3 – CONTRAST
I want to increase the contrast between the sea and the harbour wall. The blue filter gives the best initial result, as it lightens the blue tones in the image.

STEP 4 – SELECTIVE ADJUSTMENTS
Using the blue filter has lightened the sky as well as the sea, so I decide to do some dodging and burning to specific areas of the print, just as I would if I was working in a traditional darkroom. I choose the Polygonal Lasso tool and make a selection of the sky, feathering it by 150 pixels. Next, I click on Image > Adjustments > Auto Levels. This darkens the sky and increases contrast, but to add more drama, I go to Image > Adjustments > Brightness/Contrast, where I reduce the brightness and increase the contrast.

STEP 5 – CURVES
I then select the sea in the same way, and use Curves to brighten the surf to further increase the contrast between the sea and the harbour wall. I then select the harbour wall and use Curves to increase the contrast between the mid-tones and the shadows.

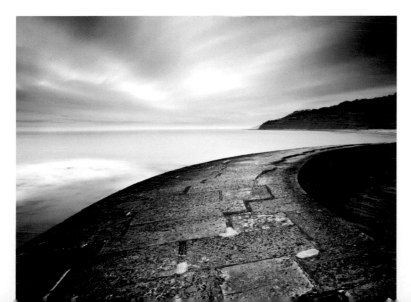

STEP 6 – CROP
All the image needs now is a slight crop to tighten up the picture on the right-hand side. The final result is very close to how I'd imagined it, with the black and white version conveying a sense of drama that was missing in the original colour photograph.

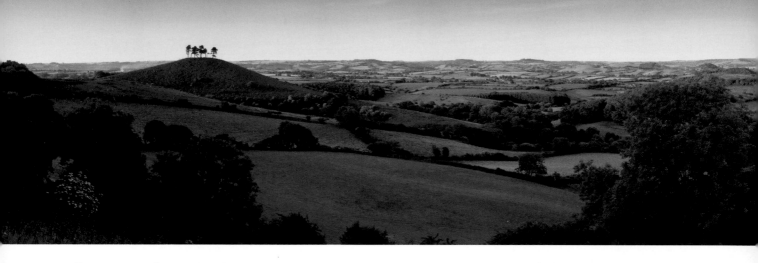

STITCHED PANORAMICS

COLMER'S HILL, DORSET, UK
This scene was a natural for the panoramic format. The conically shaped hill makes a strong focal point and breaks up the horizon.
Canon 5D2, 23–105 f/4L (at 80mm), 1/8 sec at f/11, ISO 100, 2-stop ND grad, 7-shot stitch

There's something compelling about panoramic landscapes, especially when you see them as a big print – it's the closest you can get to actually being there. Specialist panoramic equipment is extremely expensive, so most digital photographers prefer to create panoramics by panning across the scene, taking a series of shots, and then stitching them together in Photoshop or another image-editing program. This will result in a final image with far more detail than one that is cropped from a single frame. Dedicated stitching software is available, but unless you shoot a lot of panoramics, you'll probably find the tools available in Photoshop perfectly adequate.

EQUIPMENT AND TECHNIQUE

As with most landscape photography, a tripod is essential. For panoramics, you'll need a tripod head with a panning action. Keep the camera level as you pan across the scene – a hotshoe-mounted spirit level will help you do this. You can buy specialist panoramic heads, which pivot around the nodal point of the lens (the point at which the light paths cross inside the lens barrel). This prevents lines from converging and makes it easier to line up your frames. This is useful when shooting scenes that contain lots of vertical lines, such as cityscapes, or landscapes with close foreground, but is not really necessary when shooting distant landscapes.

Not all scenes lend themselves to the panoramic treatment. Scenes with strong horizontal planes, particularly those that flow naturally from left to right, are ideal. It also helps if there's a strong focal point, like a building or hill, to break up the horizon line and slow the eye down as it travels across the image. Stitched panoramics aren't hard to create, as long as you follow some basic rules:

1 Keep the camera completely level, so vertical lines don't converge.
2 Set focus, exposure and white balance manually, so they don't change from one frame to another. Avoid using polarizers, as the effect will not be even across the frames.
3 To obtain correct exposure across the whole panorama, take exposure readings from the whole scene, and average them out.
4 Shoot in portrait format, as this will reduce the amount of distortion. You'll need to shoot more frames – maybe seven or eight – to make the panoramic.
5 Overlap frames by about 25%, so that they are easy to line up.
6 Use a cable release and Mirror lock-up (see page 110) to keep the image as sharp as possible.
7 Don't waste time between shooting frames, in case conditions change – this could make lining up the images difficult.
8 Shoot slightly wider than you think you need, to allow some margin for error when lining up the different frames.

CREATING A PANORAMIC

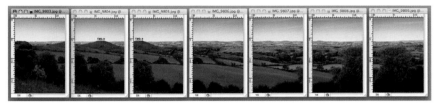

STEP 1 – CAMERA SETTINGS

First, set the exposure and focus modes to Manual. Take meter readings from across the scene and average them out. For this image, I selected 1/8 sec at f/11, ISO 100.

STEP 3 – DOWNLOAD

After shooting, download and process the pictures on your computer, making sure that the settings are the same for each frame. This is what the individual images look like all lined up together.

STEP 4 – PHOTOMERGE

Open Photoshop and click on File > Automate > Photomerge. There are various options for merging the images. The Auto setting works well, but Perspective and Cylindrical are also very effective – experiment to see what works for you. For this image, I chose Auto. Click on the Browse button, select the images from step 3 and click OK.

STEP 5 – PROCESSING

It takes a little while for Photoshop to process the images, but after a few minutes the photos have been merged. Each image is automatically placed on its own layer. There is usually some blank space around the edges, as in this example. This is a result of the way the images have been lined up, and it will be removed in the next step.

STEP 2 – SHOOT

I turned the camera on its side, using a hotshoe-mounted spirit level to make sure everything was level. Unlocking the panning knob on my geared tripod head, I took a series of seven panned shots, overlapping each one by about 25%. The camera's review screen made it easy to line up the shot I'd just taken with the next frame.

STEP 6 – CROP

To finish off the image, select the Crop tool from the Tools palette and crop the image carefully to remove the blank space. Finally, flatten the layers (Layers > Flatten Image) and that's it. Job done! You can see the completed panoramic in more detail at the top of the previous page.

► CHAPTER NINE > **PRINTING**

Although there are many other viewing options, nothing quite compares to seeing your image as a good-quality print. Digital printing has caught on remarkably quickly, and there are now far more photographers working at computer workstations than there are in traditional darkrooms. There is more to this than mere convenience: modern inkjet printing delivers superb image quality, and perhaps its biggest advantage over darkroom processing is its repeatability – once you get a print looking the way you want it, you can save the file and replicate the result almost immediately at the touch of a button. However, although it may appear simple at first glance, there is a lot to learn about the art of digital printing. This chapter will show you how to make the best prints from your favourite images.

HARBOUR
When you've taken a picture you're really proud of, nothing can beat seeing it as a large print on top-quality paper.
Nikon D300, 12–24mm (at 12mm), ISO 200, 1 min at f/14, 10-stop ND, 3-stop ND grad

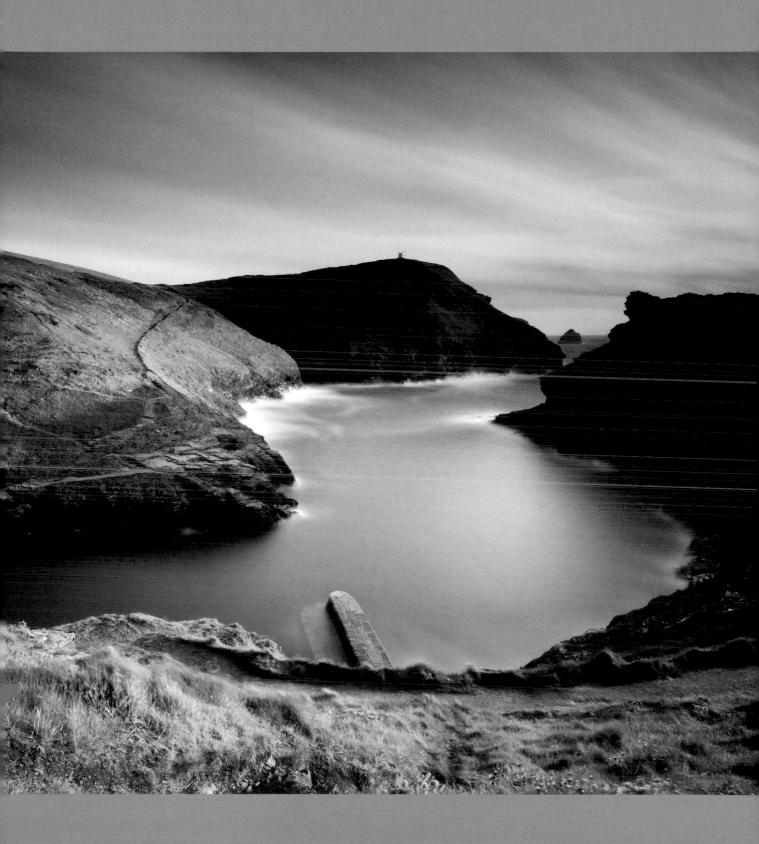

PRINTER TYPES

For such a new technology, inkjet printing has matured remarkably quickly – to the point where inkjet prints now hang on the walls of major photography galleries. The inkjet revolution really began in the mid-1990s, when the first affordable photo-quality inkjets appeared, allowing photographers to produce their own prints without the need for a darkroom. As colour printing in the darkroom is a notoriously fiddly process, people adopted the new technology with alacrity, and this enthusiasm helped to drive forward research and development. There is now a wide range of excellent printers to choose from.

DYES AND PIGMENTS

There are basically two types of photo printer, each with its own advantages and disadvantages: those which use dye inks and those which use pigment inks.

DYE INK PRINTERS

In the early days of inkjet printing, a printer that used dye inks was the only option available. Dye-based printers use water-soluble coloured liquids to render an image on paper. Tiny droplets are laid down and absorbed by the paper. Dye inks have a very wide colour gamut, and look especially good on glossy papers, which have traditionally caused problems for pigment inks. Dyes are generally derived from organic compounds and deteriorate rapidly when exposed to UV light and other environmental factors, such as pollution, so print longevity can be a problem – which is why it took a little time for inkjet prints to become accepted by galleries and art dealers. However, when printed on the right paper surface and displayed behind glass, some dye inks will last 25 to 30 years before they start to fade.

PIGMENT INK PRINTERS

Pigment inks are much more stable than dye inks and many have a longevity rating of between 100 and 200 years – greater, in fact, than many traditional darkroom prints. So why didn't all inkjet printers use pigment inks from the beginning? For a start, pigment inks are more expensive to manufacture, but there were also other inherent disadvantages to contend with – it was difficult to produce pigment inks with as wide a colour gamut as dye inks; they tended to clog print heads, as the individual pigment particles are solids; and they suffered from an effect known as 'metamerism', which meant that colours could look different when viewed under different light sources. The reason for this is that pigment ink

The Canon iPF5100, an A2 pigment ink printer.

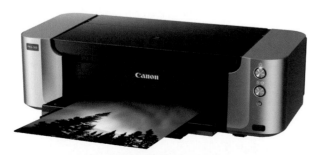

The Canon PIXMA Pro-100, an A3 dye ink photo printer.

dries on the surface of the paper, and if the individual particles of pigment are not completely uniform, they can reflect light differently. Reflections from the ink can also lead to an effect known as 'bronzing' in areas of the print where darker ink has been laid down heavily. These problems do not occur with dye ink, which is absorbed into the paper.

Although these problems were evident with early pigment ink printers, research has led to improvements that have all but eliminated these issues.

MANUFACTURERS

There are three main manufacturers of photo quality inkjet printers: Canon, Epson and Hewlett Packard. For a long time, Epson had the market to itself, but these days, there is little to distinguish between the three brands.

However, the difference in print head technology is worth noting. Epson uses piezoelectric print heads, which are permanently installed in the printer and are non-replaceable. They can be prone to clogging (though later models are much improved), but clogs can be cleared by running a cleaning cycle. HP and Canon use thermal print heads, which can be replaced. These print heads have spare nozzles, so that when nozzles become blocked with ink, the print head is automatically remapped to use different nozzles. This has two implications – firstly, although clogging is less of a problem than with Epsons, eventually the print head will have to be replaced, and secondly, any paper profiles that have been generated will become less accurate over time, and will need to be reset (see page 143).

All three manufacturers offer a wide range of printers, from A4 size up to 64in (163cm) wide. Although the smaller printers are inexpensive, running costs can be high, as ink cartridges are small and the cost of ink is high. If you are doing high-volume printing, consider purchasing an A2 or larger printer, as these take larger cartridges, some in excess of 200ml, depending on the model, and the cost of ink per millilitre is much lower.

SPECIALIST INKSETS

One way to reduce costs with printers that use smaller cartridges is to use a continuous ink system (CIS), from manufacturers such as Permajet or Lyson. These use large bottles of ink that sit next to the printer, and are more economical to buy. It is worth remembering, however, that third-party ink systems may invalidate printer warranties.

For black and white printing, some photographers like to use specialist inksets that contain a range of black inks, rather than mixing colour inks to produce blacks and greys. However, many modern printers do have three or more black inks, and you would be hard pushed to see a significant difference. Furthermore, using specialist monochrome inks means that you need a dedicated black and white printer – which, if you make colour prints too, may be impractical.

A continuous ink system (CIS) can significantly reduce ink costs with A4 and A3 printers, by allowing you to use large bottles of ink that can be purchased more economically than small cartridges. The pictures show the Lyson CIS connected to an Epson 2400, and the bottles of ink it uses.

CALIBRATION

Before you make a print, you need to know that it is going to look the same as the image you see on your computer screen. There are two steps in this process – the first is to calibrate your monitor, and the second is to calibrate your printer (or, more accurately, to create profiles for the papers you use with your printer).

WHY IS CALIBRATION NECESSARY?

If you've ever looked at a row of TVs in a shop, all showing the same channel, you'll probably have noticed that there are differences – often fairly substantial differences – in the colours they display. The same is true of computer monitors – so how do you know that the colours your monitor is displaying are accurate? The simple answer is that unless your monitor is calibrated, you don't.

There can also be differences between what a printer thinks it's producing and what it actually produces. By printing a test target, and using hardware to read the target and software to compare the output against known values, ICC (International Color Consortium) profiles can be generated for specific printer-paper combinations. An ICC profile describes the colour characteristics of a device, such as a monitor or printer, and communicates that information to other hardware, enabling it to reproduce colours accurately.

HOW TO CALIBRATE YOUR MONITOR

It is possible to calibrate your monitor by sight, using simple programs such as Adobe Gamma in Photoshop or, if you use an Apple Mac, the Display Calibrator Assistant. While this will usually be an improvement on having an uncalibrated monitor, it won't produce critically accurate results.

The second, and far more accurate, method, is to use a hardware calibration device known as a colorimeter. Monitor calibration involves placing the colorimeter on the screen and then running software that compares the colours your monitor displays against known values. Then software creates a profile, which adjusts the monitor's colours accordingly.

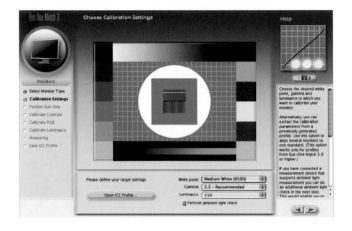

MONITOR CALIBRATION
X-rite's calibration software, showing the recommended settings for LCD monitors.

WHICH CALIBRATION DEVICE?

There are various colorimeters available, but three of the principal manufacturers are X-rite, Colorvision and Pantone. The X-rite EyeOne is the most often recommended device. The Pantone Huey is inexpensive, and is less sophisticated than the others, but produces good results. If you're willing to pay a little more, ColorEyes Display Pro is a good choice. It works with a number of different hardware devices, and allows, via adjustments to the graphics card, very fine control of LCD monitors that do not allow full manual adjustment of brightness, contrast and so on, as well as fine-tuning of the white-point setting, which is a very useful feature.

RECOMMENDED SETTINGS

Before you start the calibration process, you need to make sure that you are working in a suitable environment. Lighting should be dim, but not completely dark, and there shouldn't be any lights shining directly onto the monitor. Set your computer desktop to display a solid mid-grey background.

Calibration software will guide you through the process step by step. Some monitors allow you to make many manual adjustments to brightness, contrast, white point and RGB settings. If your monitor does not allow this, the software may provide a fully automatic calibration. You may also be asked to define target settings for the parameters listed below. There are no absolute rules about which settings to choose, as they can be affected by factors such as the brightness of your working environment. However, the following settings are generally recommended:

Brightness: in the region of 110 cd/m² to 140 cd/m²
Contrast: around 50% (the calibration software may help you arrive at a suitable level)
Gamma: 2.2 (for both Macs and PCs)
White point: 6500°K, D65

Some LCD monitors may give a better result if the white point is set to a value known as the native white point. This will give you the maximum possible color range for your monitor, and any other value may introduce banding on some monitors. In the majority of cases, the native white point will be close to 6500°K. It is often worth experimenting with different settings to see which one works best.

PRINTER/PAPER PROFILES

In many respects, creating paper profiles is very similar to calibrating a monitor: you print a test target, measure it with a hardware device and let the software create a profile. The equipment needed is generally more expensive than that needed for monitor profiling,

CALIBRATING YOUR PRINTER
Remember to turn off all colour management when you print your test target

so many photographers have profiles made for them by colour management specialists. If you have several profiles made at the same time, for different papers, this can be relatively expensive, but is generally a one-off expense.

It is important to remember that when you print the test target, you must turn off all colour management in your editing software and printer drivers. How you do this will vary depending on your operating system and printer model. If carrying out your own profiling, the software will guide you; if a specialist is making profiles for you, ask their advice.

Tip: Try to calibrate your monitor at least once a month, because profiles 'drift' over time, particularly luminance settings. Most calibration software can be set to remind you when you need to recalibrate.

RESOLUTION

Print resolution should be a simple matter. You'd think that there would be an identified optimum resolution for inkjet printing, but in fact there are several conflicting opinions. We hope that we will be able to demystify this subject and provide some practical advice on input and output resolution.

DPI VERSUS PPI

The first problem is caused by the two terms, dpi and ppi – which, although clearly different, are often used interchangeably. The former stands for 'dots per inch' and refers to the resolution of the output device, i.e. the printer – generally speaking, the higher the dpi, the better the tonal transitions of the print. If the dpi is too low, then you will literally be able to see the dots, as you can with low-resolution newspaper print.

The second term stands for 'pixels per inch'. This affects the dimensions of the printed image – the lower the ppi, the larger the image. It can also have an effect on the print quality, because if there are too few pixels per inch, individual pixels can be seen in the image, resulting in jagged edges and 'pixelation'.

You can also change the image size in software such as Photoshop by 'resampling'. This is where your software changes the number of pixels in the image. This changes both the image dimensions and the file size. If you are resampling to make your picture smaller (downsampling), it will throw pixels away; if you

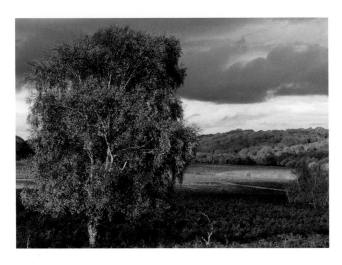

PIXELATION
With too few pixels per inch, the result is pixelation, which means you can see the individual pixels in the image. The jagged-edges effect can clearly be seen in this image, which is sized at 50 ppi.

are making the image larger (upsampling), it will create new pixels. Resampling is used if you want to change print size without changing ppi. Upsampling becomes necessary if it is not possible to obtain the print size you want without lowering the ppi too much. It is a useful technique in moderation, but if you upsample too much, the result will be a loss in image quality. The pixels created are really 'empty' pixels, which do not add any additional detail to the image.

RESAMPLING
In Photoshop, if you change ppi with the Resample Image box unchecked, the file size will remain the same, but the image dimensions will change.

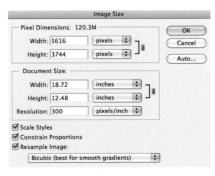

NATIVE RESOLUTION

The big question, of course, is, 'What is the lowest number of pixels per inch I can use and still obtain acceptable print quality?' In other words, 'How big can I print my image, before I have to resample?' This is where the controversy begins. For offset printing, printers have always requested files sized at 300ppi – as a result, many photographers have got into the habit of sizing files at 300 ppi and resampling, believing that this is the optimum resolution for all printing, including inkjets. However, this is not really the case.

All printers have a 'native' resolution, which is the ppi setting used by the printer driver. As an example, many Epson printers have a native resolution of 360 ppi, even though they output at 720, 1440 and 2880 dpi. It is often claimed that images should be prepared for printing by setting the ppi of the image file to match the printer's native resolution and then resampling the image to the size required for output. It is argued that this gives better results than the alternative, which is to resize the image without resampling, and let the printer driver interpolate the image.

However, modern printer drivers do an excellent job of interpolating image data, and recent thinking is that better results are obtained by setting the image size without resampling, letting the ppi fall where it may, and allowing the printer driver to interpolate the image; the only restriction here being that the ppi shouldn't fall below 180 (below which point, pixelation will start to become evident) or rise above 480 (which can confuse the printer driver). Our own testing tends to support this view, though we would always advise you to experiment for yourself and see what works best for you.

UPSAMPLING

Depending on the resolution of your camera, and the size at which you want to print, it will sometimes be necessary to upsample images. Arguments rage about the best methods for upsampling, but in fact, as long as you're not trying to increase the size of your picture by too much, it's relatively straightforward. Let's look at an example, where we want to make a print 40in (102cm) wide, using Adobe Photoshop.

The original 16-bit tiff is 120.3MB in size. At 300 ppi, this gives an image size of 18.72 × 12.48in (47.5 × 31.7cm).

In the Image Size dialog, with the Resample Image box unchecked, reduce the ppi to 180; this gives you image dimensions of 31.2 × 20.8in (79.2 × 52.8cm). Now check the Resample Image box and select Constrain Proportions. There are several options for the resampling method – select Bicubic Smoother, which gives the best results for upsampling (Bicubic Sharper is best for downsampling). In the Document Size box, enter a width of 40in (102cm). Click OK. The image will be interpolated to 197.8MB, with a height of 26.667in (67.7cm).

Image Size

Pixel Dimensions: 197.8M (was 120.3M)
Width: 7200 pixels
Height: 4800 pixels

Document Size:
Width: 40 inches
Height: 26.667 inches
Resolution: 180 pixels/inch

☑ Scale Styles
☑ Constrain Proportions
☑ Resample Image:
Bicubic Smoother (best for enlargement)

OK / Cancel / Auto...

PAPER TYPES

One of the great things about inkjet printing is the vast range of papers available – a far greater choice than exists for darkroom printing. In addition to the printer manufacturers' own papers, it is easy to name a string of companies, all of whom make excellent papers: Fuji, Hahnemühle, Harman, Ilford, Innova, Kodak, Moab, Museo, Permajet – and there are many more.

There are many different types of media available, including glossy, semi-gloss, matt, watercolour, fine art/rag and canvas. They all come in a variety of weights and each manufacturer's papers have slightly different characteristics. There are now even fibre-based baryta papers, which are almost indistinguishable from the finest fibre-based darkroom papers. In terms of the media available for printing, photographers have never had it so good.

PAPER CHOICE

Paper choice is highly subjective and there is no 'right' paper to print on, but most photographers tend to settle on a few favourites. Deciding factors will commonly be the colour gamut/saturation, contrast/shadow detail, brightness, surface texture, reflectivity, weight/thickness and affordability. It also depends on what type of images you produce.

The basic paper types are glossy, semi-gloss and matt, and these can be sub-divided into fine art, resin-coated, and fibre-based. There is no standard as to what constitutes glossy, matt or semi-gloss and different manufacturers have different names for the latter, including Pearl, Oyster and Lustre. The only way to find out which papers you find most appealing is to experiment. This can be an expensive process, especially as you should ideally be using good profiles with each paper, but luckily, many manufacturers produce reasonably priced A4 test packs, so you can try out the different papers in their range. Good manufacturers also provide profiles for their papers, which, although generic, are usually sufficient for you to gain a good idea of the paper's characteristics.

SEMI-GLOSS PRINTS
Semi-gloss papers allow you to achieve vibrant colours without the reflection problems associated with glossy surfaces.

Once you've settled on a particular paper, though, you should ideally make or have made a custom profile for it (see page 143). Despite this lack of standardization, and the variations between each manufacturer's papers, it is possible to broadly summarize the characteristics of the main types of paper, as follows:

GLOSSY

Glossy papers are highly reflective and have a smooth surface. They generally have an excellent colour gamut and are capable of reproducing deep, rich blacks. Glossy papers tend to look very 'photographic', with the look and feel of traditional glossy lab papers. If you're framing your pictures, however, one thing you should consider is that there will be two sets of reflections – one from the glass and one from the print. You can reduce this by using non-reflective glass, but this is expensive and may dull the image.

MATT

At the other end of the spectrum is matt paper. Matt paper has a dull surface with no sheen. It has a narrower colour gamut than glossy paper and is not able to reproduce such a wide range of tones. Because its surface is non-reflective, it is a popular choice for photographers who intend to display their images behind glass, and it is also often easier to perceive shadow detail in the denser areas of a print made on matt paper.

SEMI-GLOSS

Like glossy paper, semi-gloss is resin-coated, but it often has a slightly textured surface. It shares the advantages of glossy paper in that it has a wider colour gamut and greater dynamic range than matt paper, but is less shiny and reflective than glossy. For this reason, it is a good compromise if you intend to frame your images behind glass.

PAPER RANGE
There is a huge range of papers available, even from a single manufacturer. These are some of the papers available from Permajet.

CANVAS

There are also a number of inkjet canvases on the market. Quality varies, but the best ones are 100% cotton, acid-free and quite heavy. The 'canvas wrap' – in which the picture is pulled around a wooden stretcher and left unframed – is a popular look, but is arguably more suited to prints made from paintings rather than photographs.

FINE ART PAPERS

Some matt papers are classed as 'fine art' papers. These are usually heavier, have a textured surface and are made from high-grade, acid-free paper. Unlike some standard matt papers, they do not contain Optical Brightening Agents (OBAs) – chemicals added to the paper to make it appear whiter, but which can also affect longevity. Fine art papers are more expensive than standard matt papers.

FIBRE-BASED PAPERS

Fibre-based inkjet papers are available with a true baryta coating. These are incredibly close to the look and feel of traditional fibre-based photographic papers, popular with those making fine-art prints in the darkroom. They usually have a glossy or semi-gloss surface, and although they are expensive, they are worth it if you want to make an extra-special print, especially in monochrome.

PRINTING YOUR LANDSCAPE

In this section we will look at printing workflow, from opening your image on the computer, to examining the finished print. For the purposes of this tutorial, we will be using Adobe Photoshop, but the process is broadly similar in other applications.

WORKFLOW

Printing workflow can be summarized as follows:

- **Open the image in Photoshop**
- **Resize the image (see pages 144–5)**
- **Soft proof the image (simulate the appearance of the print on your computer screen)**
- **Make any adjustments necessary based on the soft proof**
- **Sharpen for output**
- **Select the paper type and paper profile in the printer driver**
- **Select the output resolution**
- **Print**

RESIZING

We have already examined resizing in depth (see pages 144–5). The important point to remember is that you should print at the native file size where possible, as long as the resolution falls between 180 and 480 ppi. If you need to upsample or downsample the image, follow the procedure outlined on page 145.

SOFT PROOFING

Soft proofing allows you to preview the way the print will look on your chosen medium. A lot of people are initially discouraged from soft proofing, because when you first click on the Preview button, the appearance of the image can change quite dramatically, depending on the options you have selected. It is, however, a useful tool, which gives you the opportunity to adjust your settings to squeeze the maximum image quality out of the print, preventing disappointment when you see the final result.

To set up soft proofing in Photoshop, go to View > Proof Setup > Custom. In the dialog box, from Device to Simulate, choose the profile for the paper you want to print on and then select your

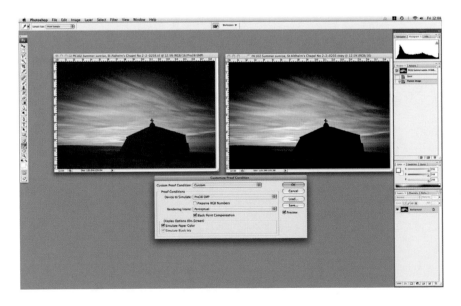

SOFT PROOFING
It's a good idea to have a copy of the original image open when soft proofing, so that you can match the soft-proofed image to the original screen image as closely as possible. By making adjustments to Levels, Curves and Hue/Saturation, it's possible to create a soft proof – and therefore a final print – that closely resembles the screen image.

rendering intent. The rendering intent 'translates' the colour gamut from the colour space of the image to the colour space of the printer. Typically, there will be some out of gamut colours which the printer cannot reproduce precisely. From the choice presented in the dialog box, we are really only interested in two rendering intents – Perceptual and Relative Colorimetric. Perceptual compresses the range of colours to match the gamut of the printer, while trying to maintain the perceptual relationship between the colours – it therefore adjusts all the colours in the image. Relative Colorimetric, on the other hand, simply removes the colours that can't be printed and doesn't change any of the colours that are within gamut. So which one should you choose? Well, the only way to know is to try them both, while soft proofing, and choose the one that works best with that particular image.

> **Tip:** Quickly toggle soft proofing on and off by pressing Command + Y (on a Mac) or Control + Y (on a PC).

So far, we have soft-proofed the colours in the image. The next step is to click on Simulate Paper Colour. Clicking on this button soft proofs the contrast range of the paper. This will always be much lower than your monitor's contrast range, so this is when you will see the major changes in the image; monitors have much deeper blacks and much brighter whites than can be reproduced on paper, so typically the image will look darker and 'muddier' when soft proofed. At this stage, it's worth double-checking that you are happy with the rendering intent you've chosen.

You now need to make adjustments to the image so that the print will resemble the on-screen image more closely. One way to do this is to open two copies of the image, soft proofing one of them and then tweaking it to match the original version as closely as possible. Typically, you will need to make changes to the image Curve – to add a little 'punch' to the blacks and lighten the mid- and three quarter tones, and the hue and saturation of individual colours. Having done this, you can be confident that your print will be as close a match to the screen image as it is possible to get. The next step is to sharpen the image.

> **Tip:** Once you have set the soft-proofing settings for a particular paper profile and rendering intent, you can save these settings with an appropriate name and use them again later.

SHARPENING SETTINGS
Display your image at either 25% or 50% and set a Radius of between 0.3 and 0.7 pixels. Experiment with the Amount setting to achieve the desired effect.

SHARPENING

Sharpening is a much broader topic than most people realize – whole books have been written on the subject – and we can only provide a basic introduction here.

As well as capture sharpening (see page 127), digital images will need additional sharpening before output. How much output sharpening an image needs depends on the size of the print and the paper type you are using. It will also vary slightly from image to image. With landscape images, the reproduction of fine detail is important, and the suggestions below reflect that.

CREATIVE SHARPENING TECHNIQUES

It is possible to selectively 'paint on' sharpening, by using Layer masks (see pages 132–3) or the History Brush tool in Photoshop. There are also several plug-ins for Photoshop that can simplify the sharpening process, and which also allow for creative sharpening. Photokit Sharpener by Pixel Genius (www.pixelgenius.com) is highly recommended.

In Photoshop, we recommend using either Unsharp Mask or Smart Sharpening. View the image on screen at 50% or 25%, as this will give you a much better idea of how the effect will look in print than viewing the image at 100%. Set a small radius – between 0.3 and 0.7 pixels works well – and push the Amount slider up until you just start to see a very slight 'halo' around the edges.

Some media, such as heavily textured fine art paper, will need more sharpening than others, but you can experiment with this when you have identified your favourite papers (see pages 146–7).

THE PRINT

You are now ready to print your image. In Photoshop, go to File > Print. In the dialog box, select Photoshop Manages Colors and choose the appropriate printer profile and rendering intent. Select the paper type. The layout of the printing options dialog box may vary depending on your operating system and printer model, but all these settings should be selectable.

When you have printed your image, give it half an hour or so to settle before you view it. You should try to view it in neutral light. If you are very serious about printing, you may want to invest in a print-viewing booth.

PRINT SETTINGS
In the Print dialog, select Photoshop Manages Colors and choose the relevant printer profile before printing.

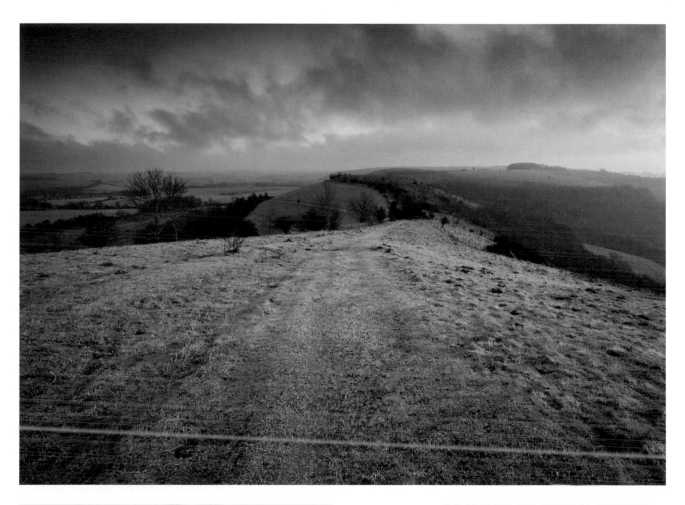

THE OX DROVE, WIN GREEN HILL, WILTSHIRE
Just as with traditional darkroom printing, digital printing requires care and skill. Soft proofing images is a vital step in the process, as it enables you to see which colours your printer will struggle to reproduce accurately, and make suitable adjustments. Blues/cyans and reds/ oranges are often problematic.
Canon EOS 1Ds Mk II, 17–40mm f/4L (at 19mm), ISO 100, 0.3 sec at f/16, 3-stop ND grad

PRINT LONGEVITY

Inkjet technology has not been around for long enough for anyone to say from experience how long a print can last without fading, but a lot of research has been carried out into this area, using accelerated testing. While much of this research has been undertaken by the manufacturers, independent testing has also taken place, most notably by Wilhelm Imaging Research (www.wilhelm-research.com), who provide information on print longevity for numerous ink and paper combinations.

▶ CHAPTER TEN >
CREATIVE ASSIGNMENTS

Workshops are a great way to expand or refresh your knowledge. They should provide inspiration, motivation and new ideas and techniques to try – both in the field and in the digital darkroom. However, the things you learn on a workshop can be forgotten quickly if you don't actually pick up your camera and use it. Don't be scared of making mistakes – doing so is one of the best ways to learn. To encourage you to get started, this chapter offers six creative projects. Instructions have been kept to a minimum – to allow for personal interpretation – but we have included some key pointers and an equipment checklist for each assignment. We've also illustrated each assignment with an image, to demonstrate how we have interpreted the theme. These projects are designed to challenge and motivate you. Time to get your camera!

TORCHLIT BOAT
With a little creative thinking, it's possible to get striking results even when the conditions are far from perfect. It was dull and overcast when this shot was taken, but I knew that if I waited until it was almost dark, the ambient light would record as a cool blue, which would contrast with the warm city lights in the background. To add further interest, the boat was illuminated by a powerful torch, which was shone onto it for about half of the duration of the exposure.
Canon EOS 5D Mk II, 21mm f/2.8, ISO 200, 180 sec at f/8, unfiltered

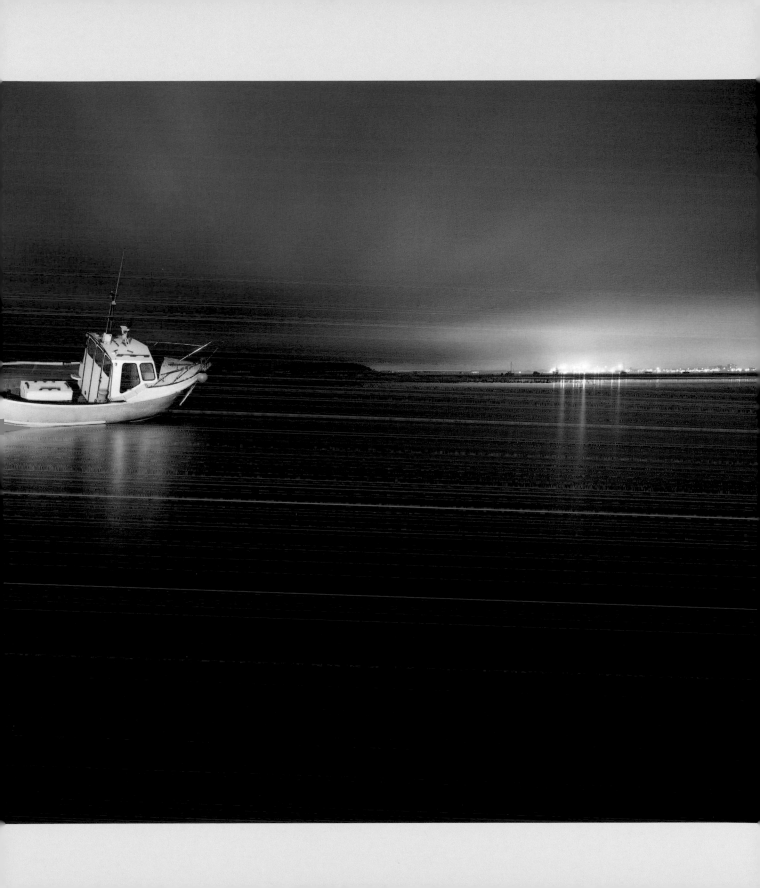

TECHNIQUE TIPS

■ Bold, easily identifiable objects – like buildings and skeletal trees – work best when photographing silhouettes.

■ Silhouettes are best captured in the early morning and late evening, when the sun is low in the sky. By shooting towards the light, objects between you and the light source will be rendered as a silhouette.

■ Silhouettes look best contrasted starkly against a colourful, interesting or textured sky. A colourful sunrise or sunset will form the perfect backdrop.

■ Switch to spot metering mode and meter for the sky. Doing so will ensure the sky is correctly exposed, while the foreground is underexposed.

■ The image's histogram will reflect the technique, so expect a high percentage of pixels skewed to the left of the graph.

EQUIPMENT CHECKLIST

LENS: A short telephoto, in the region of 50–80mm, is good for shooting silhouettes, allowing you to emphasize a subject's shape and form.

CAMERA FUNCTION: Spot metering mode. By metering from a bright region of the sky, foreground objects will be rendered as inky silhouettes.

ACCESSORY: Silhouettes are best captured in low light, so a sturdy tripod is essential.

CREATIVE ASSIGNMENT 1: EXPOSURE

Photographers are constantly striving for the 'correct' exposure. However, in practice, there is no such thing. Exposure should be manipulated for creative and artistic effect – look for ways and opportunities to do this when taking photographs. Be aware that a technically correct exposure won't always produce the most visually pleasing result – a silhouette is a good example of this. Technically speaking, a silhouette is the result of poor exposure, with the subject being grossly underexposed. However, silhouetted subjects can produce striking, eye-catching images.

THE ASSIGNMENT

This assignment is designed to encourage you to be creative and experimental with exposure. There are many ways to do this, but in order to complete this assignment, we want you to capture a striking silhouette. A silhouette is formed when a subject is captured as a black outline – it is the most extreme form of backlighting. You will need to demonstrate a good understanding of light and exposure control to capture pure silhouettes. As the subject is devoid of colour and detail, emphasis shifts to shape and form. Therefore, selecting an appropriate view, or subject, is key to achieving a satisfying result.

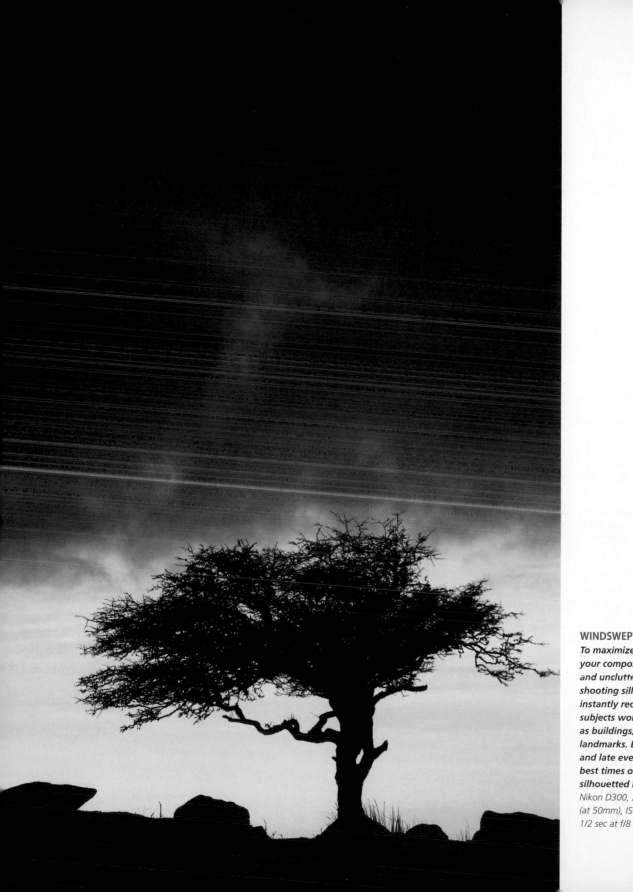

WINDSWEPT TREE
To maximize impact, keep your composition simple and uncluttered when shooting silhouettes. Bold, instantly recognizable subjects work best – such as buildings, trees and landmarks. Early morning and late evening are the best times of day to capture silhouetted landscapes.
Nikon D300, 24–85mm
(at 50mm), ISO 200,
1/2 sec at f/8

TECHNIQUE TIPS

If you're going to break the rules of composition, you'll need to think even more carefully about how to frame your subject. Here are some ideas to get you started:

■ Try using a centred horizon to enhance a feeling of tranquility. Soft lighting, light mists and reflections in lakes and ponds can suit this treatment.

■ Look for scenes with dramatic skies, and place the horizon at the bottom of the frame.

■ Aim for a minimal composition, with the horizon low and the subject close to the edge or corner of the frame.

■ Look for symmetry and try placing the main subject in the centre of the frame.

■ Experiment with 'empty' foregrounds. Some situations suit them – for example, if you have a strong reflection that you don't want to break up.

■ Attempt a composition in which there is no main subject or focal point.

EQUIPMENT CHECKLIST

Versatility is very important in this assignment, as you'll be trying a number of different approaches. You will find the following items useful:

LENS: A good range of focal lengths is important, from wide-angle to moderate telephoto. A 'superzoom' will enable you to try a number of different framing options without having to keep changing your lens or position.

ACCESSORY: A tripod with a good head, to allow precise framing and fine-tuning of compositions.

CREATIVE ASSIGNMENT 2: BREAKING THE RULES

There are a number of accepted 'rules' of composition in photography (see Chapter 3) and most of the time, these will work well. However, applying these rules slavishly, without questioning them or thinking about why they may or may not be appropriate in any given situation, will not help to further your creativity. The purpose of this assignment is to help you explore the rules of composition and deepen your understanding of them. The result should be that you make careful and considered compositions even when you choose to ignore the formal rules of composition.

THE ASSIGNMENT

This assignment sounds straightforward – to experiment with composition and take some images that break the rules. However, there's a bit more to it than that. Anyone can break the rules; your task is to make sure that your rule-breaking images are considered and successful compositions in their own right.

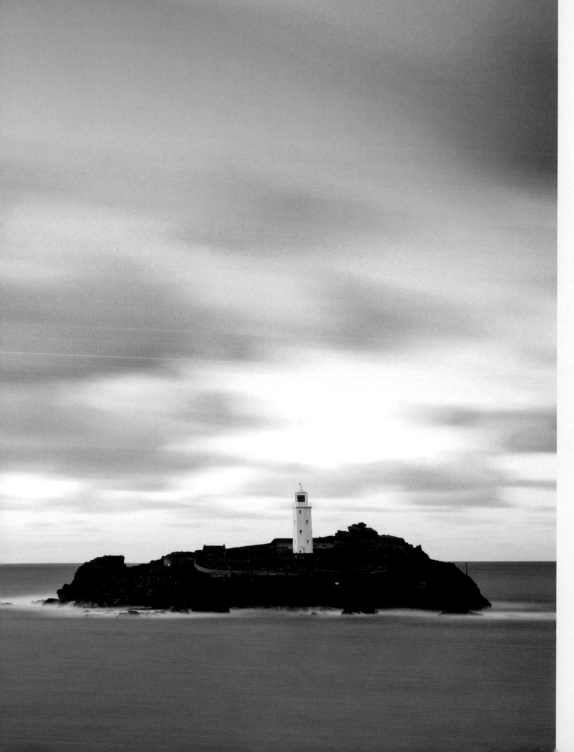

THE SKY AS SUBJECT
With the horizon low in the frame, and no foreground interest, this image breaks some of the conventional rules. However, the sky is as much the subject of the picture as the lighthouse, so it is still a successful image.
Canon 5D2, 24–105mm f/4L (at 32mm), ISO 200, 2 min at f/11, 10-stop solid ND, 2-stop ND grad

157

TECHNIQUE TIPS

■ Water is an obvious choice of subject for this assignment, but don't forget to keep an eye on the sky – cloud streaks can be very dramatic.

■ If the sky is an important part of the picture, look carefully to see how quickly the clouds are moving. If your exposure is too long and there is too much movement, the clouds will lose all texture and become a solid wall of grey or white, rather than recording as streaks.

■ Remember you can adjust aperture and ISO if you need to lengthen or shorten exposures to get the results you want. 'Stacking' ND filters is possible, but can introduce colour casts.

■ On some cameras, there is a separate Bulb setting on the Mode dial. On others, set Manual exposure mode and scroll down through the shutter speeds to find the Bulb setting.

■ To calculate exposure, take a test shot without the filter to determine the correct exposure. Then double the exposure for each stop you need to add for your filter. For example, if the unfiltered exposure is 4 sec and you are shooting with a 4-stop ND, the correct exposure with the filter in place will be 64 seconds ($4 \times 2 = 8$, $8 \times 2 = 16$, $16 \times 2 = 32$, $32 \times 2 = 64$).

EQUIPMENT CHECKLIST

LENS: A wide-angle zoom will probably be the most useful lens. With motion studies, you'll want to give lots of space to the moving elements – water or sky – and you will therefore want to compose a slightly wider scene than normal.

CAMERA FUNCTION: Bulb mode. Most cameras only allow metered exposures up to 30 sec, so you'll need to switch to Bulb mode and lock the shutter open for the desired length of time.

ACCESSORIES: One or more ND filters; a cable release, so you can lock the shutter open without camera shake; a stopwatch, if your camera or remote release doesn't have a time counter.

CREATIVE ASSIGNMENT 3: FILTRATION

Filters can help you capture the scene more 'naturally' – closer to how the human eye perceives it. They can also enhance a scene – for example, using a polarizer to increase colour saturation and add 'punch' to an image. However, filters can also be used for creative effect. One popular technique is to use solid neutral density filters to lengthen exposure times and shoot moving water so that it records with a misty or silky texture.

THE ASSIGNMENT

The purpose of this project is to experiment with the creative aspect of filtration, using it to add atmosphere to an image and capture things that perhaps the eye doesn't see – this is one of the joys of photography. The aim is to capture a mood rather than to reflect the scene precisely as the eye sees it. So, for this assignment, use a neutral density filter to photograph a long exposure – how long is up to you, and it will depend at least partly on the subject, but we'd recommend using the Bulb setting on your camera and thinking in minutes rather than seconds.

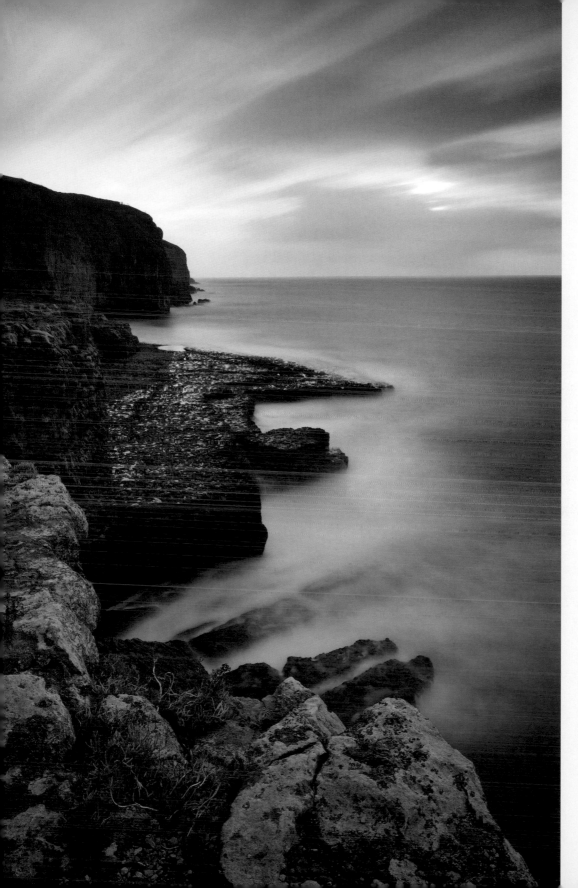

DRAMATIC SKIES

Judging the best exposure time to suit a particular scene can be tricky. When this picture was taken, it was quite windy and the clouds were blowing quickly across the sky. If the exposure had been much longer than the two minutes I gave it, the clouds would have blurred into one grey mass rather than recording as dramatic streaks.
Canon EOS 5D Mk II, 21mm f/2.8, 120 sec at f/11, 3-stop soft ND grad, 10-stop solid ND

TECHNIQUE TIPS

■ Look for texture in the sky. Even if there is no colour, texture and layering in the sky can add interest.

■ Consider long exposures using ND filters (see pages 79–80), especially if there is some layering in the sky – clouds streaking across the top of the frame can add drama to a shot. It's possible to shoot excellent motion studies in poor weather.

■ Consider 'overgrading' to add drama to the sky.

■ Shoot with black and white conversion in mind. If there's no colour, monochromatic tones can work well instead.

■ Look for bold shapes and forms in your compositions and consider silhouetting them against a stormy sky.

■ If you shoot towards dusk with a Daylight white balance setting, the image will record with cool, blue tones, which can be further enhanced in post-processing.

■ If it's windy, you'll need to take extra care with the tripod to avoid camera shake – some tripods have a hook on which you can hang your camera bag to provide extra weight and stability.

EQUIPMENT CHECKLIST

As well as all your normal photographic equipment, you may find the following accessories useful:

A RAIN COVER for your camera. There are several commercially available rain covers, or you can make your own.

AN UMBRELLA – not just to keep yourself dry, but also to protect your equipment. A rain cover will protect your camera, but won't stop rain blowing onto the front element of your lens or your filters, ruining your shots.

WARM, COMFORTABLE, DRY CLOTHING. You'll take better photographs if you're not wet and cold!

ND FILTERS to enable long exposures.

CREATIVE ASSIGNMENT 4: GREAT IMAGES IN POOR WEATHER

It's easy to recognize great light – a shaft of sunlight breaking through stormy clouds and spotlighting a castle on top of a hill, a mackerel sky painted red by the setting sun, a rainbow stretching in front of a stormy sky. Light isn't always so dramatic, however, and the ability to work in less photogenic conditions is an important skill. By learning how to work in less favourable conditions, and seeking out subjects that suit more subdued light, you will deepen your understanding of light in general.

THE ASSIGNMENT

Photographers normally use 'bad' weather to scout for locations or catch up on processing images, but for this assignment, you need to go out on a day when you'd normally prefer not to – perhaps it's dull and grey, cold and windy, or even raining – and try to produce some creative images. You'll have to work hard and spend a lot of time looking and thinking. You'll almost certainly take fewer pictures than you would in more favourable weather, but you may be surprised at the results you can achieve. Some of our most successful images have been taken in what many photographers would regard as poor weather.

However, be sensible and don't take risks. If you think there's a danger of slipping on wet rocks, for example, or if the roads are slippery, stay at home.

FOGGY MORNING
*Mist can be photogenic,
but thick fog usually
isn't. Setting up at dawn,
I'd hoped that the sun
would burn off the fog,
revealing more of the
scene and introducing
some colour to the image.
That didn't happen, but
a telezoom enabled me
to base a composition
around the shapes of the
boats and their reflections
in the calm water.*
*Canon EOS 5D Mk II,
70–200mm f/4L (at 170mm),
ISO 100, 0.6 sec at f/11,
unfiltered*

TECHNIQUE TIPS

To help you find order in the chaotic location you've chosen:

■ Look for lines that can lead the eye through the frame. They don't have to be 'real' lines – implied lines can work just as well.

■ Look for shapes. Again, these can be implied – the viewer's eye will complete the lines between three rocks to make a triangle, for example.

■ Try to pick out patterns in a scene – they can help to pull an image together.

■ Find objects that stand out against their surroundings. For example, in woodland, a tree that has a thicker or thinner trunk than those surrounding it, or which has interesting shapes in its trunk or branches.

■ Remember that backlighting and bold shadows can simplify and add structure to an image – especially in woodland scenes.

EQUIPMENT CHECKLIST

LENS: You may find that a telezoom or short telephoto is useful for picking out shapes and patterns.

ACCESSORY: A tripod with a good head will help you with precise framing, which is particularly important with this assignment.

CREATIVE ASSIGNMENT 5: FINDING ORDER IN CHAOS

Human beings like order, and we enjoy finding a sense of structure in an image. Successful compositions need to convey this sense of order to the viewer. Unfortunately for the landscape photographer, however, nature is a largely chaotic environment and imposing a structure upon it isn't always easy.

THE ASSIGNMENT

It's often tempting to take the simple option and visit locations where the elements already possess a strong sense of order – maybe a section of the coast where there is a pebbled foreshore and an interesting headland in the background – but this won't necessarily improve your ability to find interesting and powerful compositions. To develop as a photographer, you need to challenge yourself, and that is what this assignment sets out to do.

Choose a location that you consider 'difficult', one that is cluttered, chaotic and has no obvious focal point – woodland is ideal. Spend a few hours there – or as much time as you need – with the aim of finding structured compositions. You may find that you take fewer photographs than normal, but this is not necessarily a bad thing, as quality is always more important than quantity in landscape photography. Even if you come away with only one strong composition, you've achieved the aim of the assignment.

BLUEBELL WOOD

Bluebell woods are beautiful, but can be very difficult to photograph – it's a naturally chaotic environment. After much walking, I found this group of trees that formed a semi-circle, and where the carpet of bluebells was relatively 'clean'. Using a wide aperture to let the background fall gradually out of focus adds a slightly dreamy feel to the image.
Canon EOS 5D Mk II, 24–105mm f/4L (at 45mm), ISO 100, 1/15 sec at f/4, polarizer

TECHNIQUE TIPS

There are various ways of approaching this assignment. For example, you could:

■ Choose a single subject and isolate it in the frame. Remember to make the most of the space around the subject.

■ Shoot an almost empty frame with no single subject – perhaps a beach scene with just sand, sea and sky.

■ Move in very close to the subject and combine minimalism with abstraction.

■ Shoot in black and white; removing colour is one way of simplifying the image.

■ If you are working in colour, look for scenes that are made up of different shades of a single colour.

■ Look for contrasts, such as a solid, angular object surrounded by soft, moving water.

EQUIPMENT CHECKLIST

You don't need any specialist equipment for this assignment, but the following items could be useful:

LENS: A standard zoom lens offers a useful focal range for this style of photography. The long end is ideal for isolating key interest within the landscape and the wide end can be used to emphasize the space around the subject.

ACCESSORIES: A graduated neutral density filter can add drama to the sky or, in compositions that contain a lot of sky, focus attention down to the horizon. A solid neutral density filter can smooth out moving water or add a sense of movement to the sky.

CREATIVE ASSIGNMENT 6: SIMPLICITY & MINIMALISM

One of the most common reasons for the failure of a composition is that it is too complex or cluttered; the most powerful compositions are often the simplest. The ability to reduce a composition to its essential elements is an important skill to learn and one that will improve your photography.

Minimalism takes this idea a step further, stripping an image down to its fundamental features. The purpose of this assignment is not necessarily to develop a minimalist style, but to explore the concept and develop the ability to simplify and strengthen compositions by leaving out distracting and unnecessary elements.

THE ASSIGNMENT

In keeping with this theme, the instructions are also minimal: find a scene and see how far you can strip the image down.

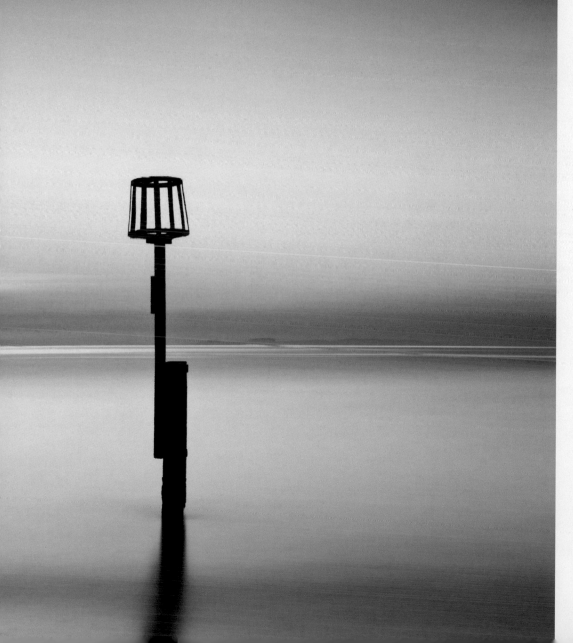

GROYNE MARKER
In this image, the groyne marker is isolated in the sea, against a simple backdrop of the dawn sky. A long exposure has smoothed the water, contrasting with the hard edges of the structure. The minimalist feeling is further enhanced by the restricted range of colours and tones in the image.
Canon EOS 5D Mk II, 24–105mm f/4L (at 65mm), ISO 200, 212 sec at f/16, 2-stop ND grad, 10-stop solid ND

FREQUENTLY ASKED QUESTIONS

We try to cram as much information and practical technique into our photography workshops as possible – and the same is true of this book. However, inevitably, we won't have answered every question you might have – or perhaps you need clarification on a particular point. Therefore, just as we normally host an informal question-and-answer session during our residential workshops, on these pages we have included a selection of the questions we are asked most often by photographers. We have made every effort to give you a straightforward, jargon-free answer – or at least an opinion – which we hope will prove helpful.

Q) Should I buy a full-frame digital SLR?

A) If your budget allows, yes – a full-frame digital SLR should provide superior image quality. Put simply, a full-frame camera is one that incorporates a sensor the same size as traditional 35mm film – 24mm × 35mm. Most entry-level and prosumer models have a smaller – or cropped – imaging sensor. But why is sensor size important? Well, the larger the sensor, the higher the image quality. The individual photosites on full-frame chips are further apart compared to those on an APS-C size sensor of the same resolution. As a result, image quality is cleaner and noise is kept to a minimum, even at high ISO settings. In addition, full-frame models do not alter the characteristics of your lenses. For example, a 28mm wide-angle is exactly that on a full-frame camera, but digital SLRs which have cropped-type sensors will magnify focal length (typically by a factor of 1.5×). However, as we have noted, full-frame models tend to be costly. If you can afford one, great – it will benefit your

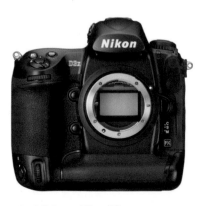

The full-frame Nikon D3x

photography. If you can't justify the extra outlay, don't worry. Image quality is very high on cropped-sensor DSLRs and, at low ISOs, noise is minimal.

Q) Should I always attach a lens hood when shooting landscapes?

A) A lens hood is designed to prevent non-image-forming light from entering the lens. Stray light can reduce contrast or produce flare, and is most likely to occur when you are shooting in bright conditions using wide focal lengths. Most new optics are supplied with a compatible hood, with wide-angles requiring a petal-shaped design to avoid vignetting. While they are effective, attaching one prevents the use of a filter holder. Therefore, the majority of landscape photographers rarely attach hoods, because they usually want to prioritize the use of slot-in filters instead. Being unable to attach a hood means photographers need to find different ways to prevent stray light hitting the sensor. Shielding the lens with your hand is one way; another is to stand to the side of the camera (tripod-mounted) and cast your shadow over the front of the lens, releasing the shutter using a remote cord.

EXPOSURE

Q) When photographing a scene reflected in water, do I still need to attach a graduated neutral density filter?

A) Photographers often assume that when photographing a scene mirrored in still water, a grad is unnecessary. In fact, the reflection will be reproduced darker than the scene itself. While this is normal, it can look odd in landscape photographs. Therefore, carefully position an ND grad so that the transitional zone is aligned at the point where the landscape meets the water. In other words,

Lens hood

push the grad down so that it covers the whole of the scene – not just the sky, but the landscape too. By doing this, you will be able to give more exposure to the reflection, creating a more balanced, natural-looking shot. Typically, a fairly weak density – a 1-stop ND grad, for example – will do the job.

Q) For many years I shot using film and often relied on a handheld light meter for exposure accuracy. Is it still worth using one for digital landscape photography?

A) In our opinion, no. Modern DSLRs have sophisticated TTL metering systems, which are highly accurate and reliable in most situations. While they are obviously not infallible, any exposure error is easy to spot if you use the histogram screen (see pages 34–5). Also, if you are exposing to the right (see pages 112–3) in order to maximize image quality, your aim will not be to achieve a technically correct exposure in-camera. While using a handheld meter was once invaluable – and is still useful for certain genres of photography, such as portrait and studio flash – they can slow you down and also add weight to your camera bag.

Q) Will light entering through my camera's viewfinder eyepiece affect exposure?

A) Light entering through the viewfinder eyepiece can, in some instances, affect metering accuracy. However, ordinarily, the amount of light entering the camera in this way is minimal and will have little or no effect on exposure. Photographers often take pictures

with their eye to the camera anyway, which blocks stray light from entering. Light leakage can prove more of a problem during lengthy exposures – particularly when using a 10-stop ND filter (see pages 83–5). When an ND filter of this density is attached, the light coming through the eyepiece can be stronger than through the lens itself. This can result in flare, a reduction in contrast or even bright, white

Handheld light meter

streaks appearing in your photographs. Therefore, we recommend photographers always cover the viewfinder eyepiece during long exposures as a precautionary measure. Covering the eyepiece during exposure is a good habit to get into – either shield it with your hand, or use the eyepiece cover supplied with the camera.

FILTRATION

Q) Which filter system would you recommend for someone new to filtration?

A) Lee Filters is renowned for being the best filter system available. However, the holder and filters are quite costly, and represent a major, long-term investment. For newcomers, we recommend the Cokin-P system. This is the system we both used when we first started out, so we can vouch for its value and quality. It holds 84mm slot-in filters and is an excellent, cost-effective introduction to filtration. There is a huge range of compatible filters available, and both the holder and filters are relatively inexpensive. You will also need adaptor rings that will fit the filter thread of the lens (or lenses) you intend attaching the holder to. Remember, there is an enhanced risk of vignetting when using smaller systems on wide-angles.

Q) Would you recommend using warm-up filters?

A) Warm-up filters are designed to alter colour temperature, either for correction or to artificially warm up a scene. They will boost colour and add pleasing warmth to images where it may not be present naturally. If you were a film user, we would say yes, and suggest you buy either an 81b or 81c version. However, if you're a DSLR user, you can save your money – colour temperature can be adjusted quickly and easily using your camera's white balance function (see pages 36–7) instead. By selecting a higher colour temperature, you can replicate the effect of traditional, optical warm-up filters. Better still, if you shoot in Raw, you can adjust colour temperature during processing. This allows you to make adjustments with even greater precision.

Cokin filter holder

Q) I want to buy a set of graduated ND filters, but can only afford either a hard- or soft-edged set. Which should I opt for?

A) We suggest you buy a hard set. Many photographers opt for soft ND grads, because they are more forgiving if you misalign the filter – for example, by pushing it too far down in the holder. While this is true, soft grads are also generally far less effective. Their density starts to tail off quite high up the filter, so their effect is minimal towards the centre. You only enjoy the full benefit of the filter's density at the very top of the filter, yet the sky is often at its brightest near the horizon – where a soft grad is at its least effective. While soft grads are useful when photographing 'broken' skylines, hard-edged grads are the best option for most scenes. While the transition from dark to clear is quite abrupt, the filter's density is more consistent over a greater area, making them more effective at lowering contrast within a scene. Although extra care is needed when aligning hard ND grads, they are far easier to position, as the transitional zone is more obvious through the viewfinder. Hard-edged grads are actually surprisingly forgiving when used on smaller formats, like 35mm SLRs.

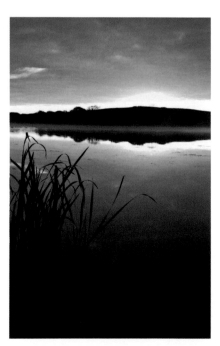

Hard-edged ND grad filters were used for this shot.

POST-PROCESSING

Q) What is Exif data and what is it for?

A) Exchangeable Image File Format – or Exif – data is recorded by the camera every time you take a digital photo. It consists of shooting information that the camera embeds into the image file – for example, lens focal length, aperture, shutter speed, metering pattern, white balance, exposure compensation, time and date. This information is useful for a variety of reasons. It allows you to review and study your settings – helpful when you wish to work out why an image was or wasn't successful. The Exif data gives a valuable insight into how certain settings affect and alter key photo characteristics, such as subject motion and depth of field. It is also useful when you are required to provide technical details when captioning images. Exif data can be read in-camera, or via applications that support image file formats – such as Raw converters. One of the easiest ways to view the Exif data for an image is in Photoshop – simply click File > File Info.

Q) I have recently set up my own website, showcasing my landscape photographs. How can I protect my images on the internet?

A) This is a good question. All photographers worry about unauthorized use of their photographs. Image theft is hard, if not impossible, to prevent once images are online. The only foolproof way to prevent it is to embed a sizeable watermark on your images. There are various ways to do this, either using dedicated software available online, or in Photoshop. In Photoshop, open the image and select the Type tool. Enter the copyright symbol and/or any

Typical Exif data

other text you want to use for the watermark. While in the Type tool dialog, click the colour swatch, and set the colour to 50% grey (set RGB values of 128, 128, 128). Resize and position your text as desired. In the Layers palette, you can alter the blend mode and opacity to suit the particular image. In some applications, it is possible to apply the watermark to multiple images automatically. However, it can be argued that watermarking images defeats the object of displaying your images for others to enjoy. Therefore, many photographers simply keep image size under 1000 pixels (at the longest edge) for online use. By doing this, they should only be good enough for web reproduction – hopefully deterring unauthorized usage in print.

Q) What exactly is chromatic aberration and how do I remove colour fringing from my images?

A) Chromatic aberration – also known as 'colour fringing' – is a common lens flaw. It is caused when the lens cannot focus different wavelengths of light onto the exact same focal plane (the focal length for each wavelength is different) or when the lens magnifies different wavelengths in different ways. The result is brightly coloured halos – typically green or purple – forming along boundaries that separate dark and light parts of the image. Chromatic aberration is most common with budget optics. It isn't normally obvious at first glance, but becomes more noticeable in larger reproductions. Therefore, if you intend to print your images at a reasonable size, it can be a genuine concern.

Effectively, there are two types of chromatic aberration – longitudinal and lateral. The degree of chromatic aberration depends on the dispersion of the lens glass. The problem can be minimized by using an achromatic lens, in which materials with differing dispersion levels are assembled together to form a compound lens. It can also be corrected in post-processing. Most Raw converters and imaging software have a function designed for this purpose. In Photoshop, the easiest and most popular way to correct chromatic aberration is using the Lens Correction Filter. Go to Filter > Distort > Lens Correction to open the dialog box. Using the Zoom tool, zoom in on the image preview to get a closer view of the fringing as you make the correction. Under the Chromatic Aberration control are two sliders. The Fix Red/Cyan Fringe slider will compensate for red/cyan colour fringing, by adjusting the size of the red channel relative to the green channel. The Fix Blue/Yellow Fringe alters the size of the blue channel relative to the green channel. The sliders are intuitive to use – move them gradually until you are satisfied that you have reduced the visibility of the fringing. Click OK to apply the correction.

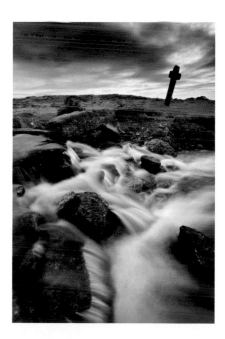

(Right) Colour fringing becomes more obvious when images are enlarged. It can be removed easily in Photoshop.

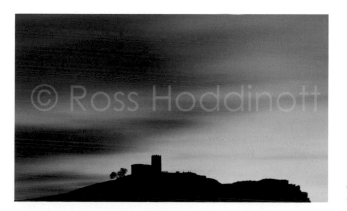

(Left) Example of a watermarked image.

GLOSSARY

Aberration An imperfection in the image caused by the optics of a lens.

Angle of view The area of a scene that a lens takes in, measured in degrees.

Aperture The opening in a camera lens through which light passes to expose the image sensor. The relative size of the aperture is denoted by f/numbers.

Autofocus (AF) A through-the-lens focusing system allowing accurate focus without the user manually focusing the lens.

Bracketing Taking a series of identical shots, changing only the exposure value, usually in increments of (+/–) 1/2 or 1 f/stop.

Bulb (abbreviated 'B') is a shutter speed setting that allows for long exposure times under the direct, manual control of the photographer. The term 'bulb' refers to old-style pneumatically actuated shutters – squeezing an air bulb would open the shutter, while releasing it would close it.

Camera shake Movement of the camera during exposure. Can lead to blurred images, particularly at slow shutter speeds. Often caused by an unsteady hold or support.

CCD (charge-coupled device) A type of image sensor commonly used in digital cameras.

CMOS (complementary metal-oxide semi-conductor): Another type of image sensor used in digital cameras. A microchip consisting of a grid of millions of light-sensitive cells – the more sensors, the greater the number of pixels and the higher the resolution of the final image.

Colour temperature The colour of a light source, expressed in degrees Kelvin (°K).

Compression The process by which digital files are reduced in size.

Contrast The range between the highlight and shadow areas of an image, or a marked difference in illumination between colours or adjacent areas.

Depth of field (DOF) The amount of an image that appears acceptably sharp. This is controlled by the aperture – the smaller the aperture, the greater the depth of field.

Distortion Typically, when straight lines are not rendered perfectly straight in a photograph. Barrel and pin-cushion distortion are two examples. Wide-angle lenses and wide-range zoom lenses are prone to these problems.

dpi (dots per inch) Measure of the resolution of a printer or a scanner. The more dots per inch, the higher the resolution.

Dynamic range The ability of the camera's sensor to capture a full range of shadows and highlights in an image.

Elements The individual pieces of glass that form the overall optical construction of a lens.

Evaluative metering A metering system whereby light reflected from several subject areas is calculated based on algorithms.

Exposure The amount of light allowed to strike and expose the image sensor, controlled by aperture, shutter speed and ISO sensitivity. Also the act of taking a photograph, as in 'making an exposure'.

Exposure compensation A control that allows intentional over- or underexposure.

Filter A piece of coloured, or coated, glass or plastic placed in front of the lens for creative or corrective use.

f/stop or f/number Number assigned to a particular lens aperture. Wide apertures are denoted by small numbers such as f/2.8, and small apertures by large numbers such as f/22.

Focal length The distance from the optical centre point of a lens element to its focal point, which signifies its power.

Grad Graduated filter. A filter that is half coated, half clear.

Highlights The brightest areas of an image.

Histogram A graph used to represent the distribution of tones in an image.

Interpolation A way of increasing the file size of a digital image by adding pixels, thereby increasing resolution.

ISO (International Standards Organization) The sensitivity of the image sensor measured in terms equivalent to the ISO rating of a film.

JPEG (Joint Photographic Experts Group) A popular image file type, compressed to reduce file size.

Landscape The visible features of an area of land, including the physical elements of landforms and water bodies, such as rivers, lakes and the sea. Also, human elements, including buildings and structures, and transitory elements such as lighting and weather conditions.

LCD (liquid crystal display) The flat screen on the back of a digital camera that allows the user to playback and review digital images and shooting information.

Lens The eye of the camera. The lens projects the image it sees onto the camera's imaging sensor. The size of the lens is measured and indicated as focal length.

Manual focus This is when focusing is achieved through manual rotation of the focusing ring on the lens.

Metering Using a camera or handheld light meter to determine the amount of light coming from a scene and calculate the required exposure.

Metering pattern The system used by the camera to calculate the exposure.

Megapixel One million pixels equals one megapixel.

Memory card A removable storage device for digital cameras.

Mirror lock-up Allows the reflex mirror of an SLR to be raised and held in the 'up' position, before the exposure is made.

Monochrome Image comprised only of grey tones, from black to white.

Multiplication factor The amount by which the focal length of a lens will be magnified when attached to a camera with a cropped sensor (smaller than 35mm).

Noise Coloured image interference caused by stray electrical signals.

Overexposure A product of too much light reaching the camera's sensor. Detail is lost in the highlights.

Perspective In the context of visual perception, it is the way in which objects appear to the eye depending on their spatial attributes, or their dimensions and the position of the eye relative to the objects.

Photoshop A graphics editing program developed and published by Adobe Systems Incorporated. It is considered the industry standard for editing and processing photographs.

Pixel Abbreviation of 'picture element'. Pixels are the smallest bits of information that combine to form a digital image.

Post-processing The use of software to make adjustments to a digital file on a computer.

Prime lens A fixed focal-length lens – a lens that isn't a zoom.

Raw A versatile and widely used digital file format in which shooting parameters are attached to the file, not applied to it.

Remote release A device used to trigger the shutter of a tripod-mounted camera to avoid camera shake.

Resolution The number of pixels used to either capture an image or display it, usually expressed in ppi. The higher the resolution, the finer the detail.

RGB (red, green, blue): Computers and other digital devices understand colour information as shades of red, green and blue.

Rule of thirds A compositional device that places the key elements of a picture at points along imagined lines that divide the frame into thirds.

Saturation The intensity of the colours in an image.

Shadow areas The darkest areas of the exposure.

Shutter The mechanism that controls the amount of light reaching the sensor by opening and closing when the shutter release is activated.

Shutter speed The shutter speed determines the duration of the exposure.

SLR (single lens reflex) A camera type that allows the user to view the scene through the lens, using a reflex mirror.

Spot metering A metering system that places importance on the intensity of light reflected by a very small percentage of the frame.

Standard lens A focal length similar to the vision of the human eye – typically, 50mm is considered a standard lens.

Telephoto lens A lens with a large focal length and a narrow angle of view.

TTL (through the lens) metering A metering system built into the camera that measures light passing through the lens at the time of shooting.

TIFF (Tagged Image File Format) A universal file format supported by virtually all image-editing applications. TIFFs are uncompressed digital files.

Underexposure A condition in which too little light reaches the sensor and too much detail is lost in the shadow areas of the exposure.

USB (universal serial bus) A data transfer standard.

Viewfinder An optical system used for composing and sometimes focusing the subject.

Vignetting Darkening of the corners of an image, due to an obstruction – usually caused by a filter(s) or lens hood.

White balance A function that allows the correct colour balance to be recorded for any given lighting situation.

Wide-angle lens A lens with a short focal length.

Workshop A brief, intensive course, seminar or a series of meetings emphasizing interaction and exchange of information, usually among a small number of participants.

Zoom A lens with a focal length that can be adjusted to any length within its focal range.

USEFUL WEBSITES AND DOWNLOADS

CALIBRATION
ColorEyes Display:
www.integrated-color.com
ColorVision: www.colorvision.com
Xrite: www.xrite.com

CAMERA CARE
Giottos: www.giottos.com
Visible Dust: www.visibledust.com

DEPTH-OF-FIELD CALCULATOR
DOF Master: www.dofmaster.com

INSURANCE
Aaduki: www.aaduki.com

OUTDOOR EQUIPMENT
Ordnance Survey:
www.ordnancesurvey.co.uk
Paramo: www.paramo.co.uk
SatMap: www.satmap.com

PHOTOGRAPHERS
Mark Bauer:
www.markbauerphotography.com
Ross Hoddinott: www.rosshoddinott.co.uk

PHOTOGRAPHY WORKSHOPS
Dawn 2 Dusk Photography:
www.dawn2duskphotography.co.uk

PHOTOGRAPHIC EQUIPMENT
Canon: www.canon.com
Cokin: www.cokin.co.uk
Lee Filters: www.leefilters.com
Lexar: www.lexar.com
Manfrotto: www.manfrotto.com
Nikon: www.nikon.com
Olympus: www.olympus.com
Pentax: www.us.ricoh-imaging.com
Sigma: www.sigma-photo.com
Sony: www.sony.com
Tamron: www.tamron.com

PRINTING
Epson: www.epson.com
Hahnemühle: www.hahnemuehle.de
Harman: www.harman-inkjet.com
HP: www.hp.com
Lyson: www.lyson.com
Permajet: www.permajet.com
Marrutt Digital Solutions (inks):
www.marrutt.com

PHOTOGRAPHY BOOKS
Ammonite Press:
www.ammonitepress.com

SUNRISE AND SUNSET DIRECTION
The Photographer's Ephemeris:
www.photoephemeris.com

RETAILERS
Bogen Imaging:
www.bogenimaging.co.uk
Robert White: www.robertwhite.co.uk

SOFTWARE
Adobe: www.adobe.com
Apple: www.apple.com/aperture
Corel: www.corel.com
DxO: www.dxo.com
Perfect Resize: www.ononesoftware.com
Phase One: www.phaseone.com
Photomatix Pro: www.hdrsoft.com

FURTHER READING
Digital Photography Review:
www.dpreview.com
Digital SLR Photography magazine:
www.digitalslrphoto.com
Ephotozine: www.ephotozine.com

WEATHER
AccuWeather: www.accuweather.com
The Met Office: www.metoffice.gov.uk
XC Weather: www.xcweather.co.uk

ABOUT THE AUTHORS

ROSS HODDINOTT

Ross Hoddinott is one of the UK's leading professional outdoor photographers and writers. His intimate, striking imagery is published widely and he will be familiar to readers of many photographic publications, including *Outdoor Photography* and *Digital SLR Photography*. In 2009, Ross became British Wildlife Photographer of the Year, and he is a multiple award winner in the Wildlife Photographer of the Year and Landscape Photographer of the Year competitions. Ross is also part of the 2020Vision photo team (www.2020v.org).

The *Landscape Photography Workshop* is Ross's seventh book. Previous titles include *The Digital Exposure Handbook* and *Lenses for Digital SLRs*. With Mark Bauer, Ross runs Dawn 2 Dusk Photography, specializing in photographic workshops in the south-west of England. Find out more about Ross at www.rosshoddinott.co.uk.

MARK BAUER

Mark Bauer is one of the UK's leading landscape photographers. He is renowned for his evocative images of his home county of Dorset and other locations throughout the south-west of England.

Mark's work has appeared in numerous publications and, as a regular contributor to the British photographic press, his name will be familiar to many with an interest in landscape photography. He shoots stock photographs for three leading image libraries and his work has been Highly Commended and Commended in the Landscape Photographer of the Year competition.

The *Landscape Photography Workshop* is Mark's third book, after *Romantic Dorset* and *Perfect Wiltshire* (published by Halsgrove). He runs Dawn 2 Dusk Photography with Ross Hoddinott. To find out more about Mark's work, visit www.markbauerphotography.com.

ACKNOWLEDGEMENTS

Thank you to Gerrie Purcell and Jonathan Bailey for commissioning *The Landscape Photography Workshop*, and a huge thanks to Simon Goggin for creating such a clean design and inviting layout. The biggest thank you is reserved for Tom Mugridge, who made our lives so pain-free while editing this title. Thanks also to Bogen Imaging, Canon, Cokin, Epson, Giottos, Hoya, Intro2020, Lee Filters, Lexar, Lowepro, Nikon, Olympus, Permajet, Sekonic, Sony, Tamron and VisibleDust for supplying product images.

Away from the book, the biggest thank you of all goes to our long-suffering families – Mark's partner Julie and son Harry, and Ross's wife Fliss and daughters Evie and Maya. Living with a photographer isn't easy. Working hours are long, unpredictable and unsociable and outdoor photographers are often grumpy and hard to live with when the weather is bad or a deadline needs to be met. Thank you all for your amazing support, constant encouragement, patience and belief.

Finally, thank you to all our Dawn 2 Dusk Photography workshop participants. We both thoroughly enjoy sharing our knowledge and experiences with other photographers on location. It is great fun and we have met some fantastic people, who have given us the belief and encouragement to write this book. If you haven't attended one of our workshops already, we hope to meet you on a future course.

INDEX

To place an order, or request a catalogue, contact:

Ammonite Press

AE Publications Ltd, 166 High Street, Lewes, East Sussex, BN7 1XU, United Kingdom

Tel: +44 (0) 1273 488006 **www.ammonitepress.com**